THE ART OF
FABERGÉ

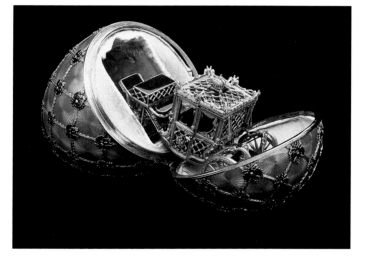

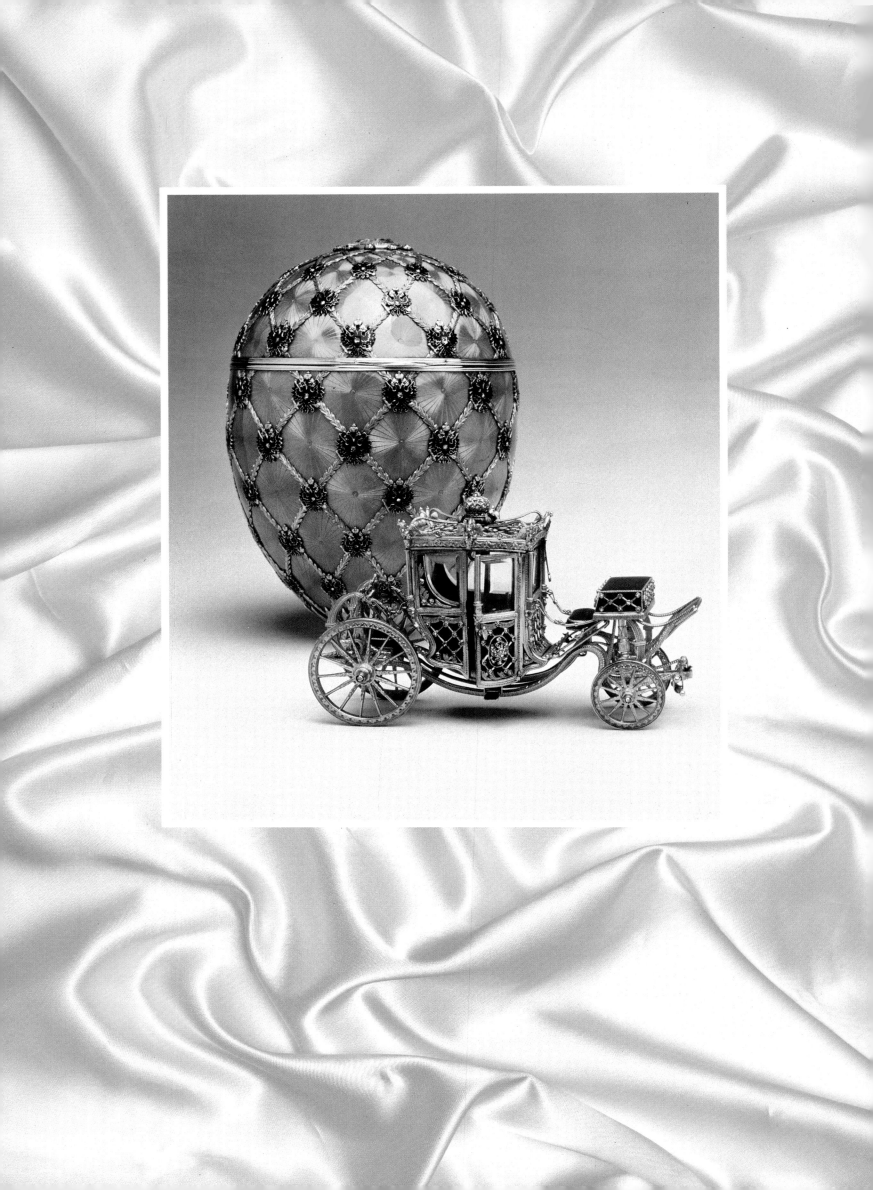

THE ART OF
FABERGÉ

JOHN BOOTH

THE WELLFLEET PRESS

A QUARTO BOOK

Published by Wellfleet Press
110 Enterprise Avenue
Secaucus, New Jersey 07094

ISBN 1-55521-443-6

This book was designed and produced by Quarto
Publishing plc, The Old Brewery, 6 Blundell Street,
London N7 9BH

Art Director: Ian Hunt
Designer: Annie Moss
Artwork: Danny McBride
Editorial Director: Jeremy Harwood
Senior Editor: Sally MacEachern
Editor: Lesley Levine
Indexer: Dorothy Groves
Picture Manager: Joanna Wiese
Picture Researcher: Deirdre O'Day

Typeset by Central Southern Typesetters, Eastbourne
Manufactured in Hong Kong by
Regent Publishing Services Ltd
Printed in Hong Kong by Lee-fung Asco Printers Ltd

Contents

CHAPTER ONE
The Last of the Great Goldsmiths
6

CHAPTER TWO
Artist or Craftsman?
28

CHAPTER THREE
The Fabergé Empire
52

CHAPTER FOUR
"Un Génie Incomparable"
78

CHAPTER FIVE
The Style Fabergé
112

CHAPTER SIX
"Fabergé in Wonderland"
142

CHAPTER SEVEN
Collecting Fabergé
162

Index
188

Bibliography and Acknowledgments
191

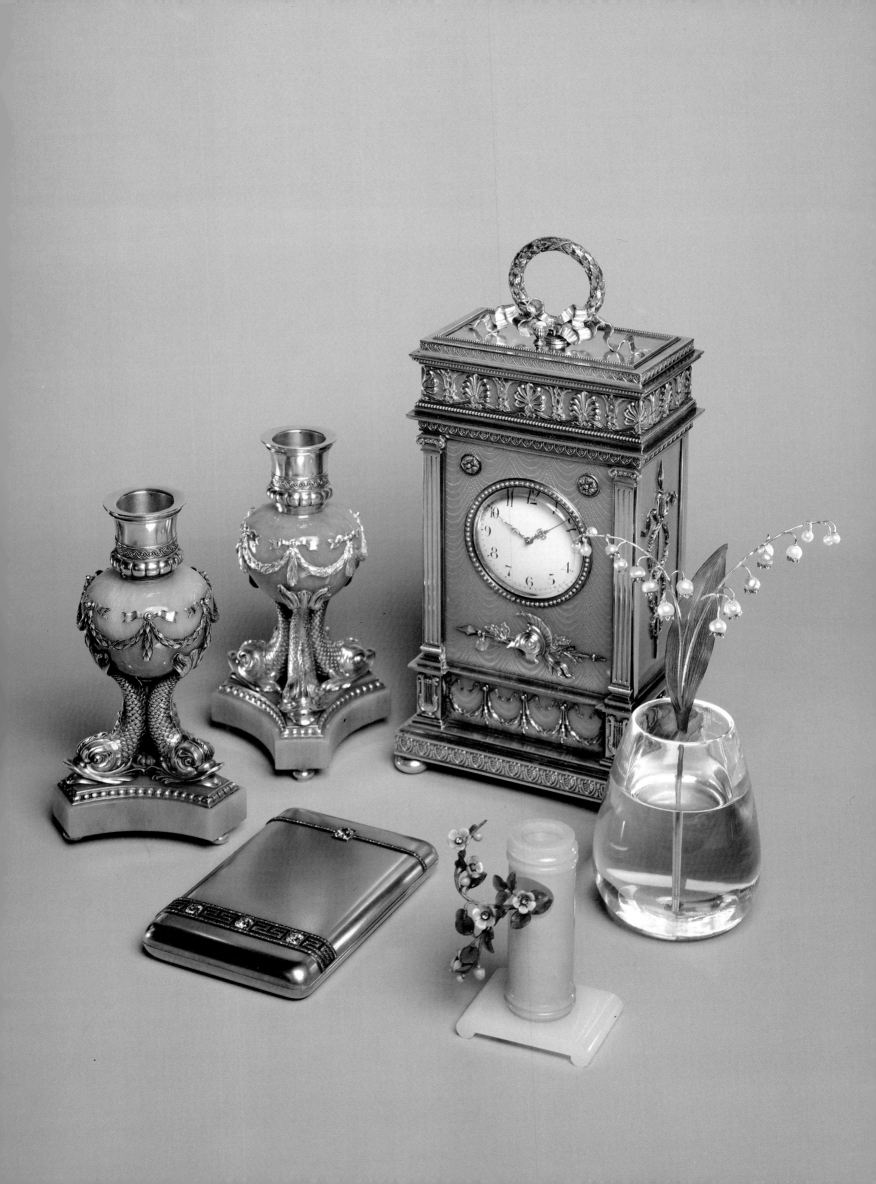

The Last of the Great Goldsmiths

The extraordinary success of Peter Carl Fabergé in his lifetime and the fact that he is remembered when other excellent craftsmen have been forgotten can be explained in a number of ways: his work reflects the highest traditions of European applied art, he used only the finest materials and employed the best craftsmen to carry out his ideas, and, finally, there is a crucial element that distinguishes his work from that of others – a unique quality that has come to be expressed in one word – Fabergé.

Superbly crafted pieces by Fabergé: typical of those displayed in the homes of the upper classes in Russia and Britain around the turn of the century. The yellow enamelled guilloche case of the clock is inscribed inside the door "2 Mai 1898, Alexis". The Grand Duke Alexis Alexandrovitch was the fourth son of Alexander II.

.

ABERGÉ. THE NAME CONJURES UP images of unbelievable splendour and unimaginable opulence. Against the backdrop of the sumptuous, glittering world of the last tsars of Russia, here was a man who dedicated his life to the creation of priceless treasures for the Imperial family, a task in which cost and time had no significance, in which gaining Imperial approval was all.

So runs the legend, and there is much truth in it, but this is by no means the whole story. Fabergé lived through one of the most momentous periods in the history of Russia, but his work reflected earlier traditions of devoted service and noble patronage that were rooted in the 18th century. The calm, patient values of the master craftsman so evident in his work were maintained at a time when Russia was on the point of cataclysmic eruption; a period of change that had lasted for more than a century and was about to culminate in the Russian Revolution of 1917.

Peter Carl Fabergé, who has been described as the last of the great goldsmiths, was born in St Petersburg on 30 May, 1846. His father, Gustav Fabergé, was a jeweller with a small but prosperous shop in Bolshaya Morskaya Street, St Petersburg. The family's French name can be traced back to 17th-century France and the reign of Louis XIV.

The St Petersburg branch of Fabergé at 24 Morskaya Street, bought in 1898, which was the headquarters of the Fabergé operation, housing showroom, studios, workshops and the family apartments.
.

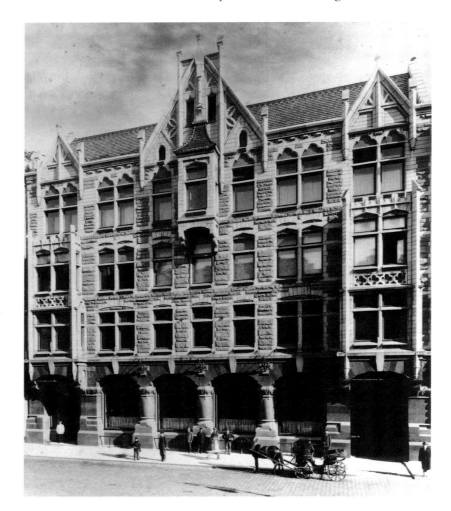

The plush interior of the St Petersburg showroom, presided over by Fabergé himself, who had a small office at the rear from which vantage point he was able to observe his clients coming and going.
.

Of Huguenot stock, they were persecuted and, like others of their faith, had to flee the country. They moved east and finally settled in Russia. Having changed their name to Fabri or Favri during their travels, they felt secure enough to revert to the original name of Fabergé in the 18th century, when Carl's grandfather, Peter, became a Russian subject in the Baltic province of Estonia. It was there, in the town of Pernau, that Carl's father, Gustav, was born in 1814.

Gustav was apprenticed as a goldsmith and jeweller to one Andreas Ferdinand Spiegel and then opened his own business in a basement in Morskaya Street in 1842. In the same year he married Charlotte Jugnstedt, who was of Danish origin. Peter Carl Fabergé, the first of their two sons, was baptized at the Protestant church at St Petersburg.

The Fabergé family was evidently in a reasonable way of business because Peter Carl (Carl Gustavovitch in Russian) was able to attend one of the best schools in St Petersburg, the Gymnasium Svetaya Anna. At this time St Petersburg was a cosmopolitan city, the capital of Russia. It had been created at enormous cost by Peter the Great on the marshland close to the Finnish border. Home of the Imperial Court, it was a city of broad streets and grand architecture where English, French and German were heard as often as Russian in sophisticated circles.

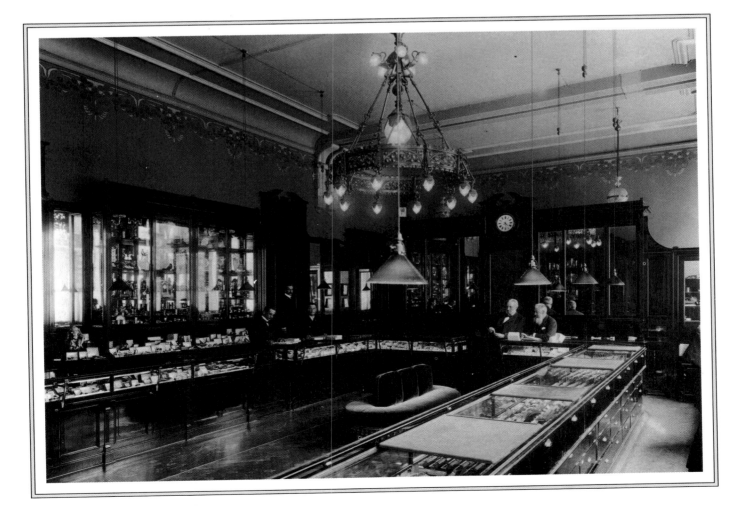

However, in spite of its cosmopolitan style, St Petersburg was essentially a Russian city. Alexandre Benois, the painter and one of the "World of Art" Society supporters, later joined by Sergei Diaghilev, who created the Ballet Russe, was a contemporary and associate of Fabergé and has given a vivid account of the city of his childhood:

"The well-to-do public walking on the main streets of St Petersburg could be mistaken for those whom they strove to copy – that is, Western Europeans, because they dressed and behaved in conformity with them. But one had only to glance away from the pavement to the middle of the street and the Western European illusion disappeared entirely, for here was a surging stream of the most extraordinary vehicles.

"Sleighs in winter, droshkis in summer, harnessed in a strange way and driven by bearded coachmen, all wearing wide greatcoats and headgear of fantastic shape. The coachmen of the nobility, foreign embassies, and even those of the Emperor himself, were dressed in similar zipouns, with the sole difference that their clothes were made of more expensive material, their hair carefully oiled and combed, their beards tidily trimmed."

Fabergé's education was evidently planned with his future career in mind. After schooling in St Petersburg he took a commercial course at the *Handelschule* in Dresden, where he was confirmed at the age of 15, in 1861. His father was living in Dresden at the time. He had retired at the early age of 46, leaving his jewellery business in the hands of a partner, Hiskias Pendin, and a manager, Zaiontchkovsky.

Fabergé's early training as a goldsmith also began in Germany, where he was apprenticed to a leading German goldsmith, Friedmann, at Frankfürt-am-Main. It was at this time that he made his European Grand Tour, an event which Fabergé scholars believe had a great influence on his future artistic development. With a friend, Jules Butz, the son of a successful St Petersburg jeweller, he visited Italy and France. In Florence, with its abundance of treasures, he is known to have visited the famous centre of hardstone carving, the Opificio delle Pietre Dure, and would certainly have seen the Medici collection of enamelled jewels and hardstone vessels. In Paris, where he studied at a commercial college, he doubtless enjoyed the splendour of the city, which during the reign of Louis Napoleon was being transformed by Haussman into the classical Paris so admired today. Here he witnessed for himself the results of the great flowering of French 18th-century jewellery, which was to have a profound effect on his future work.

So, by the time Fabergé took over the modest family business in the basement in Morskaya Street in 1870, at the age of 24, he was well equipped, having had both commercial and artistic training.

The ambition of the young man was first seen in his decision to take larger premises on the ground floor on the opposite side of the street, no doubt a preparation for expansion.

In 1872 he married Augusta Julia Jacobs, the daughter of an official in the Imperial Furniture Workshops, and the first of their four children, Eugène, was born in 1874. Agathon followed in 1876, Alexander in 1877 and Nicholas in 1884.

*P*eter Carl Fabergé
examining a parcel of loose stones. One of the most striking aspects of Fabergé's career was his decision to shift from the use of precious stones and expensive materials to semi-precious stones and natural minerals from Russia, chosen for their visual and tactile qualities rather than their value.

.

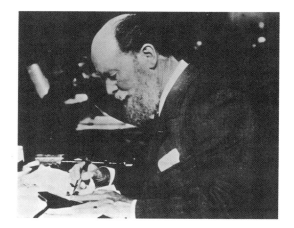

The cases which contained the precious objects from Fabergé were created with as much care as the objects themselves. They were made of polished holly by craftsmen and lined with padded white silk stamped with the Imperial warrant.

.

The second son bore the name of Fabergé's younger brother, Agathon, who was 16 years his junior but a major influence on the development of the firm because of his outstanding ability as a designer and artist. Although he only spent three years with the firm, from 1892 until his early death in 1895, he is thought to have contributed ideas while he was studying.

When Fabergé took over the firm it was a small, well-established business which someone else might have been happy to merely manage, while gradually building up a clientele from among the prosperous citizens of St Petersburg. Instead, he decided on a daring switch of style from the heavy, obviously expensive jewellery then popular to something lighter in which the design of the object was more important than the intrinsic value of the materials used. The move was surprising, even revolutionary, given the spirit of the time.

There was a shift, too, from the use of precious stones and metals to less expensive stones and natural minerals from Russia: the deep-green jade of nephrite, the glistening black of obsidian, the purity of rock crystal, the warm, tawny shades of aventurine quartz. Even wood from the forests of Russia was used by this daring jeweller: Karelian birch, palisander, white holly. The latter was highly polished and used for Fabergé boxes, which became almost trademarks, works of craftsmanship and beauty to enclose precious objects. The point about these materials was that they were selected only for their suitability in the design, not because they were of special value.

Traditional jewellery was still made, but the *objets de fantasie* (traditional *objets d'art* combined with functional items, meticulously made and stamped with a particular style) encapsulated the impulse of creativity for which the House of Fabergé came to be known. This

Fabergé style is easy to recognize but difficult to define. It has a kind of assured, restrained elegance and is notable for the quality of the craftsmanship, which is unobtrusive, seen in hinges which are virtually invisible and work effortlessly, in the depths of colour of guilloche enamel, in the subtle ways in which different colours of gold are worked and combined. It reflects a period when time was unimportant in the achievement of the desired effect, when patience was a necessary part of creating a beautiful object and when hours were not calculated or allowed to affect the decision to make something or not.

The surprise in Fabergé's first Imperial egg was probably similar to this crown from the gold Easter egg in the Danish Royal Collection.

· · · · · · · ·

The new style of work was evidently popular and the House of Fabergé prospered, but although he initiated a new approach in the craft of the jeweller and goldsmith, Fabergé looked for inspiration, particularly in his early years, to the antique world. His reputation became more widely known when he was invited to make copies of a number of Scythian treasures, ornaments from 400 BC which had been found at Kersh in the Crimea in 1867 by Count Sergei Stroganov. The results were so remarkable that the Tsar was unable to see any difference between Fabergé's work and the originals. The work was carried out by Fabergé's first workmaster, Erik Kollin, a Finn who worked exclusively for Fabergé from 1870 and whose work often contains elements taken from antiquity.

The copies of the Scythian treasures were a great success when they were exhibited at the Nuremberg Fair of 1885 and Fabergé was awarded the gold medal, a success that followed his gold medal at the Pan-Russian Exhibition in Moscow in 1882.

There were more honours. Success at the Northern Exhibition in Stockholm in 1897 was followed by his greatest triumph, at the Exposition Internationale Universelle in Paris in 1900. Here Fabergé was being judged by the inheritors of the great French tradition of superb goldsmithing. He knew their work well and was inspired by it. For the first time, the Russian Imperial family allowed some of the treasures made for them by Fabergé to be put on public display and they caused a sensation. The craftsmanship echoed that of the French 18th-century masters, especially in the use of guilloche enamelling, and the Russian exhibitor was decorated with the Knight's Cross of the Légion d'honneur. His international reputation was established beyond dispute.

There is no doubt that the most crucial event in Fabergé's career was his appointment as Court Jeweller in 1885. Without this, he would still have been as good a craftsman, and as distinguished a designer, but the opportunities presented by the appointment made him a legend.

Imperial patronage was conferred by Alexander III, a huge, bear-like man of great physical strength and uncertain temper who might have been expected to be completely indifferent to the miniature exquisites of the world of Fabergé. (Queen Victoria commented of him that he was a sovereign but one she "did not look upon as a gentleman".) He succeeded his father, Alexander II, who had embarked on a number of liberal reforms before being blown apart by a bomb in St Petersburg, a victim of the revolutionary violence erupting throughout the country.

Above: Fabergé's first Imperial Easter egg, made in 1885 (6.3cm/ 2½in). The shell is opaque white enamel with a gold interior and it holds a gold chicken with ruby eyes. The hen originally contained a surprise of a crown set with diamonds and a ruby but this has been lost.

.

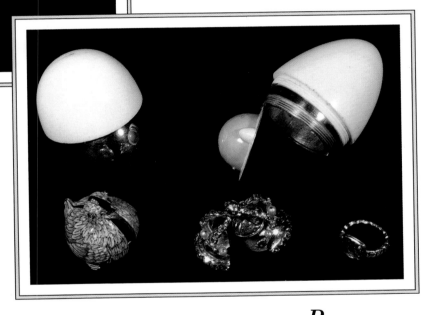

Alexander III adopted a more autocratic approach and was a monarch in the medieval mould. Yet this giant who could bend a silver rouble with his fingers acted like a Renaissance prince when he made Fabergé Court Jeweller.

With the appointment began one of the most astonishing examples of the goldsmith's art, the Imperial Easter eggs, a commission which was to last for more than 30 years. The exact circumstances of the commissioning of the first Imperial egg are not known, but there is a rather touching story that the intimidating Alexander III wished to give his wife, Marie, a Danish princess, a present that would remind her of home and so Fabergé created an egg that was a virtual copy of one in the Danish royal collection in Copenhagen.

Obviously the gift was a success, for it was decreed that a similar creation should be presented every year. This single act of patronage, made without reference to price, gave the House of Fabergé the security to attempt the extraordinary levels of invention and craftsmanship which were necessary, because the essential element of the Imperial egg was its surprise; some took years to make.

Right: The gold Easter egg in the Danish Royal Collection, Copenhagen, made in the first half of the 18th century, is believed to have inspired Fabergé's first Imperial Easter egg. Some experts, however, believe there may not be a direct connection as similar eggs were made in other parts of Europe – two can be found in Vienna and Dresden. The Danish egg has a white ivory shell and contains an enamelled gold chicken with diamond eyes, which opens to reveal a crown set with pearls and diamonds and a diamond-set ring.

.

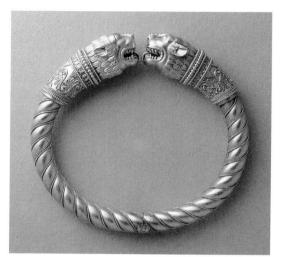

A superb example of the skill of Fabergé's first head workmaster, Erik Kollin, this Scythian gold bracelet made in 1882 is a copy of one of the treasures from 400BC which were discovered in the Crimea in 1867. It is made of yellow gold with lion finials and won the firm its first international gold medal when it was exhibited at the Pan-Russian Exhibition in 1882.

.

The patronage continued when Alexander III died peacefully in 1894 and was succeeded by Nicholas II, his son. Nicholas extended the commission, ruling that there should be two Imperial eggs each year: one for the Dowager Empress, Marie Feodorovna, and one for his wife, the Tsarina Alexandra Feodorovna.

Court Jeweller was not a courtesy title and the Imperial eggs were but the pinnacle of a string of commissions to meet the needs and obligations of the Court.

There were innumerable objects needed to mark anniversaries of institutions and families, or as tributes to individuals and groups, gifts to visiting or departing statesmen and to regiments, or in recognition of acts of service by all manner of people, rewards to the great and small — a stream of gifts that would engage much of the skills and energies of the House of Fabergé as jewellers, goldsmiths and silversmiths. There were the personal gifts needed by the Imperial family, their birthdays, christenings and weddings to be remembered. Then there was a vast and intricate web of family relationships linking the Romanov family with the royal families of Europe, especially those of Great Britain, Denmark and Germany, all of whom would appreciate some item stamped Fabergé.

With Imperial approval came the approval of the merely rich, who felt it was essential that they, too, should be able to point to their own collection of Fabergé. Among these was the fabulously wealthy Alexander Kelch, a Siberian gold millionaire who was an enthusiastic patron of Fabergé, ordering several fine pieces and a number of eggs, similar to those made for the Imperial family, for his wife, Barbara; these are known as the Kelch Eggs. Madame Kelch had a fondness for large and precious stones, a fondness indulged by her husband, and Fabergé supplied many sumptuous examples, including a superb necklace in which the centre stone weighed 30 carats.

The old aristocratic families naturally patronized the Court Jeweller: Fabergé made an Easter egg in the Imperial style that was given by Prince Felix Youssoupov to his wife, Zenaide, to celebrate their 25th wedding anniversary.

Another favoured customer for whom Fabergé made an egg in the Imperial style was Dr Emanuel Nobel, a wealthy Swedish businessman living in Russia (he was the nephew of Alfred Nobel, the inventor of dynamite, who is now remembered for the Nobel Prize). Nobel was a generous host and he was rich enough to give full rein to his instincts. He enjoyed bestowing trinkets from Fabergé to the ladies at his dinner table; on one occasion they were presented with pendants and brooches, made of rock crystal and frosted with diamonds, which resembled magnified snowflakes.

There were gifts for the stars of the flourishing artistic world of St Petersburg, the heroines of the ballet and theatre who were idolized by rich and importunate admirers and showered with precious gifts. Benois remembered how the ballerina Zucchi received the wild adulation of the audience after one performance, almost completely disappearing

under innumerable bouquets of flowers, and how, at the climax of the celebration, she was presented with an open box containing a necklace of enormous diamonds, a gift from her admirer, Prince Vassiltchikov, which was rumoured to be worth 30,000 roubles. Elizabeth Balletta, prima ballerina at the Imperial Michael Theatre, St Petersburg, was given a superb rock crystal goblet by a Russian Grand Duke, a gift described by Henry Bainbridge, Fabergé's first biographer, as "perhaps the most beautiful thing Fabergé ever made". Kchessinskaya, also of the St Petersburg ballet, had a Fabergé collection and Fabergé made a diamond setting for a brooch of Karsavina's, a superb Siberian amethyst, one of a set which had been presented by Catherine the Great to Count Zubov.

The fame of the House of Fabergé spread to Great Britain, as the result of gifts sent by the Romanovs to their English family, in particular by Marie Feodorovna, Empress of Russia, to her sister, Queen Alexandra. The pleasure-loving Edward VII admired the work of Fabergé enough to ensure that many of his wife's birthday presents came from him, and he also presented Fabergé souvenirs to other ladies who gained royal approval – very many of them, by all accounts.

Edward's enthusiasm was taken up by the fashionable world of Edwardian England and the cream of society demonstrated their sense of chic by buying from the House of Fabergé. Indeed, the enthusiasm for Fabergé was such that a London branch was opened in the early years of the 20th century. Crowned heads of Europe, earls, dukes, great ladies of fashion – all wanted to possess some unique object from the master goldsmith.

Chulalongkorn, the King of Siam, was an admirer and had several important pieces made, while many of the unbelievably wealthy maharajahs of India and the mandarins of China were also enthusiastic customers.

Fabergé was so successful that it became necessary to expand to cope with the flood of business. By 1890 the premises in Morskaya Street had doubled in size and a Moscow branch was opened in 1897, with branches at Odessa following in 1890 and at Kiev in 1905. Greater changes came in 1898 when a new building was bought at 24 Morskaya Street which was specially designed to house the many functions of the Fabergé empire.

At this period about 500 people were employed, producing thousands of articles to meet an apparently insatiable demand. What is extraordinary is that, despite so many hands, the pieces have a distinctive character, an individual style, a personality that was a result of the watchful presence of Fabergé himself, the benign ruler of this expanding empire. This uniformity of style is all the more astonishing when the range of objects created by Fabergé is considered. At the head of the output may be placed the Imperial Easter eggs, but they are, in truth, only a tiny fraction of the work of the House of Fabergé, as are the highly prized flowers and figurines and even the hardstone carvings, if they are considered against the vast outpouring of objects which adorned the

A smoky quartz goblet standing on a reeded gold base. Made by head workmaster Michael Perchin, it was a gift from a Russian Grand Duke to the famous ballerina, Madame Elizabeth Balletta of the Imperial Michael Theatre, St Petersburg. Elegant and serene, it was described by Fabergé's first biographer, Henry Bainbridge, as "perhaps the most beautiful thing Fabergé ever made".

.

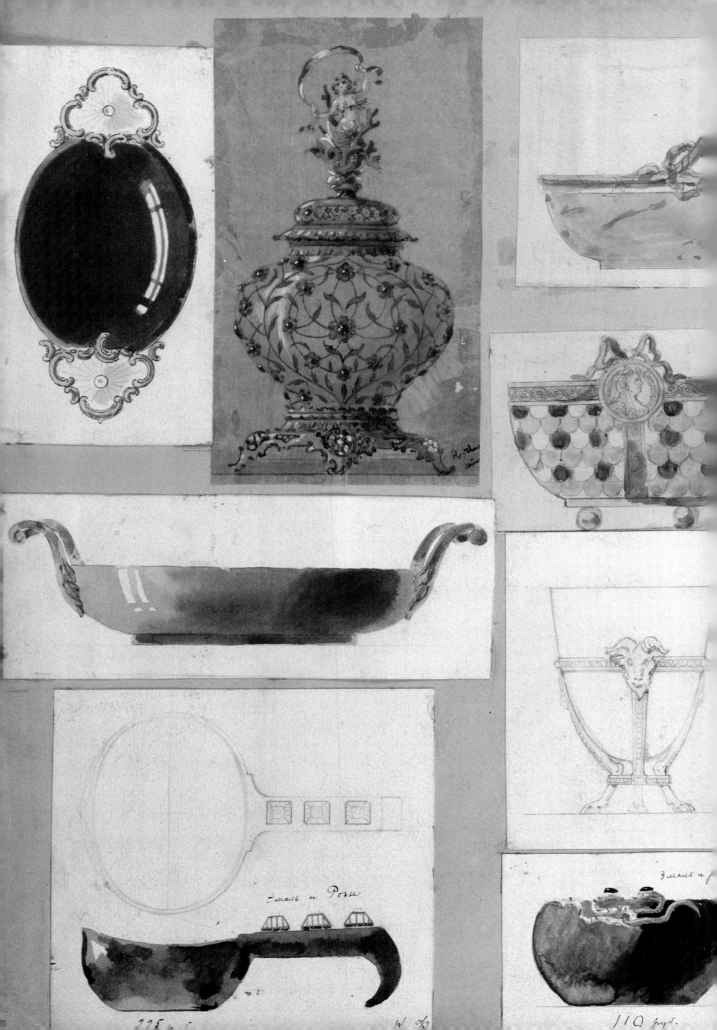

Эмаль и Розы

225

110 руб.

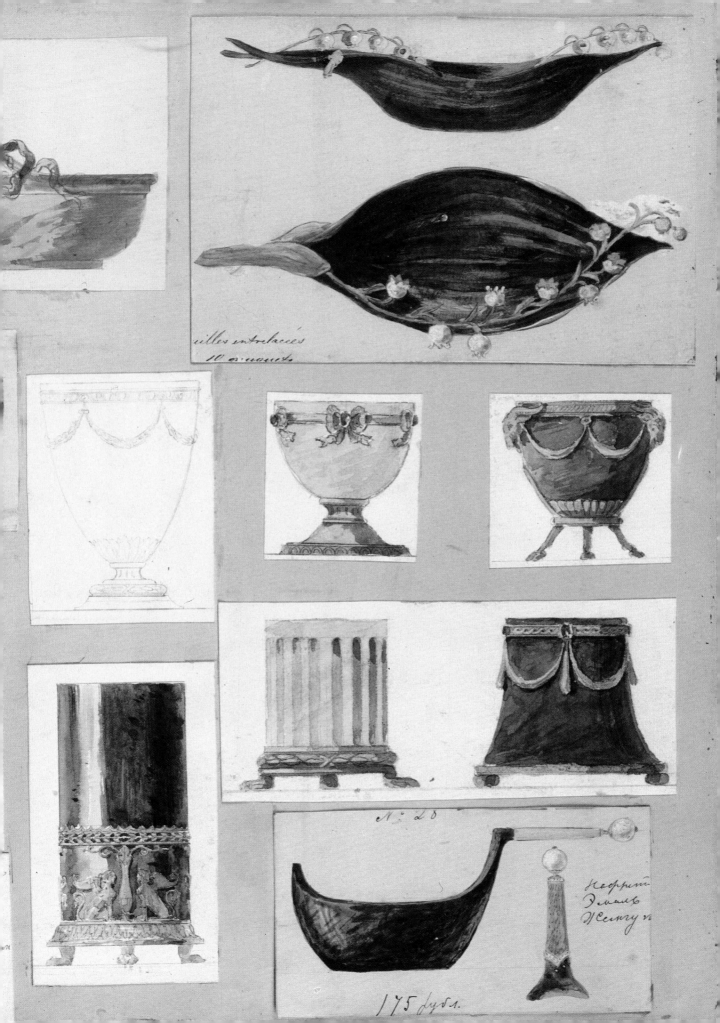

illes entrelacées

10 a monts

№ 28

175 руб.

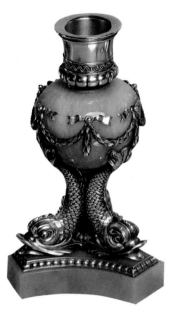

The sea monster motif of this finely crafted rhodonite and silver candlestick appears frequently in Fabergé designs.

.

Previous page: a wealth of design inspiration — these bowls, urns, dishes and kovshes were to be made in hardstones such as nephrite, bowenite, purpurine and red chalcedony.

.

residences of the fashionable at home and abroad – clocks, barometers, cigarette holders, match holders, picture frames, scent bottles, bell pushes, lorgnettes, opera glasses, letter openers, hat pins, buckles, boxes of all kinds, crochet hooks, desk sets, ink holders, paper knives, stamp dispensers, glue pots, bonbonnières, cigarette cases and more. The cigarette cases, for example, were made with such craftsmanship and style that they are as sought after today as they were when they were made; as Fabergé's equivalent of the magnificent snuffboxes of the 18th century, they elevated a functional object to a higher plane and were a delight to the visual and tactile senses.

All these items shared a common identity, however simple the materials, however humdrum the use: each had the same concentration of style, the craftsmanship, the restraint and elegance that marks the work of Fabergé.

Together with all this there was the day-to-day work of any jeweller commissioned by the Court: finding the most suitable stones and placing them in the finest of settings and making silverware for the Imperial table. The Inventaire de l'Argenterie, devoted to the silver in the possession of Nicholas II, which was published by Baron Foelkersma in 1907, describes the House of Fabergé as "the best and most celebrated in the world".

It was, however, a world in the process of change. No matter how slowly or unwillingly that change might be taking place, it was part of a process that had been going on for a century or more, recognized more clearly and acted upon more energetically by some than by others. For example, Alexander II had introduced a number of reforms and acknowledged the inevitability of change when he said, "Better to abolish serfdom from above than to wait till it begins to abolish itself from below." However, his son and grandson, Alexander III and Nicholas II, were deeply conservative.

Fabergé, his family and friends, colleagues and employees, must have been conscious of the state of their country, of the rumblings of discontent and the flashes of violence. There were assassinations of government figures, increasing protests from intellectuals and students and growing unrest and confrontation. Troops were employed to control demonstrations such as the protest by students in St Petersburg in 1898, when Cossacks ruthlessly used whips to drive them from the streets.

Yet, despite the unrest, Russia experienced considerable economic prosperity during the second half of the 19th century and it has been argued that Fabergé's success, the creation of thousands of objects by hundreds of skilled workers for customers throughout Russia and the world, was due to the economic vigour of the country rather than the patronage of a powerful ruling family.

Certainly, there was major industrial expansion in Russia during the period. The growth of trading companies exemplifies this: there was almost none in 1850, 227 by 1873 and many more by 1890. Mining, textiles and railways, all of these were part of the industrialization of

Fabergé in exile at Pully, near Lausanne, in July 1920, with his son, Eugène. The photograph was taken two months before he died.

.

Russia and the creation of a factory class. This brought about some fundamental changes, such as the movement of many peasants to the cities, especially St Petersburg and Moscow.

But history was in the making and change was in the air, accelerated by Russia's disastrous war against Japan and involvement in the First World War, both of which depleted the country's wealth and manhood.

The incompetence of the existing regime was shown up by the scandal of the lack of munitions for the Russian army, which was waging a courageous but costly campaign against the German forces in the First World War. There were increasing criticisms of the established order and louder calls for more fundamental political changes, particularly for the setting up of a proper constitution. Some minor reforms took place. With the charges of corruption in the government there were also allegations of scandal in the Tsar's circle, especially concerning the influence of the charismatic priest Rasputin.

Nicholas II was a man of great charm although he had a weak and vacillating character, quite unlike that of his father. However, he was

as rigid as Alexander III had been on the question of unswerving loyalty to the principle of autocratic rule. His Empress, Alexandra Feodorovna, was said to be even more implacably opposed to a more liberal constitution, because she was determined to preserve the monarchy for their son, Alexis.

This backdrop was a fertile setting for the revolutionary ideas which were being disseminated by the Bolsheviks (followers of Lenin whose name was taken from the phrase 'men of the majority'). The demands for change were emphasized by the horrific casualties on the Front in the 1914–18 war, the shortages of food on the home front and the fierce repression of any protests.

A detail from the clock opposite showing the fine quality of the workmanship.

.

This desire for change on the part of the people and the implacable resolve of the ruling party to resist led to the Revolution of 1917 and to a new Russia. Some observers, even those who were a part of the Imperial Court, felt that the Russian Revolution was as inevitable as the French Revolution had been over a century before. With the new order came disorder, chaos, violence and bloodshed, and the Imperial family were victims of that bloodshed. Nicholas II, Alexandra Feodorovna, their daughters, Olga, Tatiana, Maria, Anastasia, and their much-loved son, Alexis, were killed by Bolshevik soldiers in 1918 at Ekaterinburg in the Urals, where they had been sent by the new authorities. It was the end of the Romanov dynasty, which had ruled Russia, shaping its destiny, for three centuries and had celebrated the event only four years earlier.

The end of the Romanovs marked the end of the House of Fabergé, although it was not simply the absence of Imperial patronage that caused the firm's fortunes to decline. During the more austere period of the First World War the rich clientele Fabergé had served were less able to make extravagant purchases, and with the coming of the Revolution they fled the country. The business was closed for a time and then reopened under the control of a "Committee of the Employees of the Fabergé Company"; but continued only until 1918. It is clear there was no place for the business in the new Russia, that the privileged society Fabergé had served was gone for ever. Photographs of Fabergé at this time show the stricken face of a broken man.

Like so many Russians, he fled from his homeland and, with the help of the British Embassy, went to Berlin and then to the spa town of Wiesbaden in Germany. Other members of the family escaped in different ways. His wife reached Lausanne by a tortuous route involving a journey by rail, sledge and on foot via England. Their eldest son, Eugène, was in Stockholm after a similarly perilous journey. Both joined Fabergé in Wiesbaden to care for the old man – he was 74 on 30 May, 1919 – until he was well enough to travel to Lausanne, where he died on the morning of 24 September, 1920. His wife survived him by only a few years, dying at Cannes on 27 January, 1925, and being buried in the Protestant cemetery, where the family had Fabergé's remains transferred in 1929.

The death of the master craftsman came at the end of an era, severing the link between the opulence of Imperial Russia and the egalitarianism of

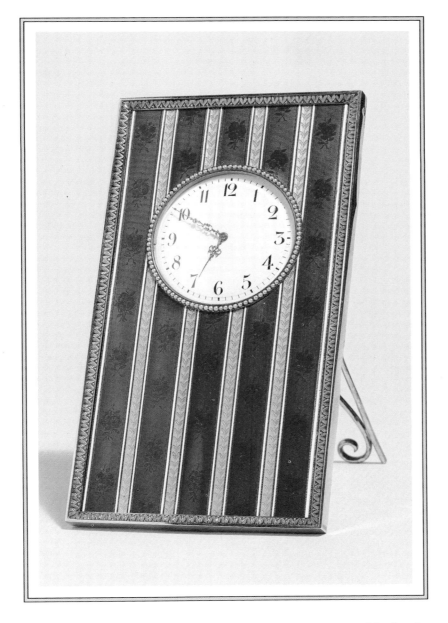

A rectangular strut clock which typifies the Fabergé style in its simple elegance. The red strips of enamel are laid over a floral background, while the narrow green strips, edged by white opaque enamel, have a leaf pattern. The acanthus border is of gold and the white enamel dial is surrounded by pearls.

.

the modern world. Without his presence, it was impossible for the House of Fabergé to continue creating the objects for which it had been so famous. Two of his gifted sons, Eugène and Alexander, did set up a business in Paris in 1924 under the name of Fabergé & Cie, but although several fine pieces were made, the business never achieved the reputation of the original. It ceased trading in 1940. The name changed hands several times and still exists in Paris, specializing in modern jewellery. A separate United States firm, with no connections with the original, uses the Fabergé name for a range of toiletries.

Trading in the works of Fabergé continued to be brisk, principally from economic necessity on the part of Russians who had fled from the new regime and were selling their treasures in order to live. An important centre for trade of this kind, La Vieille Russie, was opened in Paris in 1920, where masterpieces by Fabergé and others were bought and sold.

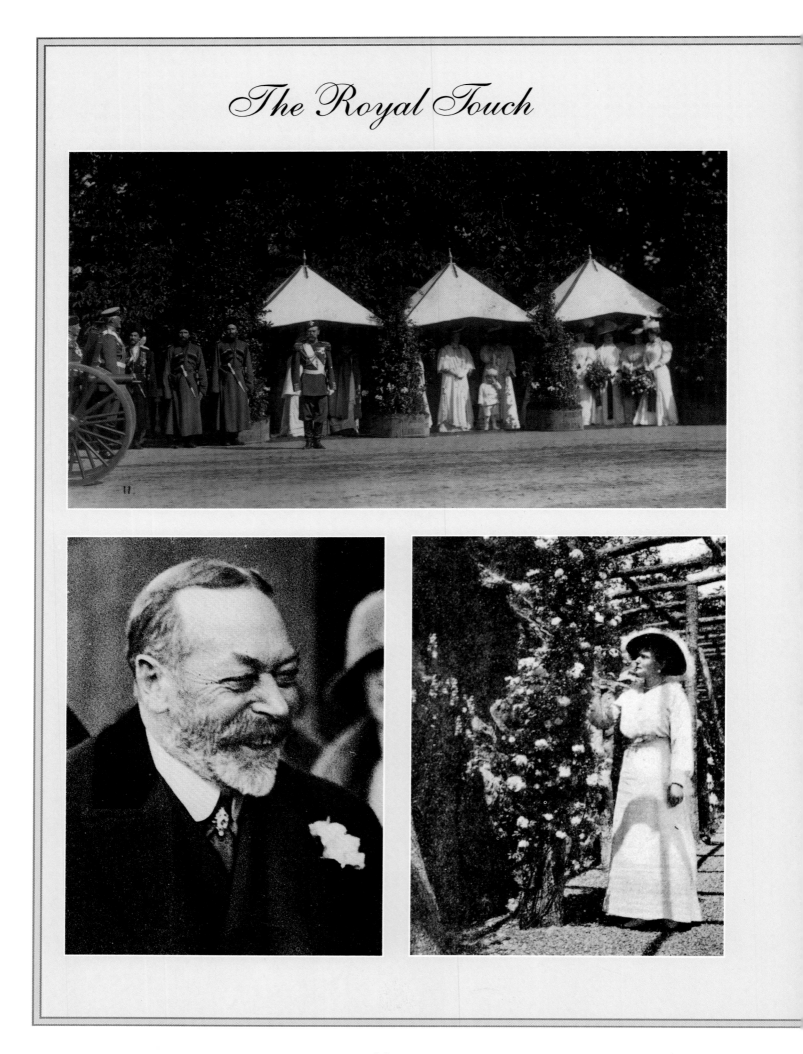

Fabergé was a great favourite with the royal families of Russia and Britain and some of his patrons are pictured here. *Opposite above: Tsar Nicholas II (standing in front of the first pavilion) at the Regimental March Past of the Jägereski Guards at Peterhof, 1907. Opposite bottom left: The pleasure-loving Edward VII. Opposite, bottom right: The Tsarina, Alexandra Feodorovna, in the gardens at Livadia.*

.

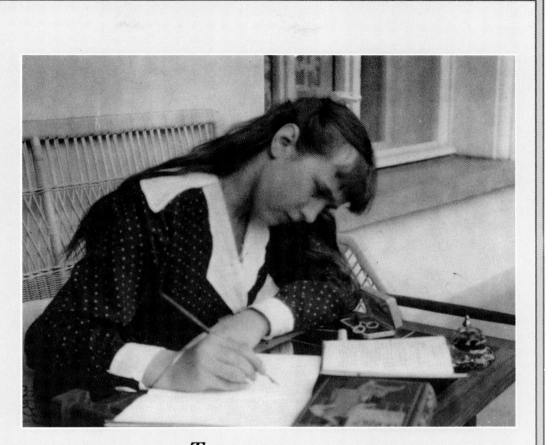

Top: The Grand Duchess Anastasia seen at her lessons in the Alexander Palace, Tsarskoe Selo. Note the Fabergé box at her side containing a pair of scissors. The photograph was taken by Charles Sidney Gibbes, the English tutor of the Imperial children.

.

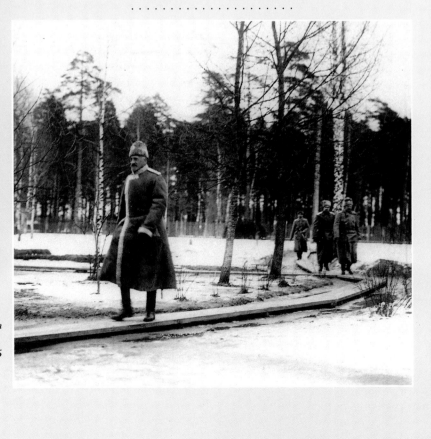

Above: Queen Alexandra, wife of King Edward VII as painted by Isaac Snowman.

.

Right: Grand Duke Nicholas, Commander in Chief of the Russian Forces from 1914 to 1915 at his headquarters.

.

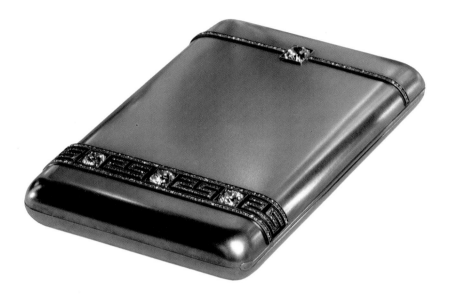

An elegant double-opening frosted gold case decorated in Greek black enamel, set with rose-cut diamonds and four brilliant diamonds, each approximately 1 carat.

.

Fabergé's work was well known in the West, of course, before the Revolution. The English Royal Family had amassed a splendid collection and examples of his art could be seen in the homes of the rich and fashionable throughout the country. But the Imperial eggs, the summit of his creativity, were not generally known, because they were private gifts from Alexander III and Nicholas II to members of their family. They were not for public display and were, indeed, shown publicly on only one occasion, by special permission, at the Exposition Internationale Universelle in 1900. With the flood of rich émigrés and their treasures, and the ensuing auctions and exhibitions, the world at large gradually became aware of these extraordinary creations, which captured the public imagination as symbols of the departed glory of the Imperial Russian Court.

Economic chaos in Russia after the Revolution led the authorities to sell off many of the Imperial treasures to raise capital to bolster the country's finances, a decision that went against the express wish of Lenin, who said that the new authorities should preserve the nation's cultural heritage. The architect of the Revolution, however, died in 1924, four years after Fabergé.

Stories of the fabulous wealth of the tsars which still remained in Russia circulated in the West and there were romantic tales associated with it: for example, there was the discovery of the hoard of jewels hidden in the home of Prince Youssoupov, for whom Fabergé had made one of the few Easter egg masterpieces not for the Imperial family — evidence of a highly valued customer. Secret passages in the Prince's palace led to a glittering hoard, itemized by Suzy Menkes in her book *Royal Jewels* as 255 brooches, 13 tiaras, 42 bracelets and 210 kilos of jewelled ornaments.

A dashing young English aristocrat, Bertie Stopford, came to the aid of the Grand Duchess Vladimir in exile and rescued her magnificent collection of jewellery. Behaving with the gallantry of a fictional hero, he made his way to Russia, disguised himself as a workman, managed

to infiltrate the Grand Duchess's former palace and retrieved the jewels. Stopford succeeded in smuggling them out of the country, via the British Embassy, wrapped in newspapers and transported in a pair of Gladstone bags.

Gladstone bags feature in the acquisition of other Russian treasures by Emanuel Snowman, a partner in the English jewellery firm Wartski, who is said to have obtained a "Gladstone bag full of imperial treasures" after long negotiations with the Soviets.

Kenneth Snowman, his son and now the chairman of Wartski, is one of the world's leading authorities on Fabergé. He remembers his father's lengthy journeys to Russia, the results of which began in 1925 to be displayed at their home in Hampstead for the family to admire – a dazzling array of boxes, flowers, eggs and ornaments which left a deep and abiding impression on the young Snowman.

Even more dramatic is the story of Dr Armand Hammer, who acquired a wealth of Russian valuables, many by Fabergé, and is probably the person most responsible for making the Russian master craftsman's work known to the American public. Dr Hammer spent nine years in Russia after the Revolution, from 1921 to 1930, and became a friend of Lenin. He originally went to Russia after qualifying as a doctor to help fight the typhus epidemic which was sweeping the country. While there, he realized food shortages presented an even greater threat to the people and negotiated a massive barter agreement with the United States which would bring in a million tons of wheat in exchange for goods. In return for this successful deal, he was granted trading concessions in a number of areas, especially mining, by Lenin. During the time Dr Armand Hammer and his brother, Victor, were in Russia they acquired an outstanding collection of art treasures, including 15 of the fabulous Imperial Easter eggs. With the beginning of the Stalin era, the Hammer brothers decided to leave Russia, but only under certain conditions, as Dr Hammer has recalled:

"An important part of the agreement for the sale of our interests was the permission granted us to take out of Russia our entire collection of art treasures. Among these were 18th-century fabrics, shimmering with silver and gold threads, glassware and porcelain made in the Tsar's private Imperial Porcelain factory, icons, and paintings by old masters. Included among the priceless jewelled pieces we had obtained was a collection of 15 Easter eggs executed in the workshops of Fabergé."

He disposed of the collection by setting up the Hammer Galleries in New York for the purpose and by taking a travelling exhibition around the country for a number of years in the 1930s. There were some 2,000 splendid items in the collection, but, as always, it was the magic of the Imperial eggs that excited most interest among the general public, and continues to do so.

His assistant at one time was the distinguished Fabergé expert Alexander Schaffer, who made a number of visits to Russia and acquired many Fabergé items, including some more Imperial eggs. He later

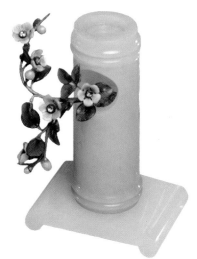

A bonsai study of a spray of japonica emerging from a hana-ire *bamboo flower pot, itself supported on a low Confucian scholar's table. The leaves are carved from Siberian jade, the pot from bowenite and the table from white serpentine.*

.

opened a branch of La Vieille Russie in New York and this remains the leading centre in the United States for the works of Fabergé.

Today the United States houses some of the most important collections of Fabergé in the world, evidence of the enthusiasm of a number of wealthy collectors, such as the Forbes family, who have built up a superb treasure trove, including 11 of the Imperial eggs, more than the number held in Russia.

Emanuel Snowman of Wartski organized an exhibition in London of the treasures he had acquired from Russian sources in 1927. It attracted much attention in the national newspapers and was the first of a number of such exhibitions. In 1935 Lady Zia Wernher, daughter of the Grand Duke Michael of Russia, a grandson of Nicholas I, was the guiding spirit behind a wide-ranging and influential exhibition of Russian art in London which included more than 100 works by Fabergé, many lent by leading collectors of the day. Lady Zia's own collection, which today can be seen in the splendid setting of Luton Hoo, was built up before the Revolution; her parents were patrons of Fabergé in Russia and her own acquisitions came from the Fabergé branch in London.

Further exhibitions were held in 1949 to coincide with the publication of the first biography of Fabergé, *Peter Carl Fabergé, His Life and Work*, written by Henry Charles Bainbridge, who had been in charge of the London branch, had visited Russia many times during the heyday of the firm and knew Fabergé and his family well. It is a valuable, idiosyncratic book, full of direct information about the period and its personalities and especially valuable on the high summer of the Edwardian era.

It was in 1953 that Kenneth Snowman published his invaluable book, *The Art of Carl Fabergé*. Revised and reprinted several times, it remains one of the most important works on the subject. It is lucid, painstaking, written with the depth of knowledge only to be expected from the chairman of Wartski, a man who has been surrounded by Fabergé objects all his life. An exhibition he organized at the same time was a great popular success (this was Coronation year), as was the major Fabergé exhibition at the Victoria and Albert Museum in 1977 (the Silver Jubilee of Her Majesty The Queen), again arranged by Snowman. Treasures from the Royal collections made up the major part of this exhibition, but there were loans from leading collectors throughout the world. All in all more than 500 items were on display for the delight of an enthusiastic public. The exhibition was an amazing success, the subject of international acclaim, but it was the enthusiasm of the general public, tens of thousands of them, that was so remarkable. Many of them were prepared to wait patiently for hours before being able to see the treasures of Fabergé.

The then director of the Victoria and Albert Museum, Roy Strong, acknowledged in the catalogue that for some critics "the art of Fabergé may well seem trivial, a pandering to the *fin-de-siècle* decadence as epitomized by late Victorian and Edwardian England and the last years of the Tsar in pre-revolutionary Russia". It was a point of view he

The finest materials and the most skilled workmanship were used in functional objects as well as in objets de fantasie. *This 14cm (5¹/₂in) desk aneroid barometer is a fine example in guilloche enamel with splendid silver carving, mounted on a bowenite base. It bears the mark of Henrik Wigström.*

.

countered with the following words: "Fabergé is almost the last expression of court art within the European tradition which brings with it a passionate conviction of the importance of craftsmanship and inventiveness of design, aligned to a celebration of the virtues of wit and fantasy applied to everyday objects, that still has a relevance to the design of today."

Further books by Alexander von Solodkoff and Geza von Habsburg followed, adding to the sum of Fabergé scholarship. Habsburg was responsible for organizing the magnificent exhibition in Munich in 1986–7 at which a unique array of Fabergé works was assembled, with loans from the royal families of Europe, principally Great Britain and Denmark, and from private collectors in Europe and the United States, together with a number of important items from museums inside the Soviet Union.

It, too, was an astounding success with the public at large and had to be extended by a month. Habsburg has recalled that it attracted more than a quarter of a million visitors, many of whom "had often queued patiently in sub-zero temperatures or pouring rain".

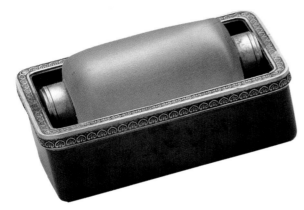

Left: Silver-mounted nephrite dampener – part of an unusual game set. It is thought that they were used to moisten the tips of fingers before dealing cards.

.

Right: Menu-holder in aventurine and silver.

.

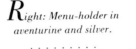

So the works of the Russian master craftsman have become known to a much wider public than would have been envisaged in the days of the Imperial Court or the privileged world of Edwardian society. It is easy to understand the interest that art historians, designers, craftsmen and collectors take in the work of Fabergé, but it is less easy to explain the fascination of the general public, people who are never likely to own anything by Fabergé and whose experience of the work is limited to glimpses in exhibitions and museums. It is possible that this fascination is prompted by the romantic associations the works have with the last days of the Tsar and the disappearance of the doomed Romanov dynasty, but it may also be that the enduring qualities of Fabergé's works, the quality of materials, the faultless workmanship, the elusive but definite sense of style, have a powerful appeal in an age in which the throwaway, the ephemeral and the plastic are paramount.

Artist or Craftsman?

Fabergé's description of himself as an artist-jeweller is an indication of his approach to his work. His best pieces show a unique alliance of the skills of the craftsman with the imagination of the artist, and it is evident that his decisions in matters of design were based on artistic judgments rather than commercial considerations.

Julius Rappoport was the Fabergé workmaster responsible for this rococo clock which stands on four feet shaped like lizards. The bowenite body is encased in silver-gilt rococo ornamentation and contains two hinged compartments which reveal miniatures of Tsar Nicholas II and Empress Alexandra Feodorovna. The two putti flanking the white enamel dial are of silver-gilt. The clock is a copy of an English clock by James Hagger, made in London in 1735, which was in the Imperial collection.

.

*A*bove: a gold and enamel cigarette case in translucent
pink.

.

*B*elow top: a jewelled, gold and enamel pendant. The
central moonstone is flanked with trefoil rose diamonds.
Below: a gold, diamond and ruby heart-shaped locket.

.

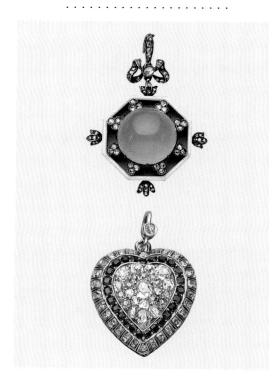

*T*HERE HAS BEEN MUCH LONG and often laborious discussion among art historians about whether Fabergé can properly be called an artist or whether he is not more accurately defined as a craftsman. If the definition of an artist is a person who makes a highly individual statement, a personal act of creation, using his or her own talents in whatever the chosen medium, then Fabergé was not an artist. Instead, he was the presiding genius of a large organization which at its height employed hundreds of people and produced thousands of objects which had the right to be called Fabergé but were not made by his hand. Indeed, there is no evidence of any piece which was made by him or of any design which was indisputably by his hand. But all the evidence we have – from primary sources, colleagues and members of the family – shows the influence he wielded and how he made it possible for this booming organization to produce a vast range of objects, all of which bore his essential, unmistakable style.

According to Bainbridge and others, Fabergé was a reticent man, but he was unusually frank during an interview in the Russian magazine *Stoliza y Usadba (Town and Country)* in January 1914, leaving no doubts as to his view of his place in the debate about artist or craftsman.

"Clearly if you compare my things with those of such firms as Tiffany, Boucheron and Cartier, of course you will find that the value of theirs is greater than of mine. As far as they are concerned, it is possible to find a necklace in stock for one and a half million roubles. But of course these people are merchants and not artist-jewellers. Expensive things interest me little if the value is merely in so many diamonds or pearls."

History appears to accept his valuation of his own work since it has not only survived but grown in popularity, while the work of contemporary jewellers, goldsmiths and silversmiths is known only to specialists. Among the best of his competitors were craftsmen such as Ovchinnikov, a celebrated goldsmith much of whose work exhibits wonderful examples of cloisonné enamelling in the traditional Russian style; Karl Hahn, who was also commissioned by the Imperial Court and made several fine pieces, including a superb tiara in the shape of a Russian *kokoshnik*, the traditional peasant headdress, but made of pearls and diamonds, which was worn by Tsarina Alexandra Feodorovna at her Coronation in 1896; Tillander, who made small objects for display in the style of Fabergé and Bolin of St Petersburg, both important rivals, who also carried out commissions for the Imperial Court; and the "English Shop" of De Nichols and Plinke, who were leading silversmiths.

Fabergé's output shows a wide variety of influences, which is not surprising in such a long career as a designer, but it is always unlike that of his contemporaries, most notably in two areas: it is generally less traditional and it shows a greater sense of restraint or understatement.

When Fabergé took control of the family business in 1870, the style of work produced by goldsmiths and jewellers in Russia tended towards the heavy, ornate and ostentatious – as, indeed, it did in most of the applied arts in Europe. The precious objects made, both for wear and

for display in the home, were designed to reflect the wealth of the owner through the value of the materials used. Fabergé and his brother, Agathon, decided to move away from statements of that kind, aiming for objects whose principal value was their design, with precious stones and materials utilized purely to suit the designer's concept.

The Fabergé style was eclectic in general but exhibits the influence of the past, using designs from various historical periods. As we know, his artistic education was broadly based and he had been given the opportunity to travel and study widely in Europe. Renaissance, Baroque and 18th-century influences are plain to see in his oeuvre, drawn in part from observation of the Medici treasures in Florence and 18th-century art in France. Perhaps more influential was his period in Dresden and his familiarity with the Green Vaults Collection, which contained a wide range of works, including gem carvings from Saxon times, Renaissance enamels and examples of 18th-century art. This collection would also no doubt have played a significant part in forming the ideas of his brother, Agathon, who was born in Dresden and studied there.

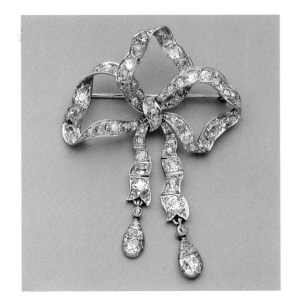

Left: Fabergé gold and diamond brooch with three-loop bow and tear-shaped pendants.

.

Right: a two-colour gold and enamel pendant with a chalcedony cabochon.

.

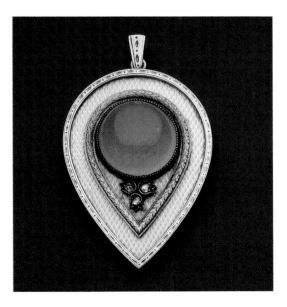

A closer and more accessible source of inspiration for Fabergé was the Imperial collection at the Hermitage and the Winter Palace. Here the tsars had amassed treasures from France, Italy, Germany and Russia, all of which were available to Fabergé.

Particularly in the early days of Fabergé's career, there are striking examples of the sources of his inspiration in the series of Imperial eggs: the first, the golden Hen Egg, dating from 1885, is a copy of a similar 18th-century creation in the Danish royal collection at Rosenborg Castle, Copenhagen, and the Renaissance Egg of 1894 is copied from an 18th-century design by Le Roy which was in the Green Vaults Collection. Yet these are not slavish copies. Although their inspiration is clear, they have a style that is recognizably Fabergé in its elegance and outstanding craftsmanship.

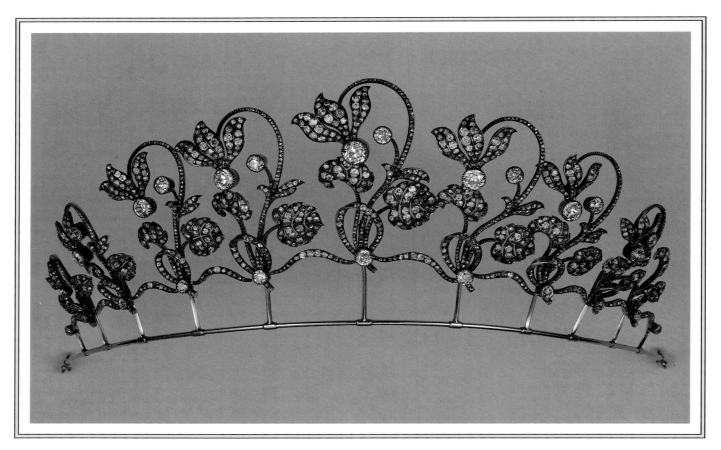

This jewelled diadem is a fine example of art nouveau in Fabergé's work. The ten cyclamens in the piece are set with circular-cut and rose-cut diamonds and are linked by a diamond-set band. The workmaster was Albert Holmström.

.

The greatest historical influence came from France, particularly 18th-century France, and Fabergé reproduced techniques used only at that time, notably the guilloche method of enamelling, which involves placing translucent layers of enamel on a machine-engraved surface. The method is costly and time-consuming but gives the most beautiful effects, especially in the depths of colour.

Looking at the variety of Fabergé's output, it is clear that he had a sharp eye for possible inspiration from any source. Repetition was to be avoided at all costs, which meant a flow of new ideas and a consequent search for more. His historical sources ranged from Gothic to Renaissance and, in his later work, Louis XVI and Empire styles. Old Russian style was a strong influence, especially in his silverwork. Around the turn of the century he was also influenced by the school of Art Nouveau, a movement which was a reaction against the reworking of ideas from the past and which used the world of nature as its inspiration. However, the movement had only a peripheral effect on Fabergé and he was rarely tempted into abstract interpretations, although some of the silver pieces made in Moscow show abstract influences.

His principal response to the natural world was in a naturalistic form, in the creation of the superb series of flowers in precious stones and materials. These are marvellous likenesses of simple country flowers, such as lilies of the valley and bluebells. At first glance they seem to be faithful botanical reproductions but in fact they are not mere copies but

artistic creations representing the spirit of the natural object, with cunning use of cut diamonds for drops of dew and delicate gold for fragile stems.

There are echoes of the Far East in the flower studies and it is true that Japanese art played an important part in the Art Nouveau movement. The influence of Japanese art can also be seen in some of the small animal carvings made in the Fabergé workshops which are in the Japanese netsuke style. Fabergé had a large personal collection of over 500 pieces of Japanese netsuke, carved belt toggles, often in ivory, which were originally functional but had become display objects.

Fabergé was never content to work in the Russian tradition of many of the goldsmiths of his time. He was too cosmopolitan, had a wider educational background and served a more discriminating range of customers.

Throughout the first half of the 19th century there had been a vigorous philosophical debate in Russia between two schools of thought, the Westerners and the Slavophiles. The Westerners believed that Russia's future lay in aligning herself to Europe, while the Slavophiles wanted Russia to find its future in itself, in its own culture. One of the leaders of the Slavophile school, Peter Chaadayev, wrote in 1836: "We are not

The crowned monogram in this Edwardian brooch refers to King Edward VII and Queen Alexandra. It is set in diamonds, as is the border, against a guilloche enamel background.
.

Designs for brooches all set with cabochon and other stones. These are from a large collection of original Fabergé designs sold at Christie's, London, in 1989.
.

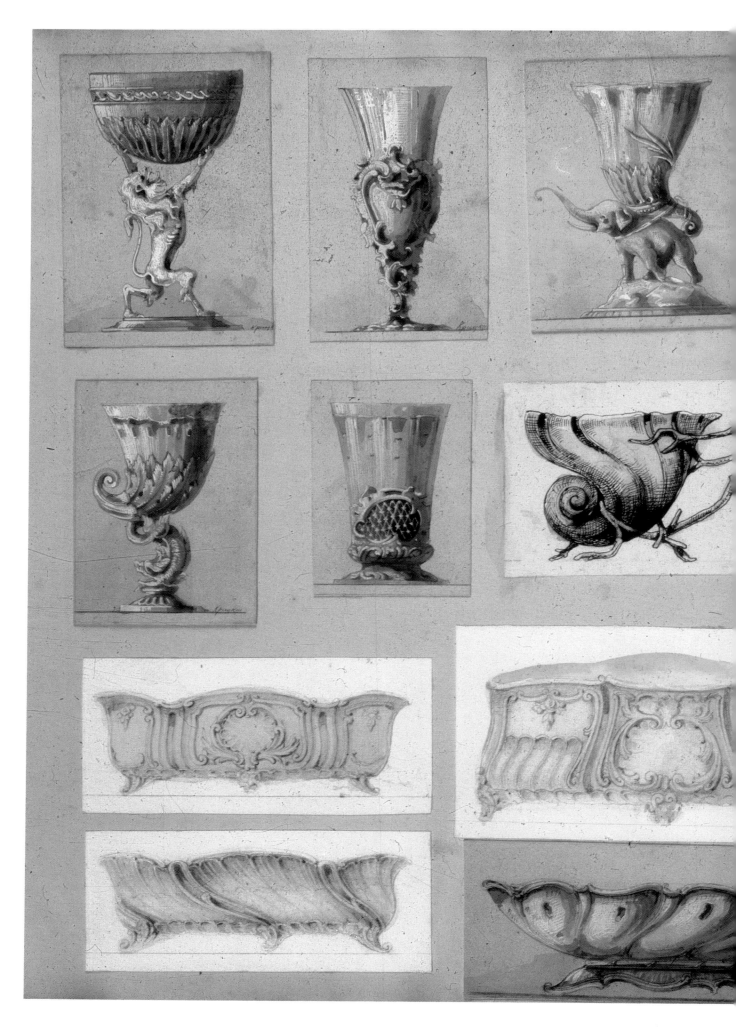

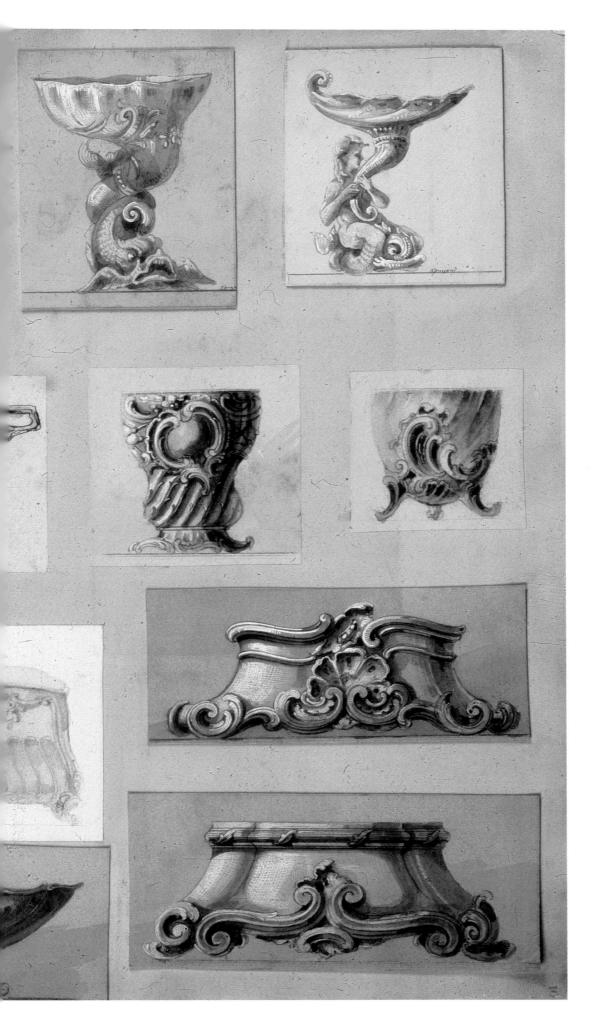

*O*rnate designs for tableware from Fabergé. They are of special interest to scholars because they throw new light on the work of the designers, most of whom are anonymous.

.

of the West nor of the East and we have the traditions of neither." This conflict was continued in the world of art. Those who followed the Old Russian school called for an end to slavish imitation of Western art and a return to Russian values, while those who looked to the West believed that doors should be opened to the European tradition.

Fabergé does not appear to have been closely associated with the Mir Iskvussa (World of Art) movement, which was a grouping of intellectuals founded in 1898 and included such figures as Alexandre Benois, Sergei Diaghilev and Léon Bakst, who produced an influential magazine and had close links with artistic movements beyond Russia. They brought new vigour to all the arts – painting, ballet, music, literature. The Ballet Russe, centred on Diaghilev, was a direct result of their ideas, and they made known the works of such artists as Cézanne, Van Gogh and Matisse in Russia. They were also interested in the applied arts, promoting such exponents as Tiffany, Gallé and Colonna, and at an exhibition in 1906 the work of Charles Rennie Mackintosh was exhibited.

The movement also sought to encourage folk crafts in Russia, but it was overwhelmingly Western in its sympathies. As Alexandre Benois explained: "We objected both to Russian coarseness and to the decorative complacency that many Russians love to parade."

Although the young Benois and his fellow intellectuals were devoted to Russia, they reacted against some elements of their country. "In Russia," he said, "much that was characteristically Russian annoyed us by its coarseness, triviality and unattractive barbarism."

There was nothing radical in the movement, its members being conservative, usually monarchist. Benois adds the surprising information that the journal, *Mir Iskvussa*, was saved from extinction by a personal gift of 10,000 roubles from the Tsar himself. Fabergé had some links with the new movement from his association with Benois, who carried out designs for the firm; it is to him that the Imperial Colonnade Egg of 1905 is attributed.

It is not clear how much Fabergé was affected by the Mir Iskvussa movement but he was certainly fully aware of it and, typically, he used whatever aspects of the movement attracted him. His approach, as

Above: Dress studs in gold and enamel, set with diamonds.

.

Below: Double portrait brooch in which the gold and platinum miniatures of Nicholas II and Alexandra Feodorovna are set with circular-cut diamonds. The ribbon above is set with diamonds and decorated by a sapphire and a rose-cut diamond.

.

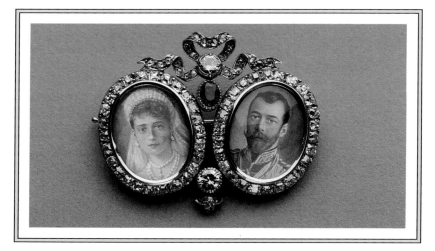

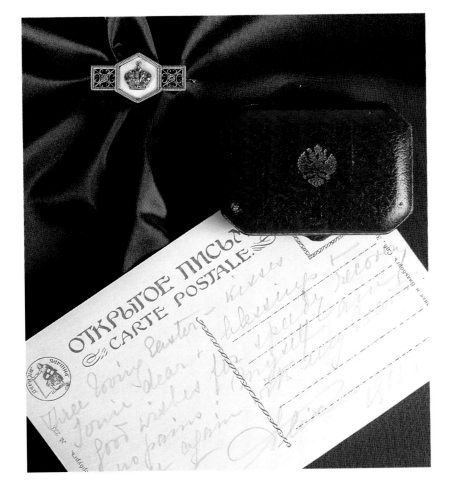

Left: Imperial presentation brooch in gold-white guilloche enamel, diamonds and sapphires, shown with its original red morocco case, stamped with the double-head eagle. The brooch was presented by Alexandra Feodorovna to her English nanny, Miss Joan Bolestone.

.

ever, was eclectic as far as sources were concerned. He was part of the cosmopolitan, sophisticated life of St Petersburg, the fashionable and artistic centre of the country, and his customers were offered works that reflected their own stylish tastes.

He was, however, Russian above all and he was influenced by the culture of his own country, just as all the artists who worked in Russia, including foreigners who came there, especially during the reign of Peter the Great, were affected by the unique spirit of that mysterious land.

Fabergé's French name and his background have led many people to think of him as a Frenchman who happened to live in Russia, but he was a descendant of generations of Russians and his use of French styles was a matter of artistic choice rather than of genetic inheritance. The Russian aspects of his work can be seen in the icons and crosses and in the range of traditionally Russian objects made to celebrate the tercentenary of the Romanov dynasty in 1913.

As an individual and as a businessman, he was alert to changes of mood and fashion and his work reflects a number of these changes during his lifetime. As has been said, he was not an artist in isolation but part of the great world, on familiar terms with the wealthy and privileged. Yet there are themes that are constant in his work: the quality of craftsmanship, the sense of restraint, the avoidance of embel-

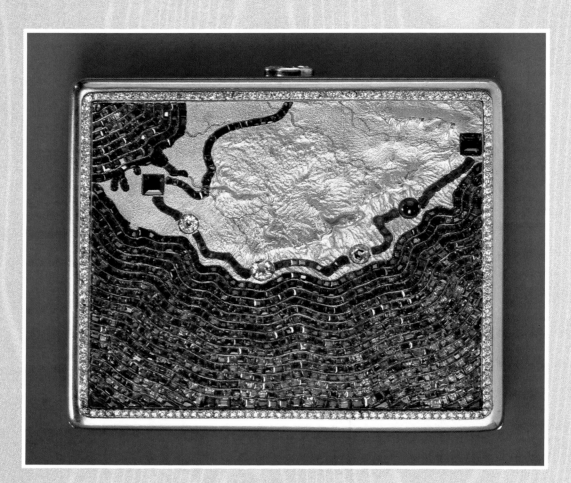

A gold and jewelled cigarette case, workmaster Henrik Wigström. The map represents Tsar Nicholas II's favourite resort in the Crimea. The Black Sea is set with calibré-cut sapphires, the Crimean mountains are formed from textured gold, a line of calibré-cut rubies marks the road from Sebastopol to Yalta, with precious stones for towns, the railway is represented by emeralds.

. .

lishment and overstatement. Some of his work is, indeed, surprisingly modern in approach, years ahead of its time. The cigarette cases are an example, fashioned in beautiful materials but strictly functional. Stripped of excess ornamentation, they are miracles of craftsmanship, combining design and workmanship, and are in themselves a definition of good taste.

One of Fabergé's great contributions to the art of goldsmithing, silversmithing and jewellery making is in the use of colour. He drew on an unusually large range of colours in almost all his work. Colour was also an important consideration in his use of gold. It could be changed by mixing gold with other metals, which was also necessary to increase the hardness, because gold is basically a soft substance and wears easily. The addition of silver gives a green tinge to the orginal yellow, copper gives red gold and nickel makes white gold. More esoteric effects are possible with the addition of other alloys to give blue, orange and grey golds, all of which can be seen in the work of Fabergé at different times.

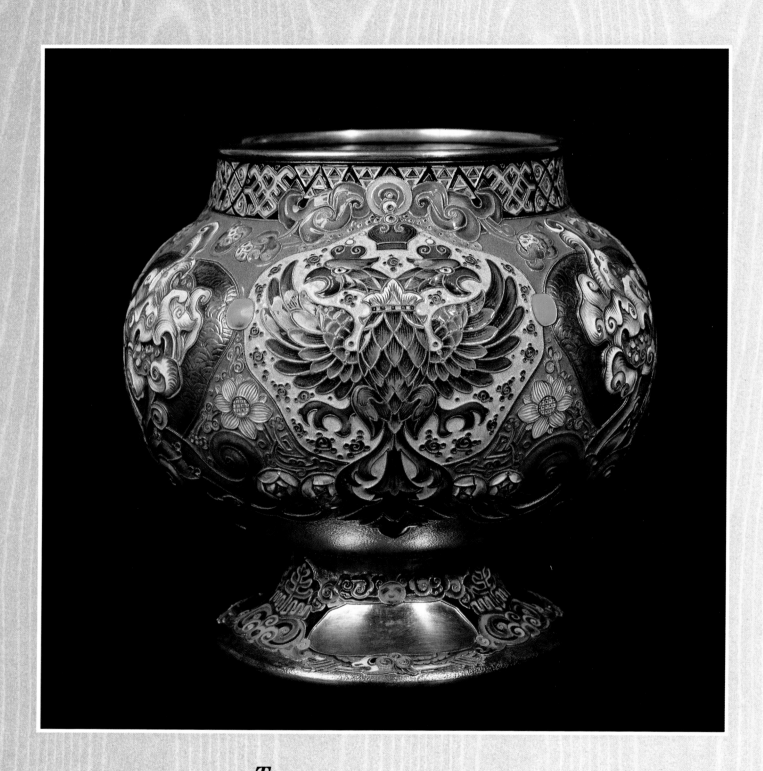

*T*he rich design of this Russian bratina, or punch bowl, of silver-gilt and cloisonné enamel incorporates the Imperial double-headed eagle. The piece is typical of many made at Fabergé's Moscow branch and was presented to the French admiral, Germinet, in 1902.

.

In general, though, as a goldsmith he favoured the more basic colours, turning once again to France in the 18th century for his inspiration with what was called *"or en quatre couleurs"*, four-colour gold, which can be seen in snuffboxes of the period. Fabergé used the technique widely, but it is probably seen at its best in the cigarette cases, where different shades of gold are juxtaposed to great effect. He also used different surfaces – ribbed, smooth, banded – to emphasize the different shades of colour and to add to the tactile pleasure of the object.

Further examples of his use of different colours of gold can be seen in the decorative touches, such as garlands in which different shades are used to represent leaves and flowers – a technique used in a vast span of objects from picture frames to Imperial Easter eggs. A novel effect used on some gold and silver objects was a rough, nugget-like appearance obtained by using the *samordok* technique, where the gold is heated to a certain point and then abruptly cooled down, the sudden drop in temperature affecting the surface.

Fabergé objects are usually made in gold of 56 *zolotniks* (14 carat) and silver in 88 and 91 *zolotniks* (the measurements of silver and gold in Russia at the time). There is a marked difference between the silver produced at the Moscow and St Petersburg houses. Moscow produced a great deal of traditional silverware, such as table silver, candlesticks

The shape and style of the bowl come from 17th century Russia but the decoration is strongly influenced by art nouveau.

.

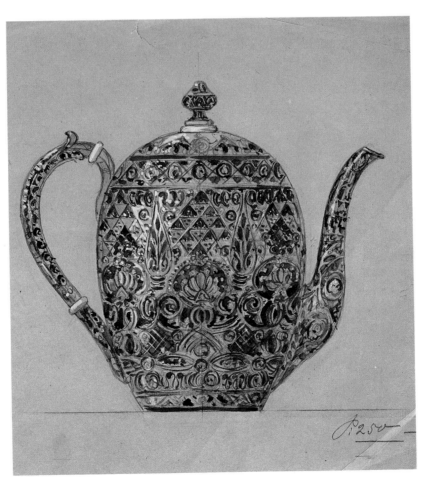

An example of a cloisonné enamel piece decorated in the Old Russian style. The colours are more muted than in the traditional examples, and are characteristic of Fedor Ruckert's workmanship.

.

41

Cigarette Cases

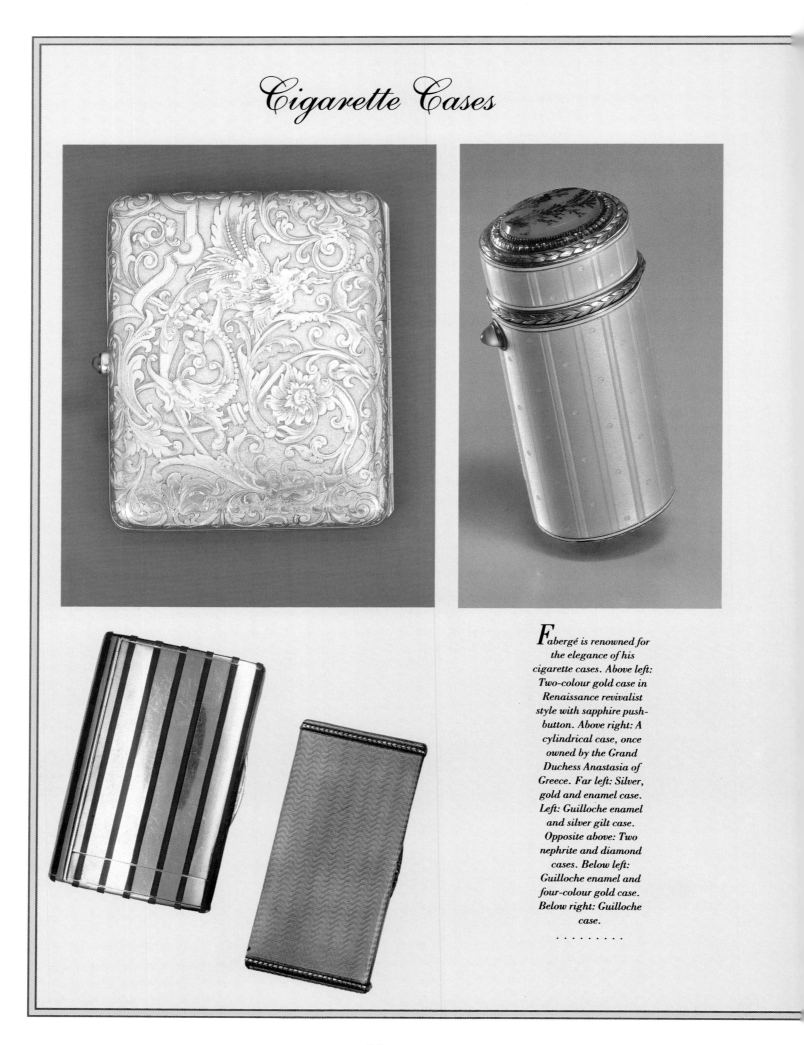

*F*abergé is renowned for the elegance of his cigarette cases. Above left: Two-colour gold case in Renaissance revivalist style with sapphire push-button. Above right: A cylindrical case, once owned by the Grand Duchess Anastasia of Greece. Far left: Silver, gold and enamel case. Left: Guilloche enamel and silver gilt case. Opposite above: Two nephrite and diamond cases. Below left: Guilloche enamel and four-colour gold case. Below right: Guilloche case.

.

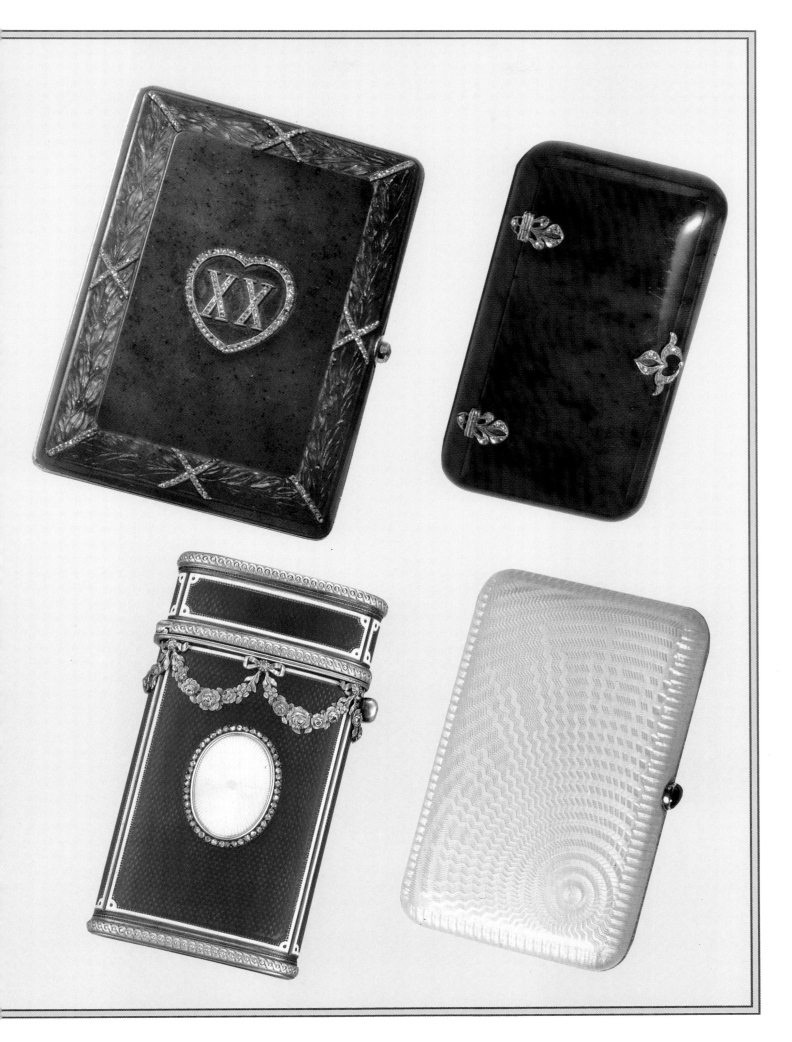

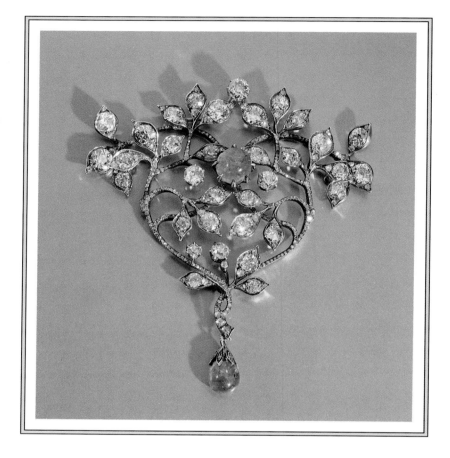

A charming example of the influence of art nouveau on Fabergé's jewellery, this brooch features diamonds and emeralds and was made at St Petersburg around the turn of the century.

and the like. Some experts believe these works lack the quality usually associated with Fabergé. It is probable that many of them were based on Fabergé designs but were made outside the Fabergé workshops and then retailed by him. The silver from St Petersburg was quite different: used more artistically, it was often heavily gilded and acted as a surface for guilloche enamelling.

Platinum was used in rare cases. An example is the Alexander III Equestrian Egg, presented by Nicholas II to his mother in 1910. In this design the egg is of rock crystal, mounted on platinum, which is an extremely difficult material to work. There was no hallmark for platinum at the time and, indeed, it was worth much less than gold at the beginning of this century.

Perhaps what is most striking about Fabergé's workmanship is the quality of the enamelling, quality achieved by the lavish use of time and labour. Again, his inspiration was the work of French 18th-century craftsmen and he both revived techniques used then but subsequently lost to later craftsmen and refined those techniques to achieve even more splendid results.

There are complicated technical problems associated with enamelling, particularly because it is carried out at very high temperatures. A compound of glass and metal oxides is heated until it begins to melt

and is then applied and fused to a prepared metal surface, usually silver, which has been engraved. Clear enamel melts at 600° centigrade, known as *grand feu*, and opaque enamel at 300° centigrade, known as *petit feu*, and it is these extremely high temperatures which tax the skills of the enameller.

Fabergé was clearly fascinated by the possibilities of enamelling and exploited them to the full, with results that can be seen in a range of objects, most of them miniatures. He also created designs which involved the enamelling of larger surfaces in a technique known as *en plein*, a method which had been used by French 18th-century craftsmen but then abandoned because of the difficulties involved. His craftsmen were also capable of enamelling rounded surfaces, a notoriously difficult exercise, using a technique known as *en ronde bosse*.

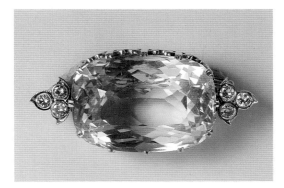

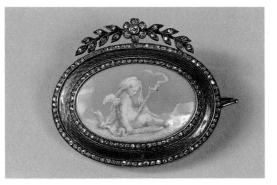

Right: this oval brooch has an enamel plaque painted with a winged Cupid in the style of François Boucher. The grey guilloche enamel border is edged by two bands of rose-cut diamonds.

.

Above: an aquamarine and diamond brooch, workmaster A. Hollming.

.

The depth of finish in Fabergé's enamelling was achieved by laying several coats of enamel, as many as six, at decreasing temperatures. This was a delicate and highly skilled process, especially when the piece was not flat. The so-called opalescent "oyster" effect seen in Fabergé's works was obtained by beginning with a semitransparent layer of enamel in an orange shade and applying a number of coats of clear enamel to achieve the much-prized and beautiful iridescent effect. Sometimes gold-leaf patterns, *paillons*, were inserted between the layers and sometimes paintings of flowers or trees, a complicated process which involved the application of the additional material to a surface which had already been fired before adding the final sealing layer. The visual effects were heightened by the decorations engraved on the metal or guilloche surface. These designs could be carried out by hand but were usually made with a machine called the *tour à guilloche*. The basic designs were waves and sunbursts. The enamel was finally polished with a wooden wheel and chamois leather for many, many hours. This skilled and lengthy job was essential if the finish for which Fabergé enamel was renowned was to be achieved.

The texture of the finished article, the all-important feel, was achieved by methods which typified both Fabergé's approach to his work and the period in which he lived, when the amount of time taken or the cost of the materials necessary to produce an object were not prime considerations.

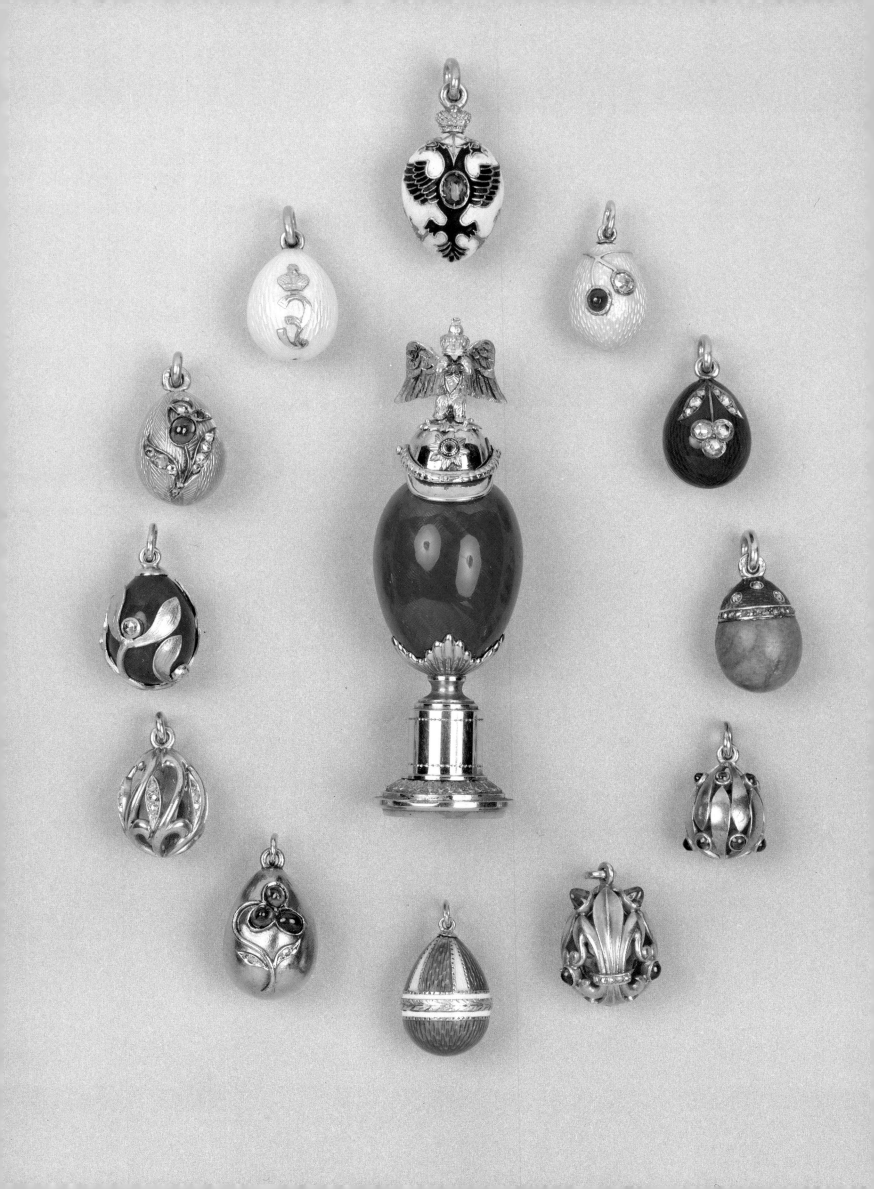

Fabergé's enamelwork is famous for its quality – revealed here in the beautiful deep blue of the egg-shaped handle of this desk seal, crowned by a replica of the Chevalier's Guard Regiment.

.

Fabergé increased the use of colour in his enamelling and was always ready to experiment with new shades, drawing on a palette of 144 different basic colours. Typically, Fabergé used them in a wide range of objects, such as Imperial eggs, picture frames, parasol handles, miniature furniture, bell pushes, flowers, boxes, tie pins, cigarette cases, paper knives and much more. Each of these objects, however ordinary, was enamelled with the same degree of painstaking care.

Since there was no mark for enamellers, unlike goldsmiths and silversmiths, the superbly skilled craftsmen who carried out the delicate work are usually anonymous, but some of the Fabergé enamellers can take credit posthumously for their skills (which, according to Kenneth Snowman, required "the combination of the gardener's green fingers and the touch of a successful pastry-cook"). Fabergé's son Eugène identified Alexander Petrov, his son Nicholas, and Vassili Boitzov for posterity.

Fabergé also used cloisonné enamelling in the traditional Russian style to satisfy his more conservative customers. In this technique, small spaces or cells (*cloisons* in French) are formed with metal wires on a silver surface and are then filled with coloured enamel. The patterns formed are vivid in colour and traditional in style, with strong floral designs. At one time the older Russian style was considered too primitive for Western tastes, but in recent years there has been greater recognition of the vigour and authenticity of the work of such leading masters as Ovchinnikov, Semenova, Ruckert and Saltikov, and modern museums are delighted to be able to exhibit their works.

The Old Russian style, which had its roots in the 17th century, enjoyed a revival in the 19th century with the development of the Pan-Slavic movement. At first Fabergé sold the cloisonné work of other people, such as Maria Semenova, who employed about 100 people at her Moscow workshop, but later he engaged Fedor Ruckert, who was a master of the cloisonné technique and used it quite differently than his contemporaries. His designs were modern, even suggestive of Art Nouveau, and the colours he employed were more muted than those of enamellers such as Ovchinnikov. The difference is quite startling when work of the two craftsmen is viewed side by side.

Champlevé enamelling was another method Fabergé used. Here the enamel is used to fill a groove, after which it is made level with the surrounding area. Then there was *plique à jour*, in which the enamel is not backed and the colour of each of the sections can be seen when the piece is held up to the light, giving a brilliant effect.

Enamelling techniques were used in much of the jewellery made in the Fabergé workshops, heightening the colour. Up to then, jewellery had tended to be rather ornate in style, emphasizing the size and value of the precious stones used.

His approach, as we have seen, was to use precious stones and materials as components of the design, choosing them for their suitability rather than their value. As a consequence, semiprecious stones which other jewellers would have considered quite unsuitable were often

A miniature Easter egg, typical of hundreds made by Fabergé and other jewellers in Russia. They were extremely popular as gifts and were often collected and strung on chains. A single chain might display dozens of eggs.

.

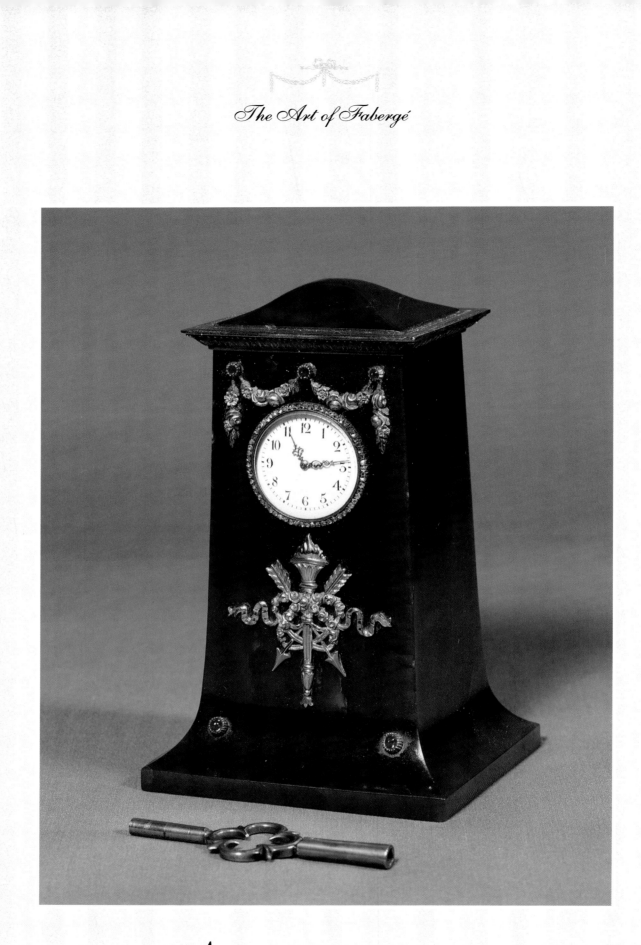

A clock made in one of Fabergé's favourite materials, nephrite. It has an opaque white enamel dial which is bordered by rose-cut diamonds. Four-colour gold is used in the floral swags above the dial, set with cabochon rubies, and in the central motif below.

· · · · · · · · · · · · · · · · · · ·

used. Favoured precious stones were emeralds, rubies and sapphires, which were usually *en cabochon* – polished but not faceted. Rose diamonds were preferred to brilliant-cut diamonds, because the rose diamond, in which the top is cut in triangular facets, is less obtrusive than brilliants.

Of course, as a jeweller to the Imperial Court, Fabergé was often called upon to provide sumptuous pieces. For example, there was the superb creation of pearls presented by Alexander III to the young Alexandra of Hesse when she became engaged to his son, Nicholas. It was said to be worth 250,000 gold roubles and was described by Agathon Fabergé as the biggest single transaction his father ever had with the tsars. Then there were the stomacher of diamonds and emeralds made for the Grand Duchess Elisabeth Feodorovna in 1900; the exquisite tiara in the form of floral sprays, the weight of the diamonds more than 40 carats; and the necklace of emeralds, pearls and diamonds made for the Bal de Costume Russe at the Winter Palace in 1898.

The House of Fabergé also held in stock a selection of major pieces of jewellery, necklaces, tiaras and so on for rich patrons in Russia and abroad. Many of these pieces have disappeared because they were broken up and sold by Russian émigrés in the years after the Revolution, and this explains why Fabergé's output of pure jewellery is not as well represented in modern collections as other examples of his work.

More typical of his work as a jeweller are the small, relatively modest pieces of jewellery such as brooches and pendants, cuff links, bracelets and the miniature Easter eggs for which the firm was famous. These were given, obviously, at Easter and were made up into necklaces, added to year by year. The miniature eggs, less than 25mm (1in) high, are marvellous examples of craftsmanship; often in brightly coloured enamel, they are decorated with precious or semiprecious stones in a variety of designs, frequently celebrating a special date or commemorating a regiment; or they are decorated with flowers and animals, and are sometimes made of superbly polished hardstones such as bowenite, rose quartz and chalcedony. These miniature marvels were popular in Russia in the traditional Easter rituals and also found favour in the more sophisticated world of Edwardian society, as is shown in the account books of Fabergé's London branch.

As jeweller to the Court, Fabergé was responsible for the care of the Imperial Crown Jewels, a legendary treasure trove accumulated over centuries which included some of the finest stones ever known. He was a keen judge of precious stones, as was his son Agathon, who shared the duty of maintaining the Crown Jewels. In fact after Agathon was released from imprisonment in St Petersburg when the Revolution was over, he was commissioned by Trotsky to catalogue the Crown Jewels, photographing and describing each piece.

From his work it seems that Fabergé preferred stones of great beauty and modest value, often from Russia's own resources but also from the rest of the world. The choice of such stones brought a new dimension to the work of the craftsman-jeweller, making available subtle new colours

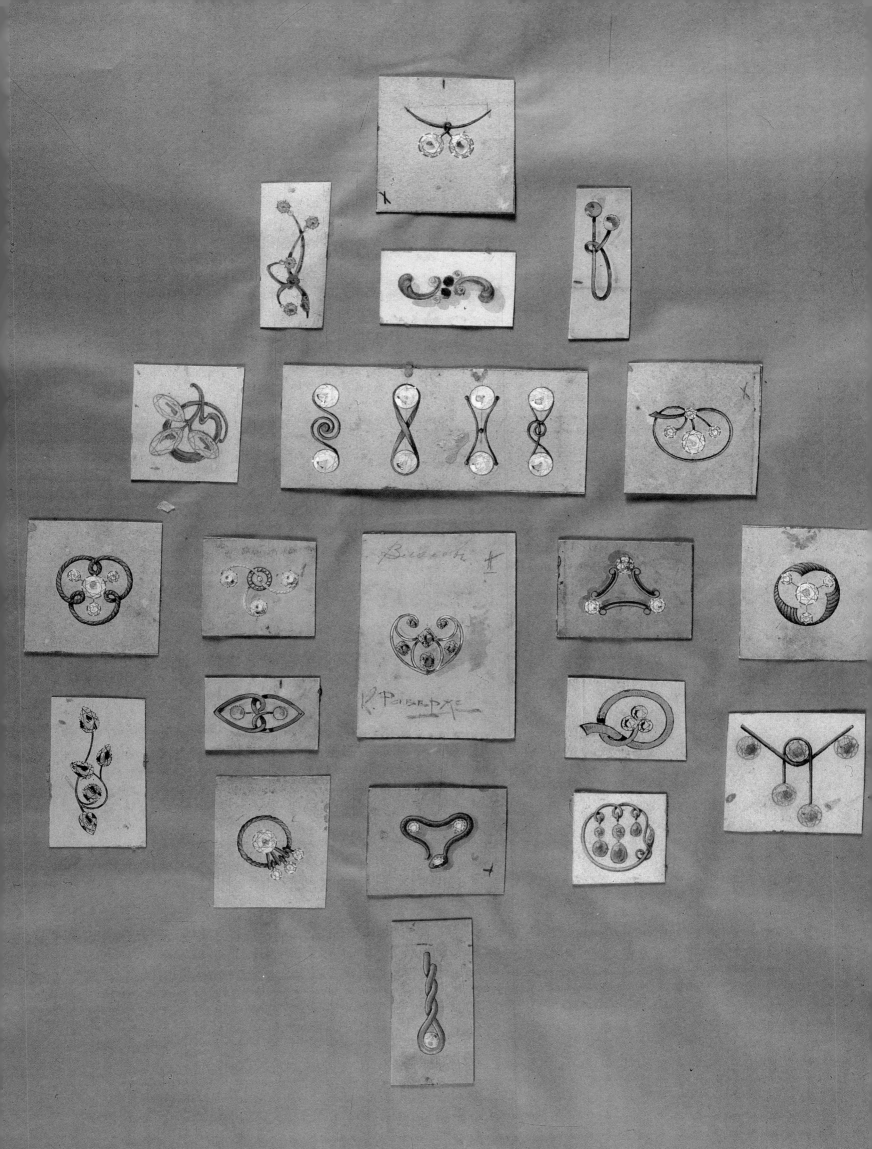

and textures. He was especially fond of the semiprecious Mecca stones, chalcedony cut *en cabochon*, which can be blue or pink and were often set with rose diamonds.

The dark-green jade, nephrite, was often used and in a great number of objects, such as clocks, boxes, bowls, dishes and even desk sets. The lighter jade, jadeite, was seldom used by Fabergé, but bowenite, a pale-green or yellow serpentine which is sometimes mistaken for jade, was often employed.

Rock crystal and smoky quartz were used to great effect in vases, such as the one presented to the ballerina Elizabeth Balletta and the Coronation vase bought by Leopold de Rothschild.

The dark blue of lapis lazuli, the green or brown of aventurine, the bright green of malachite, the velvety blackness of the natural volcanic glass, obsidian, the rosy pink of rhodonite (known as *orletz* in Russian), all added to the possibilities open to Fabergé. Another popular material, particularly in the animal figures, was purpurine, a man-made substance discovered by a workman in the Imperial Glass Factory at St Petersburg which is deep blood-red (it is similar, in fact, to a material the master glassmakers of Murano in the Venetian lagoon produced during the 18th century). Some stones could also be stained to achieve different shades of colour.

There was nothing conservative in the designer's choice of materials. Anything was possible in the search for new effects for the flood of designs necessary to meet the huge demand for Fabergé's work. Steel was used for the blue globe which was part of the Imperial Easter egg of 1913, made to celebrate the tercentenary of Romanov rule. A daring touch in the creation of a dandelion at the point of seeding was to use strands of asbestos fibre for the puff of seeds. Again, obtaining the desired effect was more important than the value of the materials.

Wood – carefully chosen palisander or Karelian birch – was used in a number of items, principally cigarette cases and picture frames. The picture frames, thousands of them produced to satisfy the demand created by the fairly recent hobby of photography, were examples of ordinary, functional objects made with the devotion to detail more usually given to a precious object. Beautifully polished and decorated, these frames occupied pride of place in palaces and wealthy homes in Russia and Europe.

Presiding over the choice of materials was the patriarchal figure of Fabergé himself. It was his influence which moulded the whole of the Fabergé empire's output, in person or in spirit, just as it was his eye that examined each item produced by the firm and judged whether it should or should not carry the Fabergé hallmark. If it did not, and there were many times when objects were rejected, the offending article was dismantled and sent back to the workshops. There were no appeals, no arguments. In this matter Fabergé was an artistic despot who did not feel the need to explain himself. Bainbridge has recorded in detail how he would simply reject a piece, seemingly faultless, without comment because it contained some flaw visible to him alone.

*J*ewellery designs from the House of Fabergé combining scrolls, rope twists and serpent themes for brooches, pendants and pins with diamonds, pearls and cabochons. These are thought to have come from the Moscow workshops.

.

The Fabergé Empire

At its zenith the Fabergé operation employed some 500 people at its various branches, and had patrons in Russia, Europe, the United States and the Far East. Thousands of items were produced to meet the almost insatiable demand for items carrying the famous name but, despite these demands, Fabergé insisted that each article produced by the firm should display the identical high standard of materials and workmanship. And it was he who made the final decision on whether or not a piece was allowed to carry the Fabergé hallmark.

Many of Fabergé's most popular pieces of jewellery had wintry themes, such as snowflakes. This pendant in rock crystal has a platinum mount and rose-cut diamonds are used to suggest crystals of ice.

.

By THE TURN OF THE CENTURY the Fabergé empire was reaching its zenith. There was a huge and growing demand for his work and the firm expanded considerably.

The important Moscow branch was opened in 1887, catering, as we have seen, for a rather different clientele. The wealthy, bourgeois Muscovites preferred more substantial, more obviously expensive pieces than the fashionable patrons of St Petersburg. There is a marked difference between items produced at the two centres, with Moscow specializing in table silver and traditional cloisonné while St Petersburg continued to specialize in the *objets de fantasie* introduced by Fabergé and his brother Agathon. When he set up the Moscow branch Fabergé took a partner, Arthur Bowe, an Englishman born in South Africa, who was later to play a part in opening up closer business links with London. The first manager of the Odessa branch, which opened in 1890, was Allan Gibson, described as a Moscow Englishman. The branch at Kiev, which was opened in 1905, closed and was merged with Odessa five years later.

A flood of exquisite objects poured out from the Fabergé workshops; it has been estimated that perhaps as many as 120,000 were produced. That level of output almost suggests mass production, but the extraordinary thing about the House of Fabergé is that every piece was made with the same perfectionism, produced by skilled craftsmen using the techniques of the goldsmith, silversmith, jeweller and enameller.

By the turn of the century a workforce of some 500 employees had been assembled. In 1900 work was completed on the new centre for Fabergé operations, 24 Morskaya Street, a handsome building of sufficient size to bring all the firm's activities under one roof. It had been specially designed for the purpose. Near the showrooms on the ground floor was Fabergé's own office, strategically placed so that he could see who was entering without being seen. Above, on the first floor, were the workshop of the goldsmiths and the Fabergé family's apartments. The second floor was the domain of the head workmaster and the third floor was the jewellery workshop. There was also an extremely large specialist library, said to contain just about every known work on jewellery and the goldsmith's art.

The enormous scale of the operation is used as evidence by those who claim that Fabergé was not truly an artist because an artist is essentially an individual, creating individual works of art. However, against this it must be remembered that Fabergé exerted a profound influence on everything made in his workshops and the whole of his oeuvre had an individual style.

Sacheverell Sitwell has compared Fabergé to a theatrical impresario like Diaghilev, writing that he "directed and animated his craftsmen, and imbued their work with his own personality". There is, perhaps, more to Fabergé's role, since his contribution was greater than simply radiating personality: he was involved in all the aesthetic judgements relating to the creation of the firm's work and in the control of the business from a strictly commercial standpoint.

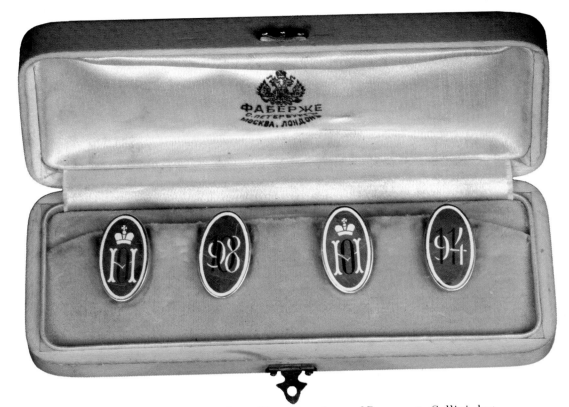

Enamelled gold cufflinks by Fabergé in a typically luxurious case which carries the Imperial warrant. The crowned monograms are those of the Grand Duchess Olga and the dates are 1908–1914.

.

His skills have often been likened to those of Benvenuto Cellini, but there is no real substance to this comparison because the Italian silversmith and sculptor was an individual artist creating works of art alone or with the help of a few assistants.

Fabergé was the guiding genius of the firm but, as there is no evidence that he produced any object himself, the credit for the brilliant works in gold and silver must go to his workmasters; craftsmen of such ability that it might be argued that it is they, as much as Fabergé, who deserve the accolade of posterity. These were the independent craftsmen who worked under contract to Fabergé in a democratic arrangement, almost as partners but with more privileges than obligations. The workmasters did not pay rent for their workshops or for the expensive materials of their trade, all of which were supplied by Fabergé, together with the designs. They employed their own teams of workers and were free to concentrate on the practical details of their work because the sale of the finished products was undertaken by Fabergé. They received a percentage of the profits.

At the head of the hierarchy came Fabergé, who was followed by the head workmaster, under whom was a series of workmasters. Below them were individual craftsmen, apprentices and general workers. At the height of the firm's prosperity more than 500 people (Bainbridge has claimed it was as many as 700) were employed, up to 20 devoted solely to making the beautiful boxes in holly wood that would contain the creations of the House of Fabergé.

The first workmaster associated with Fabergé was Erik August Kollin (1836–1901), a Finn whose tenure was from 1870 to 1886. He is best

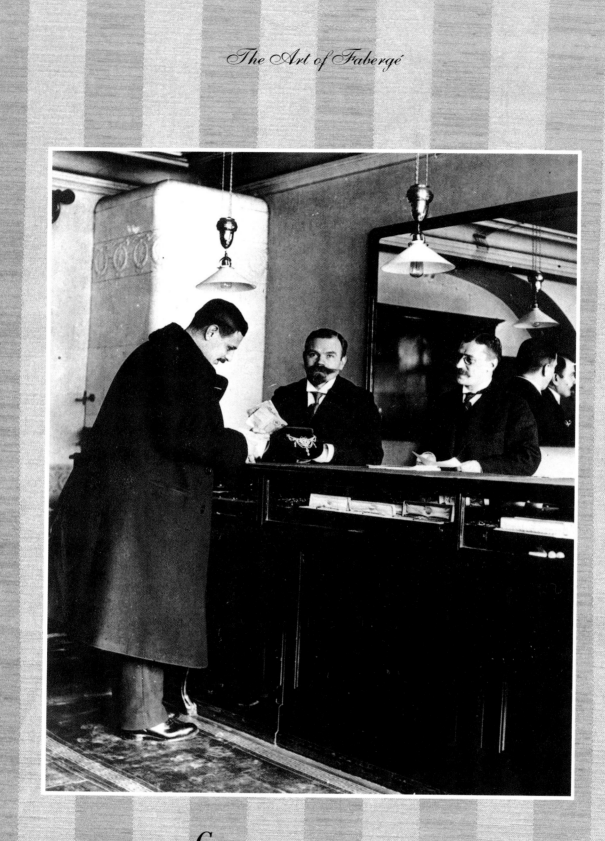

*G*rand Duke Kyrill in the showroom at Fabergé's St
Petersburg branch. In the centre is Georg Stein who made
the surprise for the 1897 Imperial Egg – a superbly
accurate replica in miniature of the Imperial Coronation
coach.
. .

known for his work as a goldsmith in the antique style, particularly for his skill in reproducing the Scythian treasures, ancient ornaments dating from 400 BC which had been found in the Crimea. His mark is EK.

Perhaps the most remarkable figure in the history of the Fabergé empire is Michael Evamplevitch Perchin (1860–1903), who joined the firm when he was only 26 and worked there exclusively until his death. He was a Russian peasant, self-taught, but his work has a rare quality. He is associated with the growing fame of Fabergé objects and it was in his time that techniques such as guilloche enamelling and contrasting colours of gold were introduced. He was also responsible for much of the House's greatest work: the incredible Imperial Easter eggs, from the Resurrection Egg (probably 1886) to the Peter the Great Egg of 1903. His mark is M. II.

He was succeeded in 1903 by his chief assistant, Henrik Emanuel Wigström (1862–1923), a Finn who remained in the post until the break-up of the firm in 1917. He presided over the workshops during the heyday of Fabergé, when thousands of objects were made, all with consummate care. His style reflects elements of the Louis XVI and Empire periods, with much use of elaborate laurel bands, but he was also responsible for the production of the simpler, cleaner styles of the cigarette cases. It is because of the high level of production under Wigström that his mark, H.W., is more common than those of his predecessors.

Looking at the work of the House of Fabergé during the periods these three men were head workmasters, it is possible to identify marked differences of style between them and this prompts speculation about the interchange between designer and craftsmen. It appears that the head workmasters were not confined to simply producing slavish copies of the designs handed to them. Each of them contributed something to the work Fabergé produced: Kollin looked to the glories of the past, Perchin used a variety of techniques and showed a fondness for the Baroque, Wigström showed French influence.

The creation of an object began in the office of Fabergé, literally at a round-table conference during which a design would be produced and discussed by the head workmaster and the designer. Often the idea would be provided by Fabergé himself; in earlier times by his brother, Agathon. The idea would then be drawn in greater detail by a designer after discussions about the way the design would be produced in the workshops. At this stage, specific problems which might require the expertise of particular craftsmen – the enameller or the silversmith, say – would be discussed. As far as possible, major pieces were the responsibility of individual craftsmen. This was certainly the case with objects such as the Imperial eggs, for which the head workmaster was responsible and with which Fabergé was involved at different stages of production. Some of these eggs, the ultimate in objects of fantasy, took years between gestation and completion.

August Holmström (1829–1903), who was in charge of the jewellery workshops on the third floor of the St Petersburg branch, had been

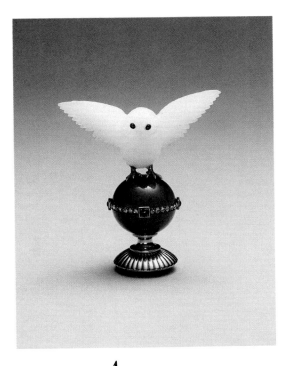

A desk seal with a chalcedony owl poised for flight from its perch on a nephrite handle encircled with rose-cut diamonds and cabochon rubies. Cabochon rubies are also used for the owl's eyes.

.

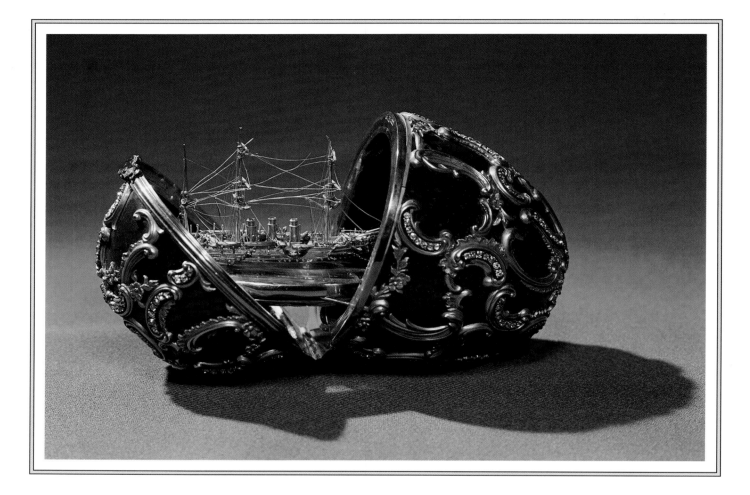

associated with the House of Fabergé since the days of Gustav Fabergé. He was responsible for much superb jewellery over a period of decades and contributed to the Imperial eggs, especially to the Twelve-monogram Egg presented by Alexander III to his wife for their silver wedding anniversary in 1892. This beautiful creation had blue guilloche panels on which the Imperial monogram was set in rose-cut diamonds. He was not only a master of the jeweller's art but also a highly skilled goldsmith. His work in gold is exemplified by his contribution to the Imperial egg of 1891 in which the 'surprise' is a tiny gold model of the cruiser *Pamiat Azova*, in which Nicholas II made a voyage around the world in 1890–91, before he became Tsar. Bainbridge records that this miniature was exact in every detail of rigging, guns, chain and anchor. Holmström was succeeded in 1903 by his son, Albert, another gifted jeweller. Father and son share the same mark, AH.

August Hollming (1854–1913) was apprenticed in 1876 and was a workmaster from 1880. He specialized in gold and enamelled objects but also made jewellery. His mark is A*H, close to that of the Holmströms, with which it is often confused.

Other workmasters included Johan Victor Aarne (1863–1934), a Finn who produced high-quality work in gold, silver and enamel; Karl Gustav Halmar Armfelt (1873–1959), who was recommended to Fabergé

The Imperial Easter egg of 1891, which was given by Tsar Alexander III to the Empress Marie Feodorovna (9.8cm/ 3⁷⁄₈in). The jasper shell with rococo scrolls opened to reveal a gold and platinum model of the cruiser Pamiat Azova *in which Nicholas II made a world cruise before he became Tsar. The workmaster, Michael Perchin, was responsible for many of the great achievements in the remarkable series of Imperial eggs.*

.

by Aarne and worked in gold, silver and enamel, especially with picture frames; Alfred Thielemann (date of birth unknown, died between 1908 and 1910), a jeweller who specialized in small pieces of jewellery and whose mark, AT, is often confused with that of others, notably Alexander Tillander, a rival of Fabergé who had a workshop in Morskaya Street and produced work similar in style, such as miniature Easter eggs, picture frames and cigarette cases.

Apart from the workmasters there were others who were essential to the success of the Fabergé organization. There was a team of designers, headed by Fabergé. His younger brother, Agathon, and his sons, Eugène Agathon, Alexander and Nicholas, played their parts and there were contributions from outside sources, such as Alexandre Benois. Of the permanent staff of the design team the best known is François Birbaum, a Swiss, who was a brilliant draughtsman.

There was a team of modellers to carry out the highly skilled work of making the wax models from which carvings in stone were made. It included George Malycheff, who made models of the statues of Peter I and Alexander III which were used in the Imperial Easter eggs. Modellers visited patrons for special commissions: for example, the commission for creating carvings of all the Sandringham farm animals for Edward VII and Queen Alexandra.

Then there were the miniature painters who created the delightful miniatures held in beautifully made picture frames of precious materials: men such as the Court Miniaturists Vassily Zuiev and Johannes Zehngraf.

Many contributed to the successful working of the firm. On the administrative side was Paul Blomerius, a polyglot of Swedish origin who was involved in the international trade of the firm.

There were others, too, anonymous workers who carried out the instructions of the workmasters and who made the lovingly prepared boxes which would carry the objects produced by the House of Fabergé. All were aware of the degree of care required by the master craftsmen, all were contributing to the Fabergé style.

There are often close family links between the people who worked with Fabergé. For example, fathers were often succeeded by their sons, as in the cases of August and Albert Holmström and Alfred and Karl Rudolph Thielemann. Knut Oskar Pihl (1860–97) was a jeweller and head workmaster at the Moscow branch, a position for which he had been recommended by August Holmström, to whom he had been apprenticed and whose daughter, Fanny Florentina, he married. The family tradition was continued by his son, Oskar Woldemar Pihl (1890–1959), who worked in Holmström's workshop as a designer before joining the Tillander company in Helsinki, and by his daughter, Alma Teresia Pihl (1888–1976), a brilliant designer who also worked for Albert Holmström and is known to have made designs for some of the Imperial eggs, particularly the Mosaic Egg of 1914.

Fabergé's four sons all inherited his talent. Eugène (1874–1960) worked closely with his father, mainly as a draughtsman, producing ideas and drawings; he was an accomplished painter. Agathon

(1876–1951) was an outstanding judge of stones and succeeded his father as the firm's gemologist. Alexander (1877–1952) was a painter who worked as a draughtsman with Eugène in Paris after the Revolution. Nicholas (1884–1939) was also endowed with artistic ability, studying under John Singer Sargent in London, where, from 1906, he managed the London branch with Bainbridge.

Although conditions in Fabergé's workshops were good, the hours were long, with employees working from 7.00 am to 11.00 pm on weekdays and from 8.00 am to 1.00 pm on Sundays. These hours were long even by the standards of the time, but overtime pay was good.

The rise of a new factory class with the growing industrialization of Russia had led to crude exploitation of this group of workers, especially in Moscow, where there was a large pool of labour willing to work for little pay. In St Petersburg, where labour was scarcer, employers treated their workers better. Reforms were on the way, prompted not so much by charitable impulses as by a recognition of the need for greater efficiency and the fact that tired workers produced bad work. In 1897 laws were introduced which limited the hours of work for adults to 11½ a day; regulations in 1882 had forbidden minors to work at night and had established that children betwen the ages of 12 and 15 should not work more than eight hours a day.

Fabergé, although a kindly, paternalistic employer, clearly required great commitment from those around him. This was necessary to maintain his standards and to satisfy the demand for his work. It must be remembered that, judged in the light of most modern businesses, the firm was in the extraordinary position of being able to sell all the work it produced, and Fabergé was under constant pressure to produce more to delight his patrons. Bainbridge recalls discovering the demands on the House of Fabergé in the early days of his association with it and concluded "that it was no business of mine to tout for orders, rather was it to turn customers away".

The Englishman also recorded that Fabergé had a marked dislike of letters and was generally suspicious of committing anything to paper, preferring to deal with people directly, which explains why so much of the information about him comes from sources other than the man himself. Having said that, though, a body of documents was discovered in 1986 which adds invaluable information to the store of knowledge about Fabergé's operations. These are Albert Holmström's stock records, in which every item made in the workshops from 6 March, 1909, to 20 March, 1915, is recorded in detail. It is appropriate that this major discovery should have been made by Kenneth Snowman, the leading authority on Fabergé, who has spent much of his life researching and explaining the art of Fabergé. The records were taken from Russia to Latvia in 1925 by a diamond setter in Albert Holmström's workshop and emerged decades later in San Francisco, where they were eagerly acquired by Snowman, who has described his reactions on seeing them for the first time: "[It was] as though the original manuscript score of a favourite and familiar piece of music that one had been playing and

The beautiful Mosaic Egg was presented by Tsar Nicholas II to his wife, Alexandra Feodorovna in 1914 (9.2cm/3⅝in). The complicated pattern is made up of rubies, emeralds, diamonds, garnets, sapphires and topaz, bordered with pearls. It opens to reveal a surprise of a bejewelled gold frame on a pedestal, containing cameos of the five Imperial children painted on a pink enamel background. It was designed by Alma Theresia Pihl in the workshops of Albert Holmström and is said to have been inspired by petit-point embroidery.

.

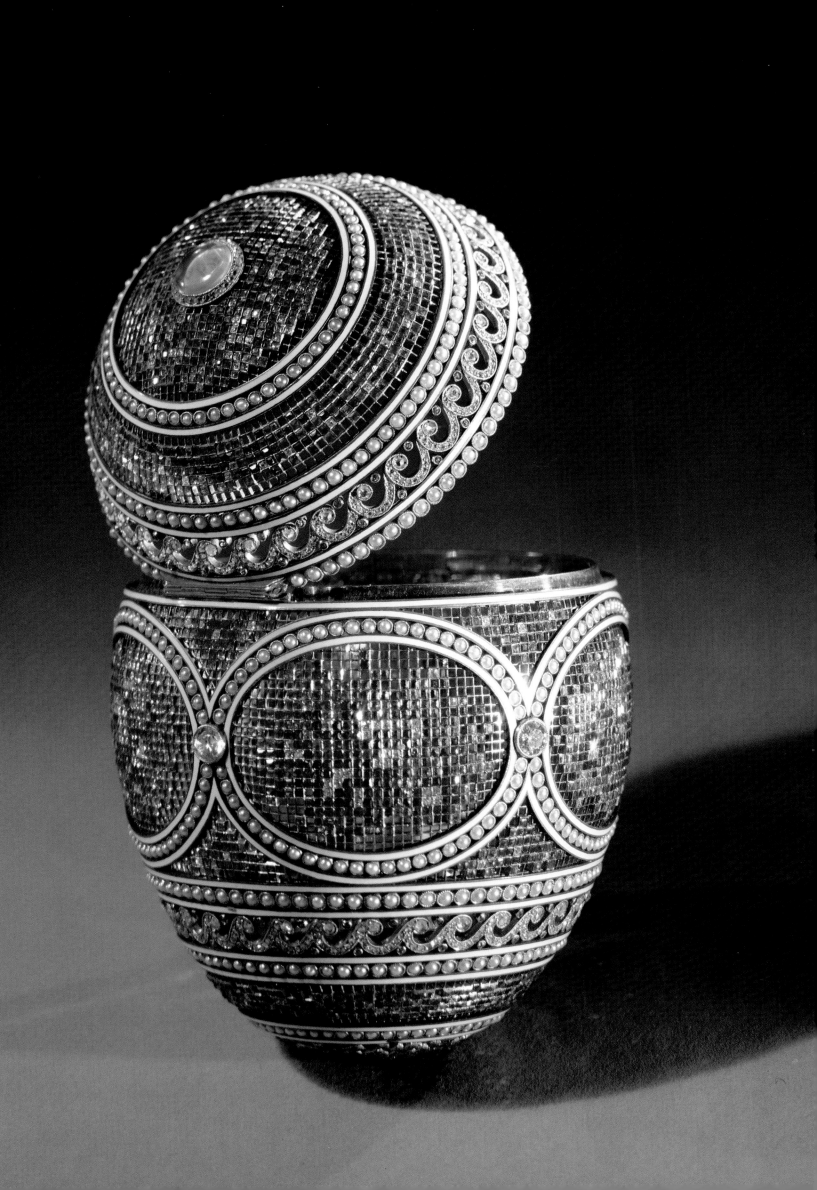

A gift for a lady's dressing table, the Balletta Box was presented by Grand Duke Alexei Alexandrovitch to the ballerina Madame Elizabeth Balletta of the Michael Theatre, St Petersburg – a lady who had many admirers. It is a vanity case in gold and blue enamel decorated with trelliswork and containing a gold pencil, mirror, lipstick tube and compartments for powder.

.

enjoying for most of one's life had quite suddenly, as if by a miracle, been thrust into one's hands."

The two volumes were described by Snowman in an article, 'Two Books of Revelation', in *Apollo* in 1987. They comprise 1,221 large pages, covered with drawings and paintings which show how each design was carried out, with a description of the materials and stones used and their cost. There are hundreds of such drawings – of brooches, pendants, miniature Easter eggs, cuff links, rings, necklaces.

The illustrations are vivid in colour and precise in detail, as can be seen if the design is compared with the finished object, when the exquisite paintings – many of them in watercolour – are translated into three-dimensional form. The care, precision and artistry of the record's compilers were typical of the Fabergé approach: nothing ugly or shoddy was to be tolerated.

An important discovery made from this source is the number of platinum objects made by Fabergé. Since there was no Russian hallmark for this metal, many platinum objects could exist without their owners knowing they are by Fabergé.

The records illustrate the wide range of stones used: Mecca stones, rhodonite, moss agate, aquamarine, nephrite, rock crystal, rubies,

The Head Workmasters

*T*he design studio in St Petersburg – the photograph
was taken by Nicholas Fabergé and shows a number of
designers including Ivan Lieberg, seated in the
foreground, and Alexander Ivashov, standing to the
right.

.

ERIK AUGUST KOLLIN
(1836–1901)
Head workmaster 1870–86.
Best known for work as gold-
smith in antique style, partic-
ularly for reproductions of
Scythian treasures. Mark is EK.

**MICHAEL EVAMPLEVITCH
PERCHIN**
(1860–1903)
Head workmaster 1886–1903.
Responsible for some of the
most exquisite objects produced
by Fabergé, including the
Imperial Eggs – from the Res-
urrection Egg (1887 or 1890)
to the Peter the Great Egg of
1903. In his time that workshop
introduced guilloche enamel-
ling and *quatre-couleur* gold.
Mark is M. П.

**HENRIK EMANUEL
WIGSTRÖM**
(1862–1923)
Head workmaster 1903–17.
Style reflects elements of Louis
XVI and Empire periods.
Mark H.W.

Workmasters

Careful, patient work in the workshops of Fabergé.

JOHAN VICTOR AARNE
(1863–1934)
Workmaster 1891–1904. Specialized in picture frames and bell pushes, working in gold, silver and enamel.

FEDOR AFANASSIEV
Little is known about him, but mark appears on small, high-quality objects, particularly miniature Easter eggs.

KARL GUSTAV HALMAR ARMFELT
(1873–1959)
Workmaster 1904–16. Bought Aarne's workshop. Specialized in enamel.

ANDREI GORIANOV
Took over workshop of Wilhelm Reimer in 1898. Specialized in gold cigarette cases – carry only his name, not that of Fabergé.

AUGUST FREDERIK HOLLMING
(1854–1913)
Qualified as workmaster 1880, moved into Fabergé's building 1900. Made fine enamelled pieces, particularly cigarette cases.

VAINO HOLLMING
(1885–1934)
Workmaster 1913–17.

AUGUST WILHELM HOLMSTRÖM
(1829–1903)
Senior member of firm, having started working with Gustav Fabergé in 1857. Head jeweller, responsible for all company's jewellery. Also highly skilled goldsmith. Contributed to many of the Imperial Eggs.

ALBERT HOLMSTRÖM
Succeeded his father in 1903. A skilled jeweller, he continued to use his father's hallmark AH.

KARL GUSTAV JOHANNSSON LUNDELL
(born 1883, date of death unknown)
Thought to have been workmaster at the Odessa branch, his mark is often found on cigarette cases.

ANDERS MICKELSON
(1839–1913)
Became a master goldsmith in 1867. Produced gold cigarette cases and small enamelled objects.

ANDERS JOHN NEVALAINEN
(1858–1933)
Started in workshop of August Holmström but later had own workshop, working exclusively for Fabergé. Made small gold and silver objects and cigarette cases.

GABRIEL ZACHARIASSON NIUKKANEN
Workmaster 1898–1912. Manager of Odessa workshop for a time and his mark is found on gold and silver cigarette cases, but these are rarely accompanied by Fabergé's hallmark.

KNUT OSKAR PIHL
(1860–97)
Chief jeweller at Moscow branch 1887–97, specializing in small pieces.

JULIUS ALEXANDROVITCH RAPPAPORT
(1864–1916)
Head silversmith, producing large silver pieces and silver services, trained in Berlin.

WILHELM REINER
(died around 1898).
Made small objects of enamel and gold.

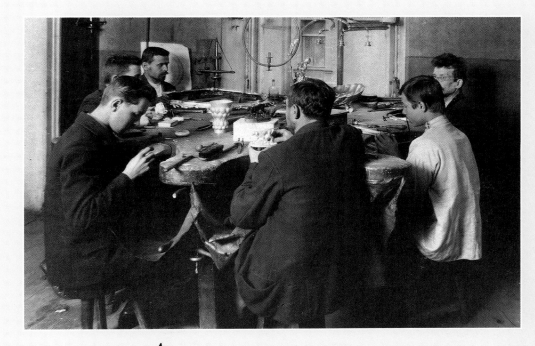

A view of one of the Fabergé workshops – in its heyday the firm employed some 500 people and produced thousands of articles for customers all over the world.

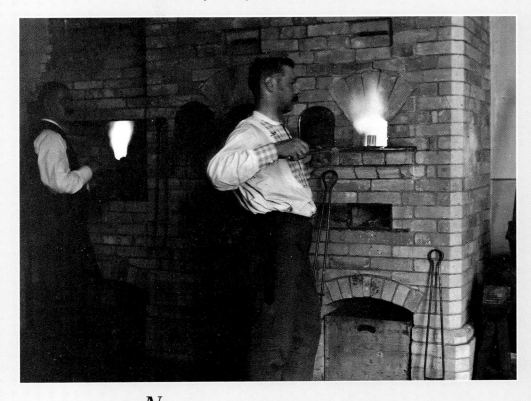

Nikolai Petrov, who succeeded his father, Alexander, as chief enameller for all Fabergé objects.

.

PHILIP THEODOR RINGE
With his own workshop from 1893, it is thought he worked occasionally for Fabergé, providing small enamelled objects in gold or silver

FEDOR RUCKERT
Notable for his work with cloisonné enamel, particularly in the way it departs from the traditional Russian style, showing clear influence of Art Nouveau. Supplied Fabergé and other customers, which is why many of his pieces do not carry the Fabergé signature.

EDUARD WILHELM SCHRAMM
Made gold cigarette cases and small pieces. It is thought he provided work for Fabergé only occasionally and most of his work carried just his own initials.

VLADIMIR SOLOVIEV
Took over the workshop of Ringe on his death and produced similar work.

ALFRED THIELEMANN
(date of birth unknown, died between 1908 and 1910)
Qualified as a master in 1858 and was in charge of production in one of Fabergé's jewellery workshops from 1880. Made small pieces and trinkets. Mark often causes confusion because it was also used by three other masters who were not connected with Fabergé: Alexander Tillander, who made *objets d'art* in the Fabergé manner; A. Tobinkov, a silversmith; and A. Treiden. Thielemann's son, Karl Rudolph, succeeded him when he died.

STEFAN WAKEVA
(1833–1910)
Silversmith specializing in tea and coffee services and table silver. When he died, his son, Alexander, took over the workshop and used his own initials as a mark.

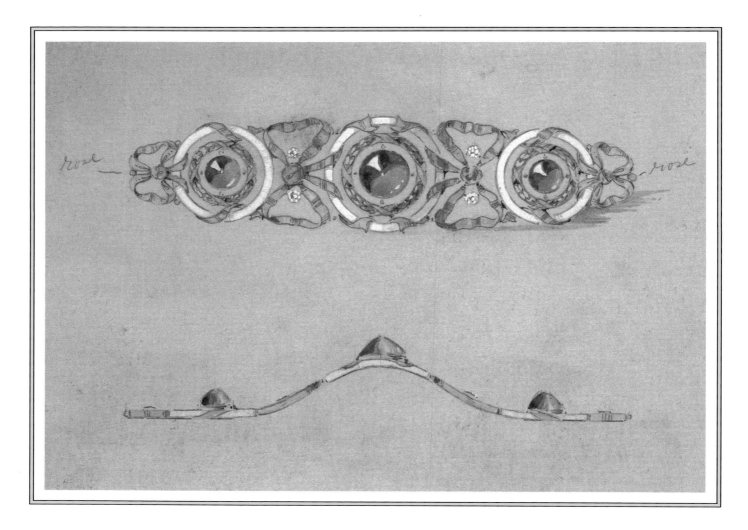

*Design for an
enamelled, diamond-set
cabochon hair slide.*
.

sapphires, emeralds and, of course, rose-cut diamonds. The pieces are enchanting. There is, for example, a flowing design in the form of an initial A, a sumptuous and colourful object which includes 17 rubies, 73 brilliants and 228 rose diamonds.

Many of the pieces were made to celebrate the tercentenary of Romanov rule, with pendants and brooches incorporating the significant dates, 1613–1913, and the Imperial double-headed eagle. This was a vast commission, a series of precious objects, all different, to be presented to the Grand Duchess and the ladies of the Court. Some of the designs, according to Bainbridge, were based on drawings provided by the Empress Alexandra Feodorovna.

There is evidence, too, of commissions from other major patrons, such as Dr Emanuel Nobel, the immensely rich oil tycoon of Stockholm, who liked to give the ladies at his parties some memento from Fabergé, many of which reflect a wintry theme of frost crystals or snowflakes.

The designs for these were provided by Alma Pihl. She worked with her uncle, Albert Holmström, her first job being to draw and paint objects produced in the workshops for the records. Her first opportunity as a designer came with a rush order from Emanuel Nobel for some 40 small pieces in a new design. Her inspiration is said to have come from

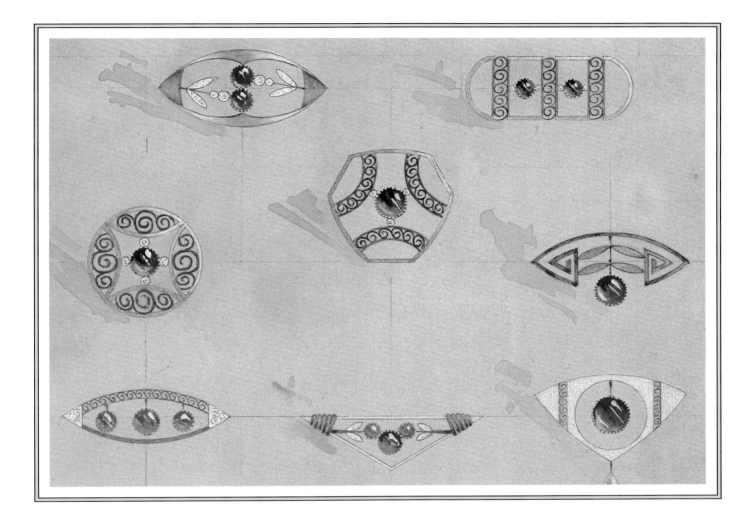

the ice crystals forming on the windows of the workshop and the famous snowflake design was created, a design which was to be repeated many times in the future.

The Holmström stockbooks revealed a fascinating piece of information in the shape of a small, precise watercolour of a mosaic brooch in coloured stones, surrounded by half-pearls and opaque white enamel. Designed by Alma Pihl and dated 24 July, 1913, the drawing is clearly the forerunner of the Mosaic Egg of 1914, which was presented by Nicholas II to his Empress. Alma Pihl is also credited with the design of the enchanting Winter Egg, presented to the Dowager Empress by Nicholas II in 1913. Carved out of rock crystal, engraved with frost flowers and containing a surprise of a basket of snowdrops, this is a breathtaking piece, prompted, perhaps, by more wintry introspection in the workshop of Albert Holmström.

Perhaps the most beautiful study in the two volumes is a life-sized drawing of a spray of forget-me-nots, a favourite subject for Fabergé's flowers. Dated 12 May, 1912, it shows how the flower was to be made: the leaves of nephrite, the flowers of turquoise with rose-cut diamonds at the centre, the stem of engraved gold, placed in a simple pot made of rock crystal which was cunningly cut to give the illusion that the flower

Designs for brooches in various geometric forms set with cabochon stones. The inventiveness of the designers of these items – and many others – is remarkable for they rarely allow repetition. Actual examples of such work are fairly rare, partly because many jewellery items were sold by Russian emigrés for the value of the stones.

.

Designs from the Workshops

The discovery of two volumes of designs from August Holmström's workshop provided fascinating insights into the artistic and technical variety of the designer's work. *Far right:* Pencil and watercolour were used in creating this design for a silver table lamp in rococo style with scrolled arm and scrolled feet. *Below:* A large gilt metal kovsh in the Louis XV style decorated with scrolls and rocaille. *Right:* Designs for a selection of colourful drinking vessels with rich decorations.

.

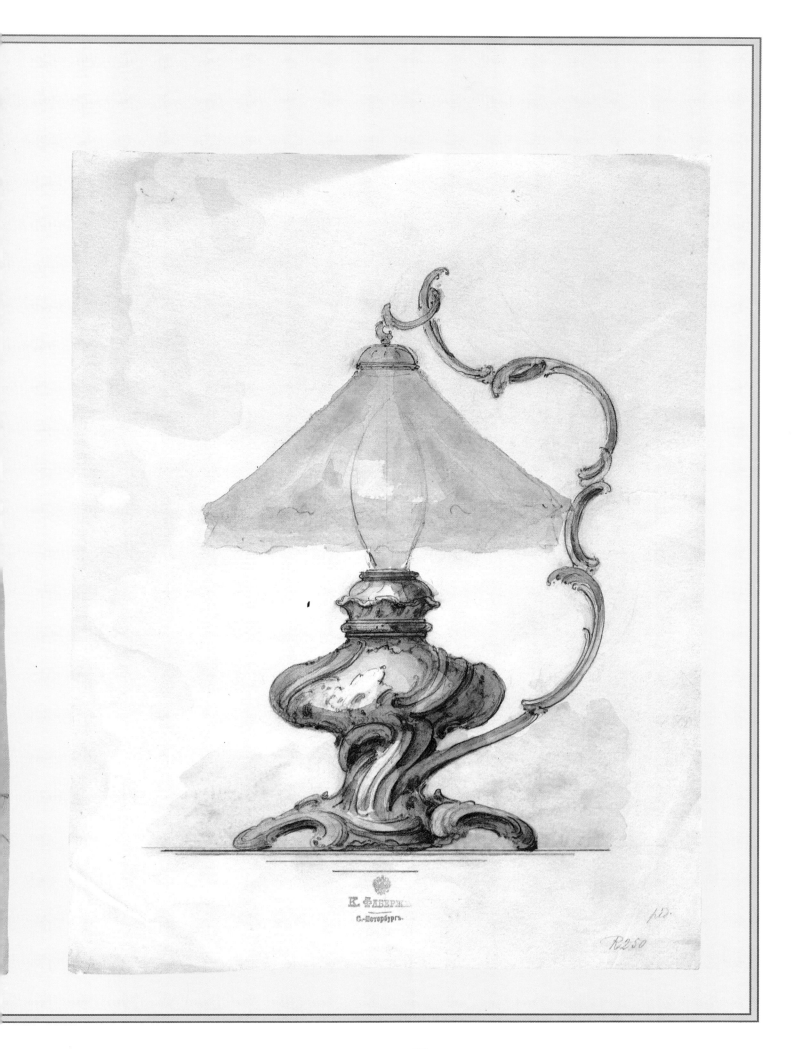

К. ФАБЕРЖЕ
С.-Петербургъ.

R250

Designs from the Workshops

Right: Vases, bowls and a table centrepiece lavishly decorated with sea monsters, scallops and other marine life. Below: Hardstone horn-shaped vase with spreading gold rim, the base terminating in a ram's head.

.

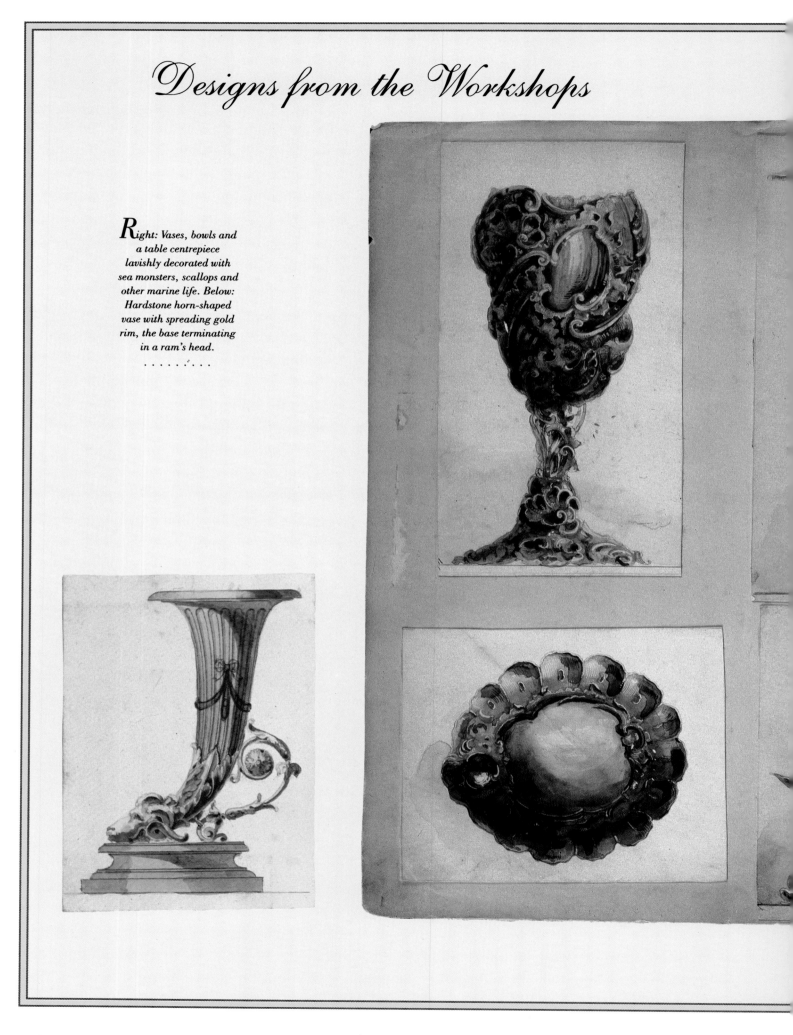

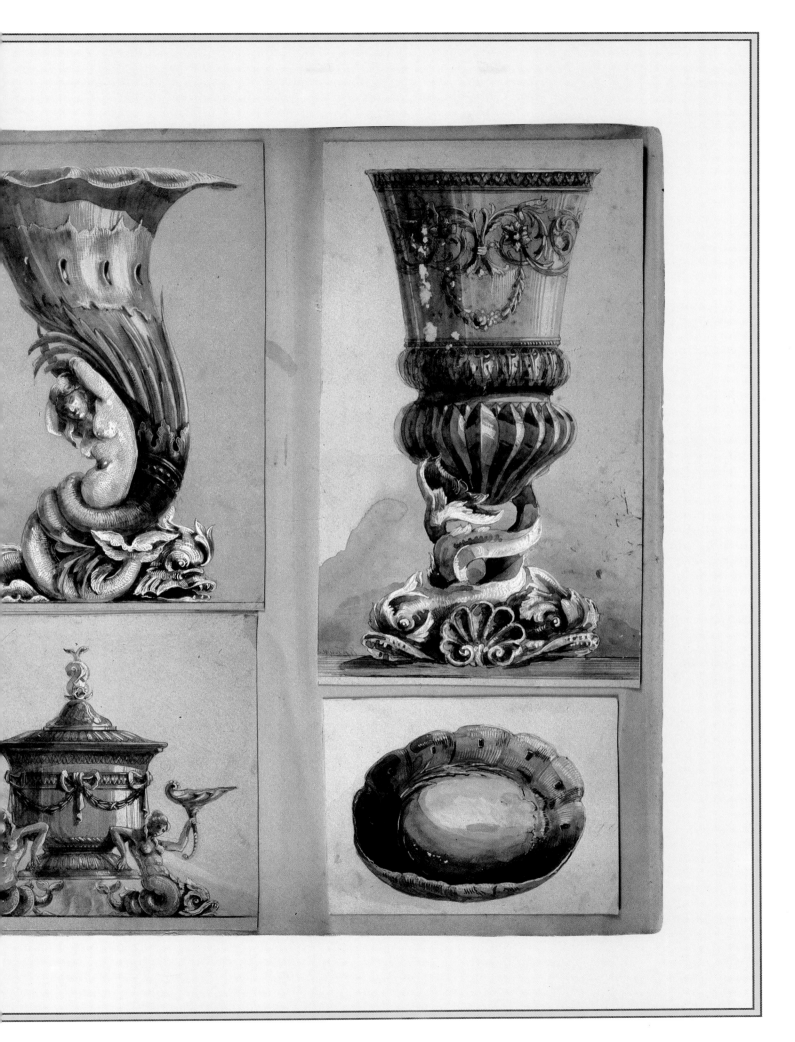

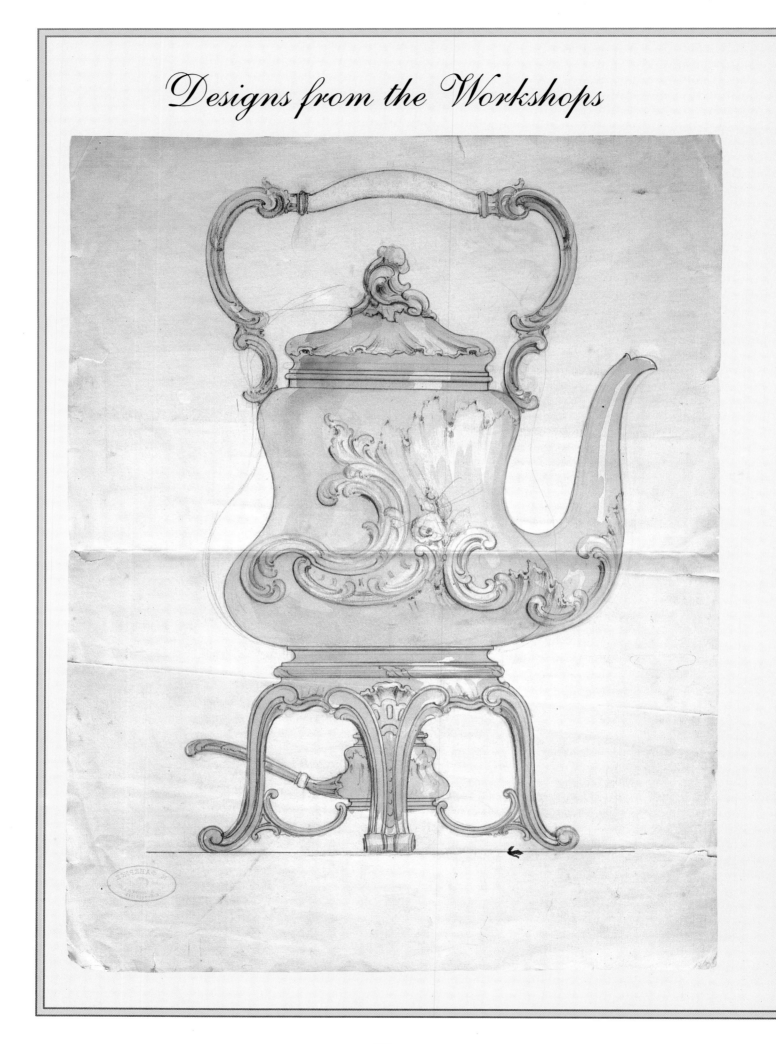

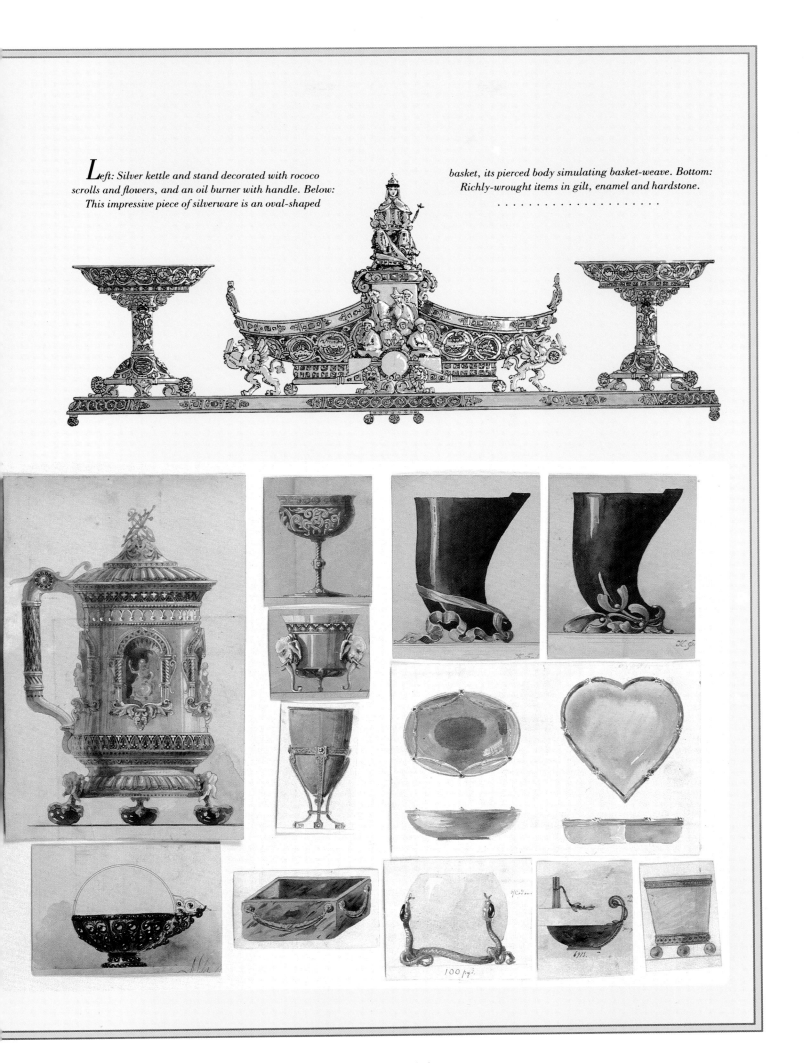

Left: Silver kettle and stand decorated with rococo scrolls and flowers, and an oil burner with handle. Below: This impressive piece of silverware is an oval-shaped basket, its pierced body simulating basket-weave. Bottom: Richly-wrought items in gilt, enamel and hardstone.
.

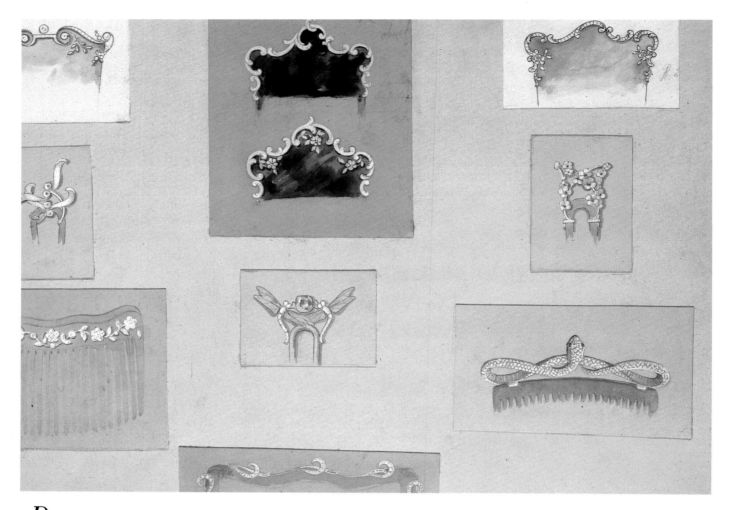

Designs for jewelled and tortoise-shell hair combs and pins, some showing art nouveau influences and one using an entwined snake, a favourite theme in Fabergé's work.

.

was standing in water. Snowman, in his 'Two Books of Revelation' article, makes the observation that although the stems of some of Fabergé's flowers are sometimes stamped with the mark of goldsmith: "The very fact that a flower design should figure among those for jewels seems to demonstrate that . . . their nature is, in a sense, ambiguous, existing in some sort of no man's land or neutral soil between *objet de vitrine* and jewel". It also shows how the most appropriate craftsmen were used for particular works, a decision made at the conference during the planning of the design. This flower requires a high level of skill from a jeweller; had it been an object requiring the skill of the goldsmith, it would have been in the workshop of Henrik Wigström.

The workmasters had their own marks, which, with other markings, help to identify and date the objects. The state hallmarks indicate that the work is made of precious metal. In Fabergé's time the Russian gold and silver standards were calculated in *zolotniks*, 96 *zolotniks* being the equivalent of 24-carat gold or pure silver. The standard of gold used in Russia was indicated by the marks 56 or 72 *zolotniks*, equivalent to 14- or 18-carat gold, with 72 used for most export articles. Silver objects have marks indicating 84, 88 and, occasionally, 91 *zolotniks*, which correspond to 875, 916 and 947/1,000 standard silver.

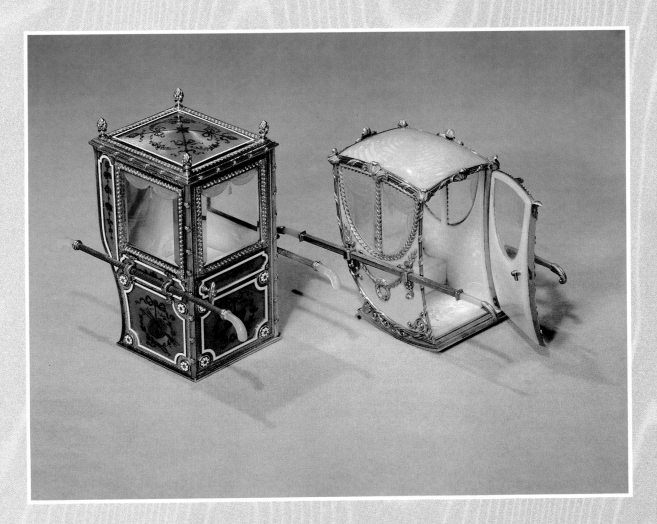

These two miniature sedan chairs are masterpieces of the enameller's art. The example on the left has pink guilloche enamel panels painted with symbols for the arts of painting, music and love. The chair on the right is a deliciously pearly pink guilloche enamel. Note how the windows in both examples are carved to simulate curtains.

· · · · · · · · · · · · · · · · · · ·

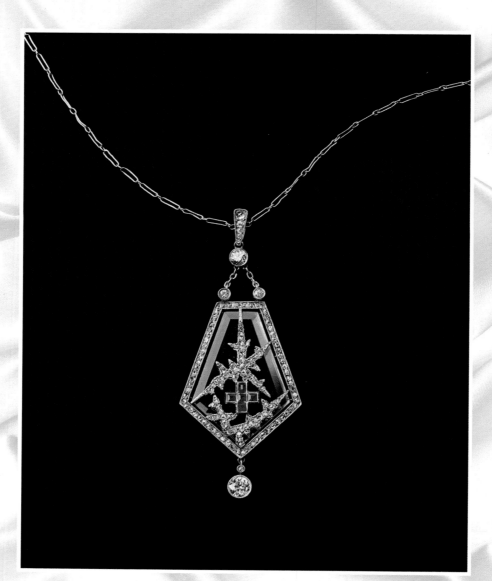

*T*he snowflake theme of this jewelled pendant with a
ruby cross is found in many pieces of jewellery carrying
the mark of workmaster A. Holmström. Snowflake
jewellery is particularly associated with commissions for
one of Fabergé's wealthy patrons, Dr Emanuel Nobel.

. .

The origin and dating of Fabergé items is helped by the state hallmarks. St Petersburg and Moscow had different marks: in the 19th century, until 1899, the St Petersburg mark was the city's coat of arms, crossed anchors and sceptre, with the date, assayer's mark and the standard of metal in *zolotniks*; Moscow's mark was of that city's coat of arms, St George and the dragon, with the date, assayer's mark and standard of metal in *zolotniks*. Between 1899 and 1908 the St Petersburg hallmark was a female profile wearing the traditional Russian peasant headdress, the *kokoshnik*, facing left and carrying the initials of the assayer and the metal standard. The Moscow hallmark for the same period was a *kokoshnik* facing left with the assayer's initials and the metal standard.

Between 1908 and 1917 the St Petersburg mark was of a *kokoshnik* facing right with the Greek letter alpha and the standard of metal expressed in *zolotniks*. At the same time the Moscow mark was a *kokoshnik* looking right with the Greek letter delta and the standard of metal.

Fabergé's own marks differ according to whether the piece originated in St Petersburg or Moscow. Items from St Petersburg usually carry Fabergé's full signature in Cyrillic characters, without the initial. For smaller objects from St Petersburg the mark is Fabergé's initials in Cyrillic characters. Objects originating in Moscow have C. Fabergé in Cyrillic characters and the stamp of the double-headed Imperial eagle. The Imperial eagle is also seen on articles in silver made or sold by the St Petersburg branch which were made in the workshops of Anders Nevalainen, Julius Rappoport and Stefan Wakeva, and the First Silver Artel (the Artels were co-operatives of goldsmiths, silversmiths and jewellers which Fabergé made use of from time to time).

Objects intended for the European market have Fabergé's name or his initials in Roman letters and most of the work has inventory numbers scratched on the metal.

A significant point about the markings is that the Moscow workmasters did not sign the objects they produced but those of St Petersburg always did; even when Fabergé's name is missing from work produced in St Petersburg, which often happens, the pieces will carry the name of the workmaster responsible for it. This appears to be a recognition of the autonomous status of the workmasters, indicating that the piece is the work of an individual craftsman in the Fabergé empire.

It should, however, be remembered that not all Fabergé pieces have the appropriate markings. If they did, dating and establishing provenance would be easy matters, but this is not always the case, since Fabergé had a somewhat casual approach to the importance of marks. In some cases, such as the stone animals, it would be impossible to stamp a mark on the piece, because it would disfigure the material. Delicate pieces, such as the flowers and jewellery, are often unsigned, because of the problems of finding a place to put the signature. In these cases, the experts rely on their experience of Fabergé's work and their ability to recognize the Fabergé style.

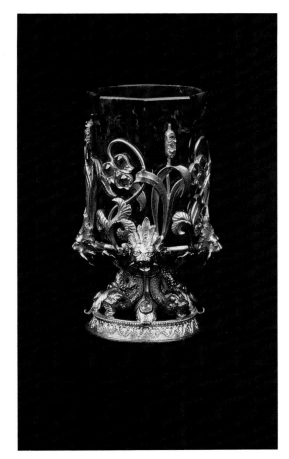

A jasper matchholder lavishly decorated in the art nouveau style with flowers and reeds set with rubies. The base is richly wrought with the heads of lions and dolphins.

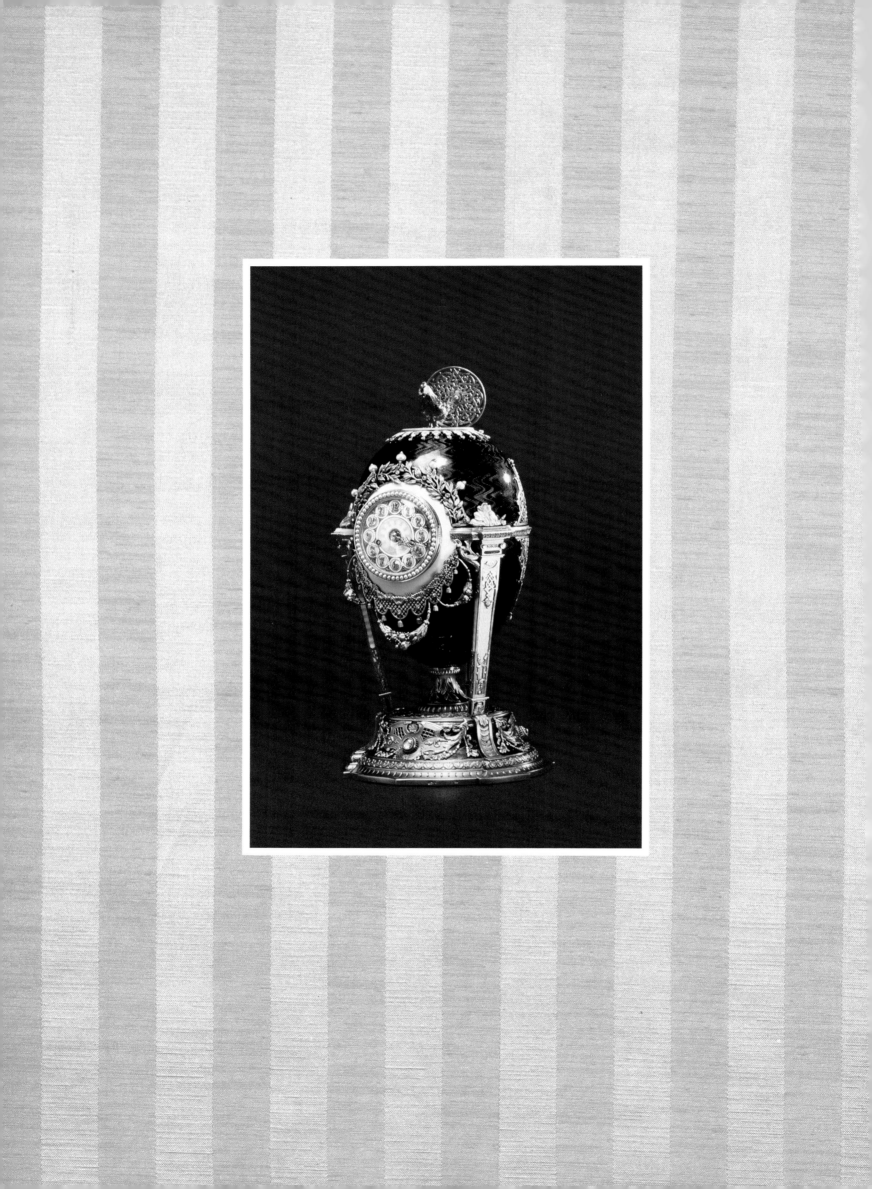

"Un génie incomparable"

*Fabergé's fame rests on his achievement in creating the
series of Imperial eggs — the result of an act of patronage on
the grand scale by the Imperial family of Russia. The
commission gave Fabergé the freedom to ignore questions of
cost and time and to concentrate on the challenge of
creating something new and spectacular each year, a
challenge he met with outstanding success as can be seen in
the extraordinary examples of craftsmanship and
imagination described in these pages.*

*The Cuckoo Egg, workmaster Michael Perchin,
presented by Tsar Nicholas II to his mother, the Dowager
Empress Marie Feodorovna in 1900 (20.6cm/8⅛in). The
shell is a beautiful shade of violet, enamelled on a
guilloche ground, and is supported by three slender
columns. When a button is depressed at the back of the
clock a gold grille opens and a bird appears (not a cuckoo
but a cockerel), crowing and moving its wings.*

.

 HE IMPERIAL EGGS, which have been seen by so many and are guaranteed to attract vast crowds whenever they are exhibited, were never intended to be seen by the public at large. Their creation and presentation were private matters between patron and artist. Indeed, secrecy surrounded the creation of each egg at all stages. Bainbridge has recalled how he discovered the existence of these extraordinary works quite by accident in the St Petersburg offices one morning when he saw Henrik Wigström carrying "something the like of which I had never seen before". The Englishman went on:

"There was I, admitted to every intimacy by the head of the house and his family, with carte blanche to roam where I liked and do what I liked on the business premises, ask questions of anybody, and open any drawers that took my fancy, and yet but for this chance happening I should have remained ignorant of the finest objects the House was all the time producing."

There is some doubt about how the first commission came about. One story is that the eggs were a speculative creation by Fabergé in an effort to win the favour of the Tsar. Another is that they were an attempt by Alexander III to relieve the grief of his wife, Marie Feodorovna, after the assassination of Alexander II in 1881. The most popular story, however, is that they were a sentimental gesture on his part to remind the Empress of her Danish home, a commission for which Fabergé had the happy idea of re-creating a jewelled and enamelled gold Easter egg which was in the possession of the Danish Royal Family.

Some authorities have pointed out that similar eggs exist in Vienna and Dresden and may have served as Fabergé's inspiration, but the similarity between the Danish egg and the one created by Fabergé is so great that a direct connection seems definite. The Danish egg is a copy of a hen's egg, with a white ivory exterior and gold inside for the yolk. It opens to reveal a gold chicken with diamond eyes, which also opens to reveal a miniature crown and a diamond ring. The egg made by Fabergé has a shell of gold with white polished enamel to make it look like the shell of a hen's egg. It opens to reveal the yolk in yellow gold, which opens to reveal a hen in gold with ruby *cabochon* eyes, which opens to reveal a miniature in diamonds of the Imperial Crown, which contained a tiny ruby egg.

Whatever the circumstances were, the first Imperial Easter egg was so well received that Alexander III ordered that a similar work should be created each year for his wife. The commission was continued by his son who increased it to two: one for his mother and one for his wife.

The series of Imperial Easter eggs is a spectacular achievement, recalling the works of art created by artists and craftsmen for the great princes of the Renaissance. Cost was not a consideration and the precious materials used were the least important part of the creation. The craftsman's contribution was inspiration: what mattered most was that the piece should be new and surprising. If Fabergé had unusual freedom because of the nature of the commission, he also had the responsibility of finding something novel to delight his Imperial patrons. With the

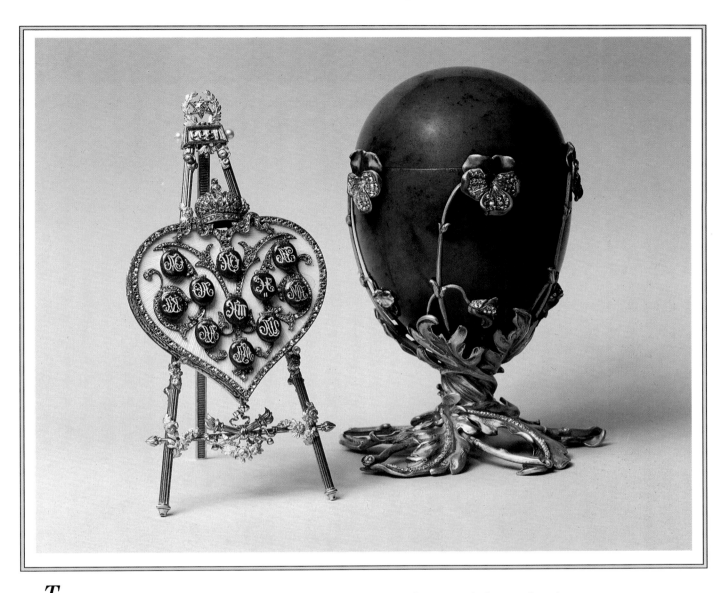

The Pansy Egg, workmaster Michael Perchin, presented by Tsar Nicholas II to his mother in 1899 (14.6cm/5¾in). The egg is made of nephrite, decorated in the art nouveau style with violet enamelled pansies, and stands on a stem of silver-gilt leaves and twigs. The surprise is a gold easel supporting 11 scarlet enamel lockets, each with its own monogram. When a button is pressed the lockets open at the same time to reveal miniatures of 11 members of the Imperial family.

.

help of his team of designers and craftsmen, he succeeded magnificently, creating more than 50 works of art, extraordinary examples of ingenuity, craftsmanship and imagination.

There has been some uncertainty about the date of the first Imperial egg, but recent research in Russia by Marina Lopato of the Hermitage Museum, Leningrad, has established that it was 1885 (the commission continued until 1917).

It was appropriate that Alexander III, the most Russian of Tsars, should have chosen to present his Empress with an egg at Easter. The exchanging of eggs at this time of year was a popular custom in Russia then, as it is today. In earlier times, these symbolic Easter offerings were natural eggs, painted in simple colours, but they began to become more exotic in the 18th century, probably influenced by the appearance of expensive, jewelled eggs in Western Europe. They were made of a variety of materials such as wood, papier-mâché and porcelain, beautifully crafted and highly prized, sometimes enamelled and jewelled. Miniature eggs in the form of pendants appeared in the 18th century and examples must have been known to Fabergé, who made a speciality of producing a range of these enchanting objects in a variety of materials

and decorations and in a staggering number of designs, barely repeating himself. They were collected by the wives and daughters of wealthy families and worn as chains; some linked as many as 100 of the tiny objects and admirers would add others to mark different occasions.

Easter is the most important festival in the Russian Orthodox year but the significance of the egg is rooted in earlier pagan times. It celebrates the spring equinox, a fact observed by the early fathers and incorporated into their religion. It was an important and powerful symbol because it represented the creation of life. In Ancient Egypt the priests would not eat eggs because they represented life and in Roman times the breaking of eggs was believed to ward off evil spirits; they were often placed in tombs, a custom observed in other religions.

Miniature of the Grand Duchess Tatiana.

· · · · · · · · ·

By the Middle Ages the egg had become a part of the Christian religion as a symbol of Christ's resurrection. Ostrich eggs appeared in Europe during the 13th century and were hung in cathedrals and churches, often decorated with gold and silver. They were used to hold saintly relics and as part of Easter celebrations. The records of Avignon cathedral for 1511 refer to "three ostrich eggs with chains and attachments in silver, ornamented with the coat of arms of the Holy Lord, Pope Jules, who at the time was archbishop and legate in Avignon", and there are numerous references to ostrich eggs in the records of many churches in France, Germany and other European countries.

These ostrich eggs, which, according to an account in the 16th century, "are as big as a child's head, round, and when they are old they look like ivory", gradually ceased to have a religious role and came to be prized by the wealthy. They were usually richly mounted, painted and engraved.

Decorated hens eggs appear to have originated in France. At the court of Louis XIV hundreds of coloured eggs were distributed by the Sun King to his family and friends and he ordered that some should be painted with scenes. In the reign of Louis XV it is reported that painters such as Watteau and Boucher painted scenes on eggs which were to be royal gifts. In the 18th century there was a small zoo at Versailles, which, according to Victor Houart in his fascinating book on Easter eggs, had a resident painter attached to it whose job it was to paint scenes on the ostrich eggs produced there for presentation to the King at Easter.

Surprise eggs appeared in 18th-century France, in the reign of Louis XVI, who had the charming habit of hiding a precious object in an egg, which he would press on some favourite at Easter. An unusual example of the surprise element of these eggs is a gift by the King to his aunt, Madame Victoire, of two eggs which contain dramatic scenes illustrating a real-life story of a young girl being attacked by robbers, saved by soldiers and returned in safety to her home. The miniature world – the eggs are not more than 5cm (2in) in diameter – by an unknown hand are beautifully made, with figures of wax and foliage of silk and velvet.

During this period extravagant Easter eggs were exchanged by royalty and the aristocracy. These were the magnificent creations of the French

The Fifteenth Anniversary Egg, signed Fabergé, presented by Tsar Nicholas II to his wife, Alexandra Feodorovna in 1911 (13cm/5⅛in). The miniatures, painted on ivory, by Vassily Zuiev, are of the Tsar and Tsarina and their five children, Olga, Tatiana, Marie, Anastasia and Alexis. In addition there are paintings of major events from the Tsar's reign between 1894 and 1911. The portraits are framed with rose diamonds and separated by translucent bands of green enamel tied with rose diamonds. The egg is topped with a table diamond covering the Tsarina's monogram in black enamel on gold.

· · · · · · · · ·

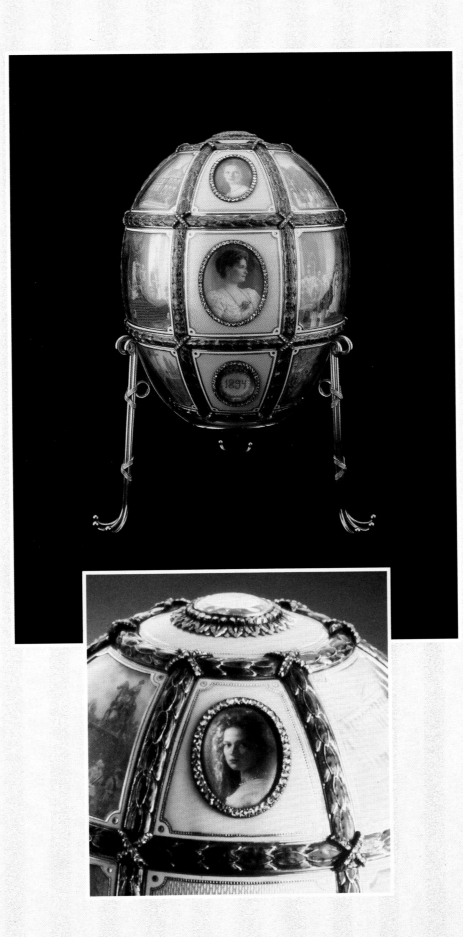

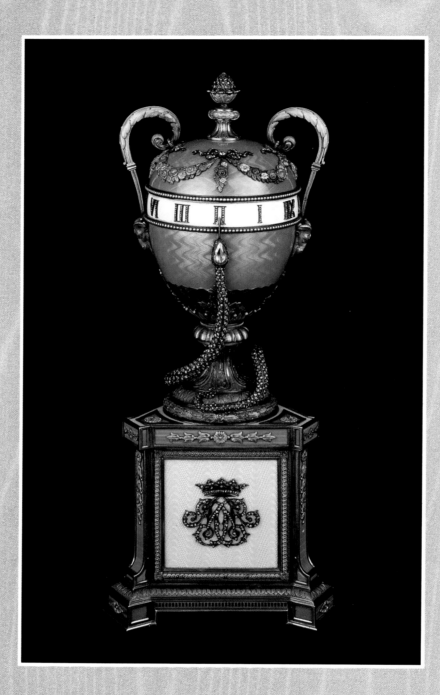

*T*he Duchess of Marlborough Egg, workmaster Michael
Perchin, made for Consuelo, Duchess of Marlborough, in
1902. The Duchess was American, a member of the
extremely wealthy Vanderbilt family. The egg is almost
identical to the Imperial Serpent Clock Egg presented by
Tsar Alexander III to his wife, the Empress Marie
Feodorovna in 1889, except that the Duchess's egg is pink
rather than blue.
.

goldsmiths of the 18th century to whom Fabergé was indebted. There are numerous examples in the Louvre in Paris, exquisite works, beautifully crafted in precious stones and materials.

There were richly wrought eggs made in other countries, too, especially Germany and Austria, and the Hermitage Museum in Leningrad has a number of treasures of this kind from the 18th century which would have been known to Fabergé.

There has been some uncertainty about the number of Imperial Easter eggs produced by Fabergé and there are doubts as to the dating of some of them. This reflects the private nature of the commission. In other words, they were not regarded as lavish works of art to be talked about and admired on the public stage but were family gifts, precious and highly imaginative but also simple, personal tokens of affection.

From the first Imperial egg of 1885, Fabergé presented Alexander III a further creation each year until the Tsar's death in 1894. His son, Nicholas II, then continued the custom. So, 10 eggs were made during the reign of Alexander III and a further 44 during the reign of Nicholas II, making a total of 54 eggs (or 56 if the Imperial eggs for the fateful year of 1917 are included, although they are lost and there is no evidence that they were ever delivered).

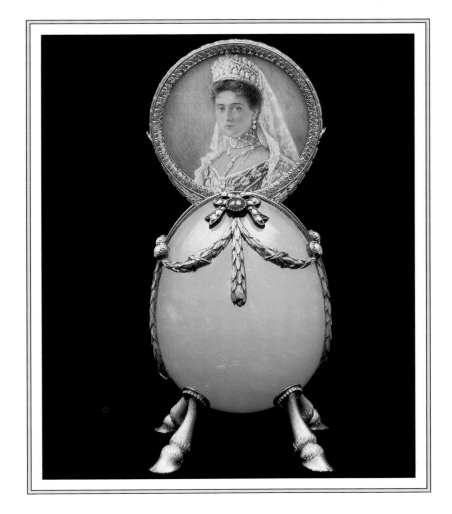

The Hoof Egg, workmaster Michael Perchin, is thought to have been presented by the Empress Alexandra to one of her friends. The bowenite shell stands on four cloven-hooved legs and is decorated with gold laurel pendants and swags with diamond-set ruby bows. The surprise is a gold-framed miniature of the Empress wearing the kokoshnik *diadem.*

.

Research in Russia has suggested that more Imperial Easter eggs than the 10 of Alexander III's reign were made by Fabergé. Fabergé scholar Geza von Habsburg has speculated that these may have been gifts to the Tsarevitch.

Whatever the difficulties of establishing dates for the creation of the Imperial Eggs, we know that 47 of the original 54 (or 56) exist today. The Armoury Museum of the Kremlin has 10, but many of the others have passed through several hands since the Revolution. America has the richest collection: with that inveterate and persistent collector Malcolm Forbes having no less than 11 of these now priceless objects. Eight are in European collections and some are lost. It is known that some owners are reluctant, given the value of the Imperial eggs, to admit they own them.

As surprise was the essential element of the Imperial Easter gifts, this helps to explain the secrecy surrounding their creation. When the Tsar asked to be allowed some details of the forthcoming gift, even he was denied by Fabergé, with the words: "Your Majesty will be content."

Fabergé made the delivery of each Easter gift personally to the Tsar and later, when there were two eggs to be delivered, the duty was undertaken by one of his sons. It was obviously a ceremony everyone looked forward to, the Imperial family eager to see what masterpiece the craftsman had created, the craftsman anxious for their approval.

Alexander von Solodkoff, in his book *Fabergé*, has described the approval of the Dowager Empress Marie Feodorovna of the Easter egg given to her by her son, Nicholas II, in 1914:

"Fabergé brought it to me himself. It is a true chef-d'œuvre, *in pink enamel and inside a* porte-chaise *carried by two negroes with Empress Catherine in it wearing a little crown on her head. You wind it up and then the negroes walk — it is an unbelievably beautiful and superbly fine piece of work. Fabergé is the greatest genius of our time. I also told him:* Vous êtes un génie incomparable.*"*

The Grisaille (also known as the Catherine the Great) Egg has eight grisaille panels, enamelled translucent pink, edged by narrow white enamel bands and pearl borders. The paintings, by Vassily Zuiev, represent the Muses.

· · · · · · · ·

The surprise inside the Grisaille Egg, workmaster Henrik Wigström, presented by Nicholas II to the Dowager Empress Maria Feodorovna in 1914. The sedan chair, containing Catherine the Great, complete with crown, is carried by two negro servants who walk when the mechanism is wound.

· · · · · · · ·

Ornate borders and edgings are an integral part of Fabergé's designs, whether for Imperial Eggs or for more humble objects.

· · · · · · · ·

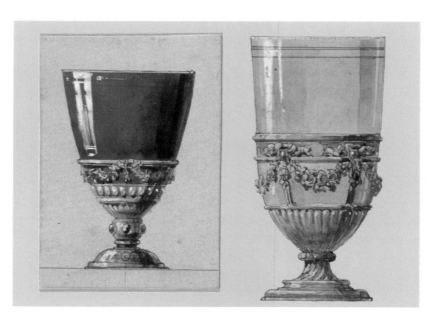

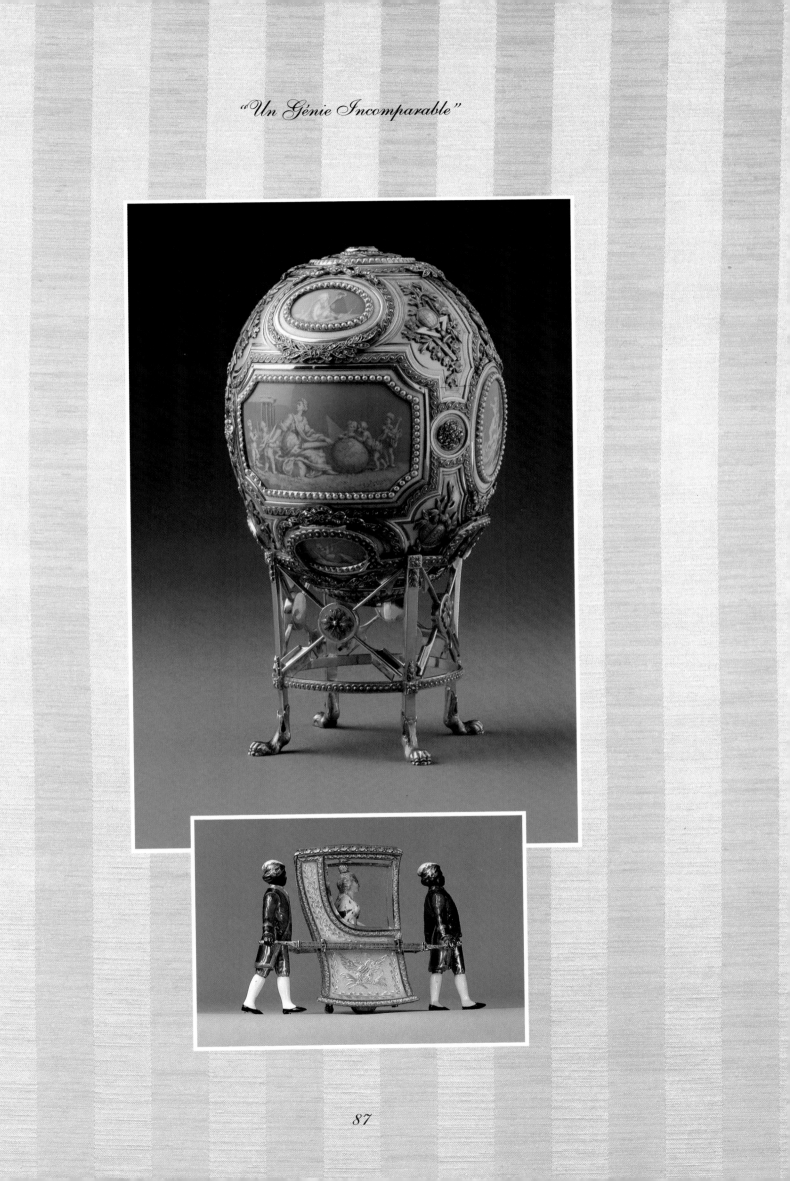

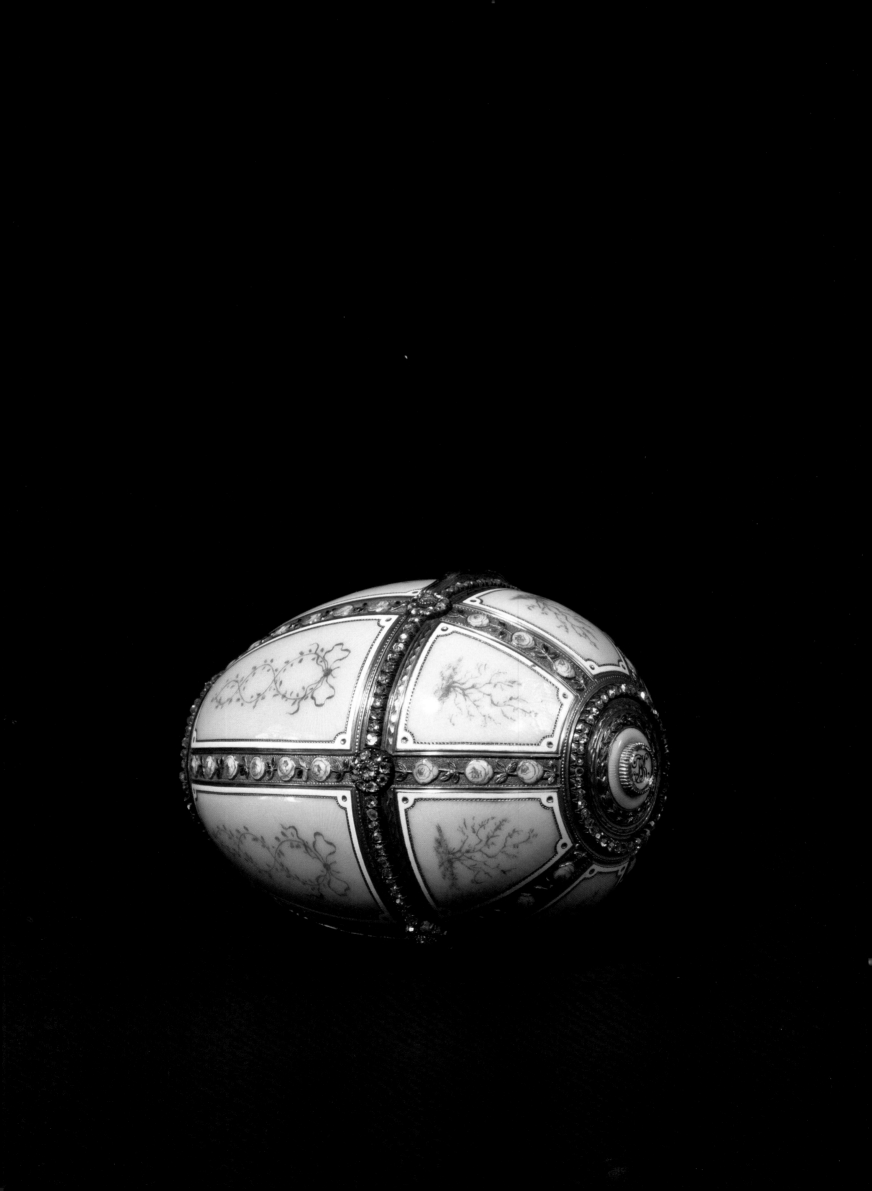

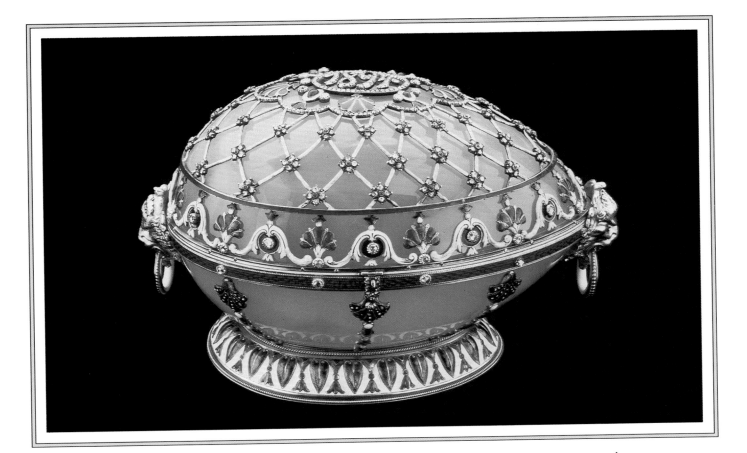

Left: the Easter Egg with Twelve Panels, workmaster Michael Perchin, was a gift to Barbara Kelch from her husband in 1899 (8.9cm/ 3½in). It is enamelled in pale translucent pink and has 12 panels, each with a violet painted motif. The dividing bands are of enamelled roses and leaves. Barbara Kelch's initials are under a diamond on the top.

.

Her enthusiasm, lively and infectious, had been expressed many times at these Easter ceremonies, for the 1914 presentation was the 29th year Fabergé had created a masterpiece for her. The workmaster for the Dowager Empress's Easter gift was Henrik Wigström and it is a superb example of his work, made of gold, decorated with eight grisaille panels and translucent pink, set within pearl borders and white enamel bands, with each panel depicting one of the Muses, painted by Vassily Zuiev. Known as the Grisaille or Catherine the Great egg, it is now in the Marjorie Merriweather Post Collection at Hillwood Museum, Washington, DC.

Eugene Fabergé has described how he travelled across Russia, from St Petersburg to Sebastopol, to deliver the 1912 Easter gift for the Empress Alexandra, being driven to the Tsar's palace at Livadia, with its magnificent views over the Black Sea, for an audience with Nicholas II, who expressed his satisfaction with the egg. Known as the Tsarevitch Egg, it contained the Russian double-headed eagle in diamonds framing a portrait of the Tsarevitch Alexis. The egg itself is carved from a solid block of lapis lazuli, elaborately decorated with gold motifs of flowers, cherubs and scrolls. It is now in the Lilian Thomas Pratt Collection, Virginia Museum of Fine Arts, Richmond.

Most of the early Imperial eggs are derivative, drawing on the styles of the past, much as the rest of Fabergé's early work had done. The inspiration for the first egg, the Hen Egg (or First Imperial Egg) of

Above: the Renaissance Egg, workmaster Michael Perchin, presented by Tsar Alexander III to his wife, the Empress Marie Feodorovna in 1894 (13.3cm/5¼in long). This sumptuous object is in grey agate, encased in a trelliswork of white enamel and rose-cut diamonds. The date is set in diamonds on a red guilloche emblem. Carved heads of lions with rings in their mouths act as handles. The inspiration for the piece is an almost identical work by Le Roy, dating from the early 18th century, which is in the Green Vaults at Dresden.

.

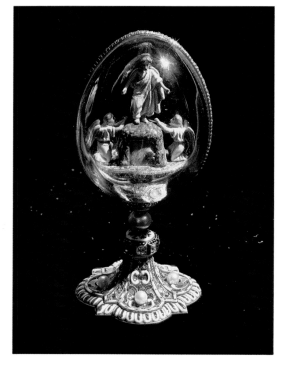

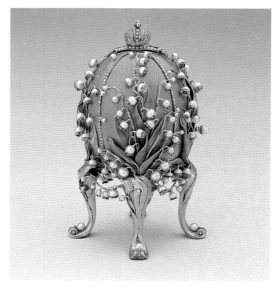

Top: The Resurrection Egg, workmaster Michael Perchin, presented by Alexander III to his wife (9.8cm/3⅞in). Bottom and right: The Lilies-of-the-Valley Egg, workmaster Michael Perchin, presented by Nicholas II to his mother in 1898 (15cm/5¹⁵/₁₆in open) Its surprise is three miniature portraits of the Tsar and the Grand Duchesses Olga and Tatiana.

.

1885, as has been mentioned, was clearly designs of the same kind, especially the gold egg in the Danish royal collection. The Renaissance Egg, dated 1894, is a sumptuous object in grey agate with white enamel bands set with quatrefoils of rose diamonds with ruby centres where the bands cross; on the top is a red guilloche enamel plaque on which the date 1894 is set in rose diamonds; around the sides are brilliant red, green and blue enamelled Renaissance motifs set with diamonds and *cabochon* rubies. The inspiration for this object was a jewelled casket made by the goldsmith Le Roy, which was in the Green Vaults Collection at Dresden and which would have been known to Fabergé from his student days there. Although it is virtually the same, it is not a perfect copy as the shape is slightly different, Fabergé's casket being more egg-shaped. This fact has led some scholars to suppose that Fabergé's inspiration came not from Le Roy's work itself but from a colour print of the original. Both works can be seen and compared — Fabergé's is in the Forbes Collection, New York, and Le Roy's is still in the Green Vaults Collection. The original surprise, probably a large jewel, has been lost, a fate which overtook many of the surprises of the Imperial eggs. The surprise from the Blue Enamel Ribbed Egg, dated 1887 or 1890, has also been lost. This beautifully enamelled work in royal-blue guilloche enamel is thought to have been inspired by four vodka cups in the form of Easter eggs in the Hermitage Museum.

The Resurrection Egg is evidently influenced by the Italian Renaissance and may well have been inspired by a particular piece. It is a fantastic creation: the base is richly enamelled in the Renaissance style, above it sits a large natural pearl and poised above that is a carved egg of rock crystal which contains a scene from the Resurrection. Although modern scholars are unsure of the date of the piece; it is thought now to be the second Imperial egg given by Alexander III to his wife. It is, incidentally, one of only two in the entire series of Fabergé's Imperial eggs to make any direct reference to the religious significance of Easter, which is a little surprising because Empress Alexandra Feodorovna was intensely, perhaps obsessively, religious. The Russian people of the period were also greatly influenced by the Orthodox church and there was a lively trade in eggs bearing the words *Kristos voskresy* (Christ is risen), some with hand-painted icons inside.

Many of the surprises have family associations: the Silver Anniversary Egg, probably from 1892, features the monograms of Alexander III and his wife in rose diamonds; the surprise of the Lilies of the Valley Egg of 1898 is three miniatures of Nicholas and the Grand Duchesses Olga and Tatiana; Alexander III is commemorated in the Imperial eggs of 1904; celebrated Romanov rulers in the Romanov Tercentenary Egg of 1913; the Mosaic Egg of 1914, the design of which is said to have been inspired by *petit-point* embroidery, has a surprise of a miniature frame with portraits of the five Imperial children. Some referred to Imperial residences: the Imperial egg of 1901 contained a replica, beautifully executed, of the Gatchina Palace, a favourite of the Dowager Empress; that of 1895 to the Dowager had a surprise of a screen of ten panels

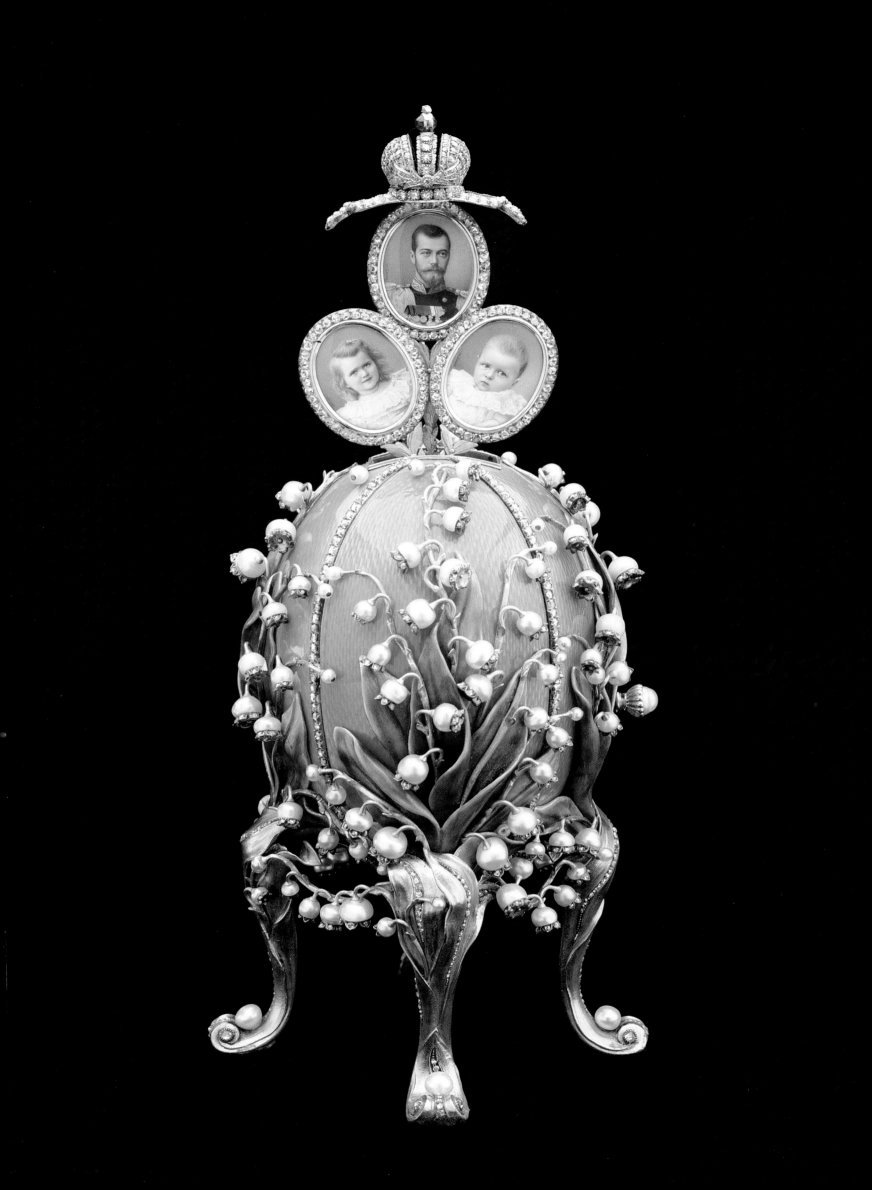

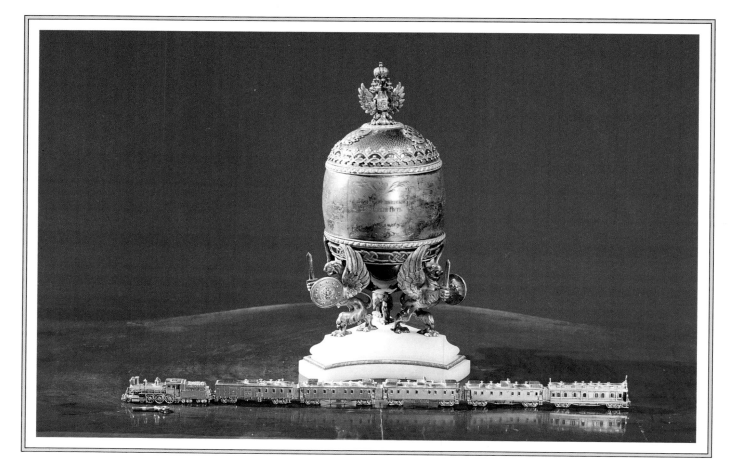

The Trans-Siberian Railway Egg, workmaster Michael Perchin, presented by Tsar Nicholas II to his wife, the Empress Alexandra Feodorovna in 1900 (27cm/10¾in). The silver band is engraved with a map of Russia showing the stations of the railway, which was inaugurated in 1900.

.

showing Danish and Russian palaces and the Imperial yachts. Some commemorate special events: the surprise of the Imperial egg of 1891 was the model of the cruiser *Pamiat Azova*, on which Nicholas II had made his world cruise when Tsarevitch; an equally accurate representation, faithful in every detail, is the surprise of the Imperial egg of 1900, the year the Trans-Siberian railway was inaugurated, which has a clockwork model of the Trans-Siberian express, exquisitely made with diamonds for the front lights and rubies for the rear lights.

The finest of the commemorative eggs — for some, the greatest achievement of Fabergé — is undoubtedly the Coronation Egg of 1897, which was presented by Nicholas II to Empress Alexandra the first Easter after the Coronation. It is probably the most famous of the Fabergé eggs, a sumptuous creation, rich in materials and style, a fitting memorial to the powerful Romanov dynasty. The workmaster was Perchin, the genius who became head workmaster at St Petersburg at the age of 26 and was responsible for the glittering series of Imperial eggs from then until his death in 1903. The colour scheme is based on the Coronation robes of Nicholas II: gold with panels of translucent primrose enamel over guilloche sun-ray patterns, it has a trelliswork of laurel bands with black enamel Imperial eagles, each set with a rose diamond, at the points where the laurel bands cross. On the top is the monogram of the Empress in rose diamonds and *cabochon* rubies. Exquisite as this is, it

Right: The Coronation Egg, workmaster Michael Perchin, presented by Tsar Nicholas II to his wife, the Empress Marie Feodorovna in 1897 (12.7cm/5in). This is probably the most stunning of all the Imperial eggs. The colour scheme is based on the Coronation robes of the Tsar — the shell is gold with panels of yellow enamel over guilloche sun-ray patterns. Bands of gold laurel-leaves, decorated with black enamel double-headed eagles, form a trelliswork.

.

Bottom right: The surprise of the Coronation coach in its nest of grey velvet. It is a perfect copy of the original and took 15 months to make.

.

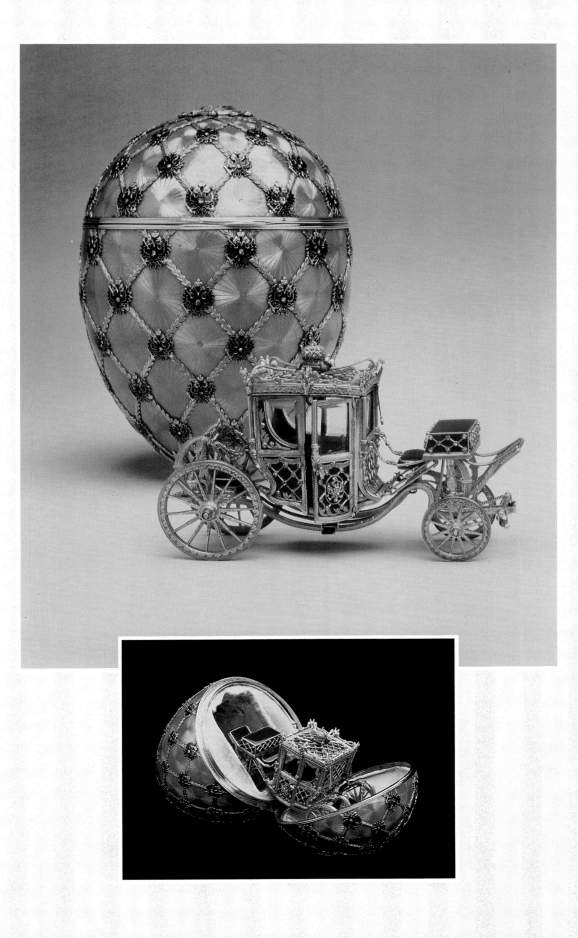

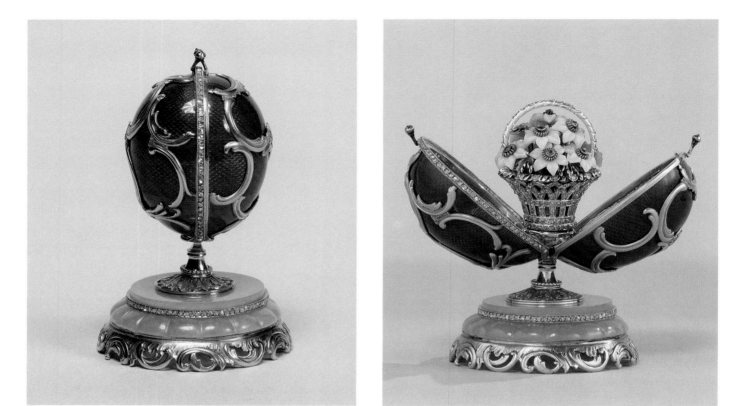

The Spring Flowers Egg, presented by Tsar Alexander III to his wife in 1890. The gold shell is enamelled translucent strawberry on a guilloche ground and is decorated with gold in the style of Louis XV. The surface is charming, a bouquet of wood anemones, with white chalcedony petals, garnet centres and green enamel leaves, in a basket of platinum set with rose-cut diamonds.

.

is followed by an enchanting surprise: a perfect miniature of the Coronation coach. The velvet upholstery of the original is reproduced in red enamel, the gilt wood frame in chased gold, the glass windows in rock crystal; the interior is enamelled with powder blue for the curtains and turquoise for the ceiling and above the coach is an Imperial crown in rose diamonds. It is a perfect copy in every way, even down to the steps, which are let down when the doors are opened. This degree of fidelity was achieved by taking extraordinary care and having great patience, as always with Fabergé's masterpieces. It was modelled by George Stein, a former coachmaker turned goldsmith, who spent 15 months on the task under the direction of Perchin and his then assistant, Wigström (Wigström's daughter remembered going with her father to the Imperial stables to check on the exact colours of the interior of the Coronation coach).

For some, the most pleasing of Fabergé's Imperial eggs are those which are not linked to people, places or events but which are truly objects of fantasy, having no point other than to give pleasure. The Spring Flowers Egg, possibly from 1890, is a delight: the gold shell is enamelled a deep strawberry red on a guilloche pattern and the whole shape is encased in rococo goldwork in the Louis XV style, opening to reveal a basket of spring flowers which have white chalcedony petals with garnets, engraved gold stems and petals in enamelled translucent green. The Clover Egg of 1902 continues the theme of nature, the inspiration of Art Nouveau: the shell of clover leaves is in green enamel, a deceptively simple, stunning design.

Right: The Colonnade Egg, workmaster Henrik Wigström, presented by Nicholas II to his wife, the Empress Alexandra Feodorovna in 1905. This is a romantic creation, a temple of love in bowenite surmounted by a silver-gilt cupid with four silver-gilt cherubs at the base. The clock dial below the silver cupid is set with rose diamonds.

.

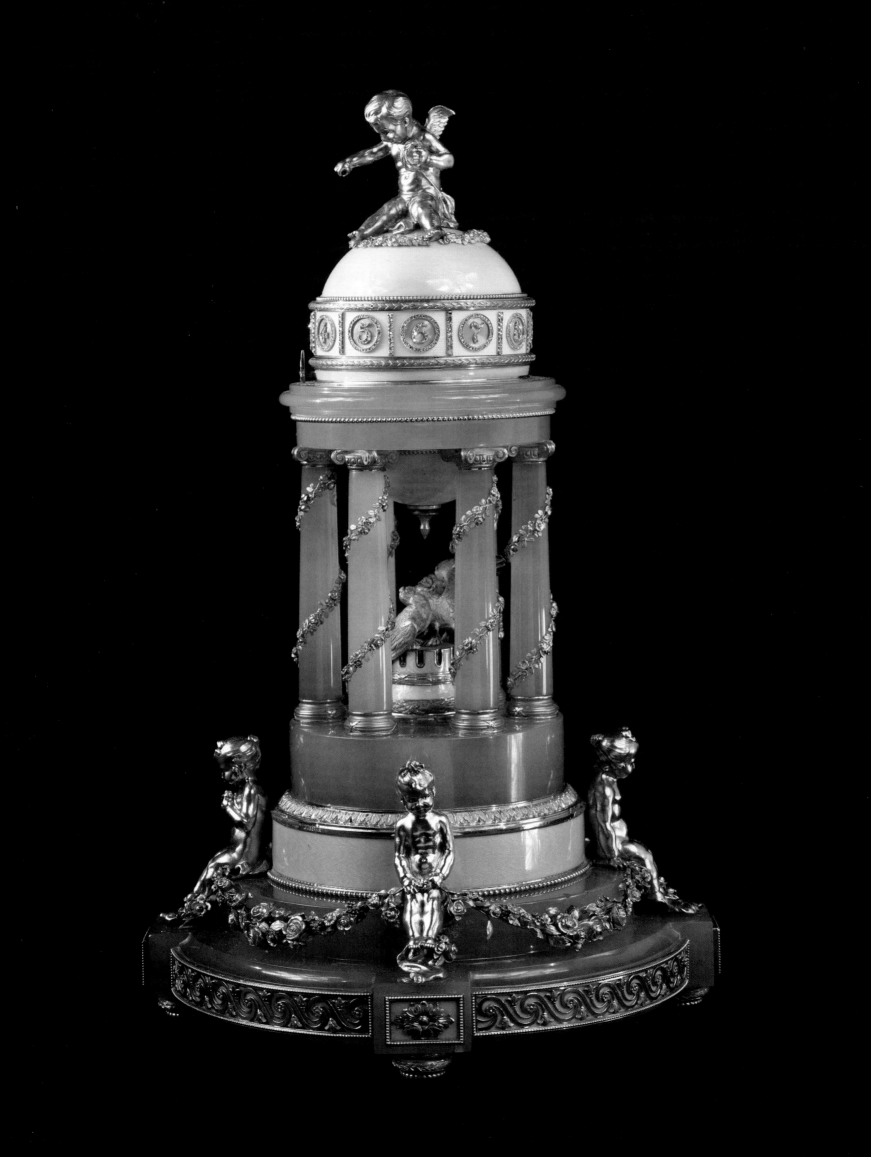

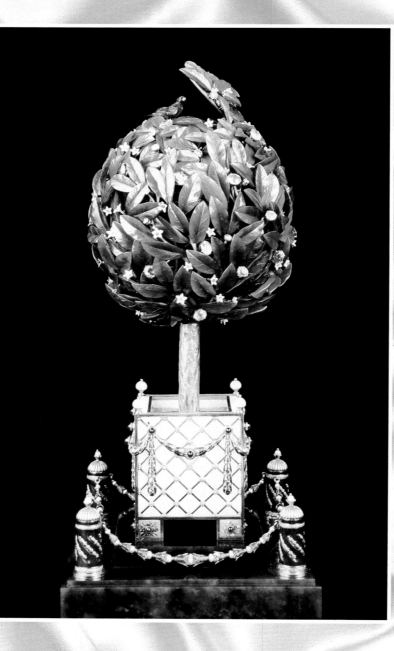

*T*he Orange Tree Egg, signed Fabergé, presented by
Tsar Nicholas II to his mother, the Dowager Empress, in
1911 (26.6cm/10½in). The leaves are of nephrite, the
flowers of white enamelled gold with diamonds at the
centre and the oranges made of precious stones such as
amethysts and pale sapphires. When one of the oranges is
turned, the leaves rise at the top of the tree, a nightingale
appears, sings and disappears again.

A quite different note is struck in the Colonnade Clock Egg, probably from 1905, which is said to have been designed by Alexandre Benois. It is a deeply romantic piece surmounted by a silver-gilt Cupid on a dome of opalescent pink enamel around which is a series of numbers in rose diamonds. The principal material used for the colonnade is pale-green bowenite, which is beautifully worked in the base and the six columns which are the principal part of the design; the whole object is richly embellished with silver-gilt cherubs and floral swags in different colours of gold. This was truly a temple of love.

A return to the theme of nature is seen in the Rose Trellis Egg, dated 1907, which is a superb piece made of gold in pale-green, translucent enamel, decorated with enamel roses in light- and dark-pink enamel and translucent green leaves. The Orange Tree Egg, dated 1911, may have been inspired by nature, although in the catalogue of the Munich exhibition of 1986–7 Geza von Habsburg suggests it may have been an interpretation of an orange tree with a mechanical device made by Richard in Paris in the middle of the 18th century. Knowing Fabergé's sympathies, this would not be surprising. True or not, the fact is that Fabergé's creation is not a copy but a highly original work of art. The miniature orange tree has gold branches with beautifully carved nephrite leaves, white enamelled gold blossoms with diamonds at the centre, and oranges made of precious stones such as amethysts, champagne diamonds and pale sapphires. The tree is in a white tub of chalcedony decorated by gold trelliswork with green swags of laurel studded with *cabochon* rubies. The whole piece stands on a base of nephrite, with four nephrite posts connected by a chain of gold leaves, enamelled green, and linked with pearls. Magnificent as it is, the pleasure of the piece is heightened by the surprise, which is started by turning one of the oranges. This makes the leaves at the top of the tree rise, revealing a miniature nightingale, which obligingly bursts into song before automatically disappearing. It is a work of such splendour that it is easy to understand how Dr Everett Fahy of the Frick Collection in New York was prompted, when writing about it, to remember the lines of Yeats in his poem 'Sailing to Byzantium', which was inspired by the poet's memory of "the Emperor's palace at Byzantium . . . a tree made of gold and silver and artificial birds that sang".

Mechanical surprises were featured in a number of the Fabergé Imperial eggs and it is possible that Fabergé's interest in mechanical toys was kindled by his old mentor, Peter Hiskias Pendin, who had acted as friend and adviser when the young Fabergé took over his father's business in 1870. Pendin had been trained as an optician, a not uncommon background for makers of automata, as Kenneth Snowman has pointed out; a number of gifted Swiss craftsmen of the 19th century had originally been opticians.

The Cuckoo Clock Egg of 1900, a richly ornate creation in the Baroque style, had a bird surprise. When a button is pressed at the back of the clock, a gold grille on the top rises and the bird – not a cuckoo but a cockerel, as it happens – appears, resplendent in natural

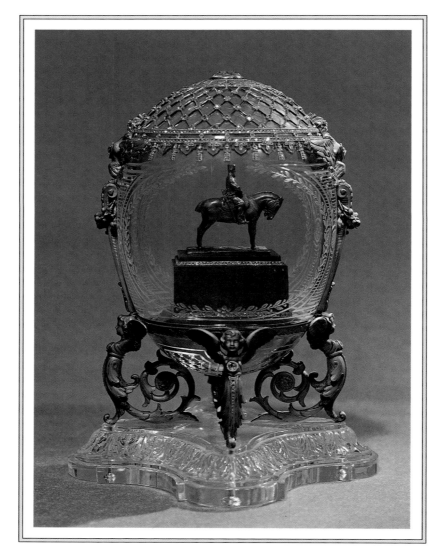

*T*he Alexander III
Equestrian Egg, signed
Fabergé, presented by
Tsar Nicholas II to his
mother, the Dowager
Empress in 1910
(15.5cm/6⅛in). The shell
is made of rock crystal
mounted on platinum and
inside is a gold statue of
Alexander III on
horseback.

.

feathers, gold legs and *cabochon* ruby eyes. The beak and wings move
as the bird crows and then descends into the clock.

The Swan Egg, dated 1906, is quite amazing. The exterior of the
gold egg is enamelled mauve, with a trellis of rose diamonds, and
inside there is a breathtaking surprise: a miniature lake of aquamarine
upon which rests a platinum swan. The mechanism is concealed under
one wing: when activated, it makes the bird move, gliding forward,
lifting its webbed feet, arching its neck and opening its wings to display
the feathers.

The Peacock Egg, dated 1908, also has a sophisticated mechanical
surprise: a superb gold and enamelled peacock, which can be seen
inside a rock-crystal egg within the branches of a gold tree, which has
flowers of precious stones. The peacock can be taken from its perch
and wound up to strut in authentic fashion, moving its head and proudly
displaying its magnificent tail in various colours of enamel. The bird is
said to have been a copy of a peacock automaton by James Cox in the
Hermitage Museum. Such sophisticated mechanisms took considerable

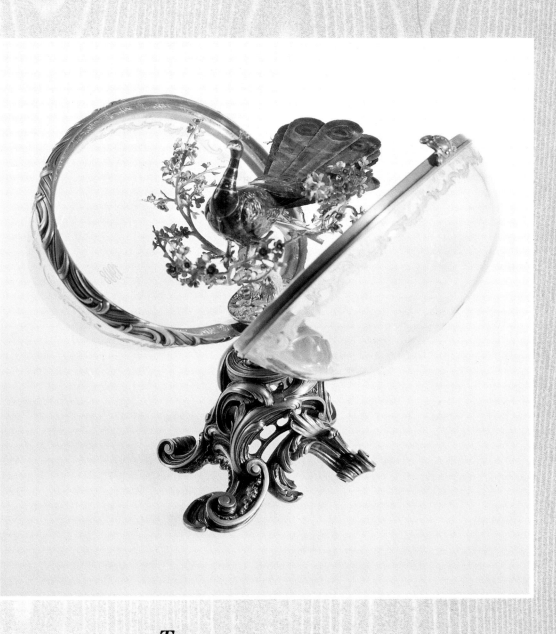

*T*he Peacock Egg, workmaster Henrik Wigström,
presented by Tsar Nicholas II to his mother, the Dowager
Empress, in 1908 (15.2cm/6in). Inside the rock crystal
egg is a gold and enamelled peacock which can be taken
out and wound up so it struts to and fro, moving its head
and displaying its splendid tail. It is said that it took the
workmaster responsible for the mechanical model three
years to complete, beginning with a life-sized model and
gradually reducing it to the required miniature scale.

.

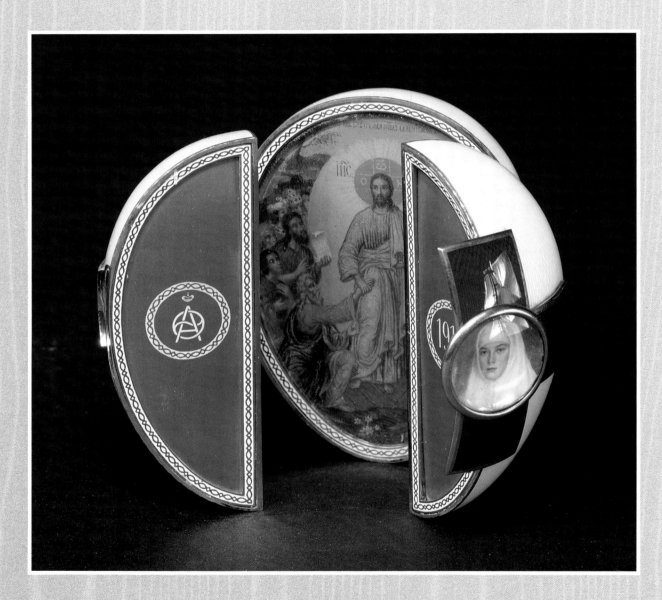

*T*he Red Cross Egg with Resurrection Triptych,
*workmaster Henrik Wigström, presented by Tsar Nicholas
II to his wife, the Empress Marie, in 1915 (8.5cm/3⅜in).
The shell is of white transparent enamel with crosses in
red enamel. In the centre of the crosses at the front and
back are miniatures of two of the Tsar's children, the
Grand Duchesses Olga and Tatiana. The egg opens to
reveal a triptych.*

.

time to make and refine: the Peacock Egg took workmaster Dorofeiiev three years to complete, beginning with a life-sized model and gradually reducing it to the necessary miniature scale.

The bold flights of imagination and the lavish use of materials ended with the arrival of the war in 1914. Such exotic objects, inspired by the desire to give pleasure regardless of cost, fantastic indulgences, had no place in a country suffering terrible losses in war. The two eggs of 1915 have a more sombre style. The one presented to the Empress Alexandra by Nicholas II is in white enamel with a large red enamel cross on each side; on each cross is a miniature portrait of the Grand Duchesses Tatiana and Olga in Red Cross uniform and the egg contains a triptych painting of the Resurrection of Christ. The one presented to the Dowager Empress is also in white enamel, decorated with the symbol of the Red Cross. It has an inscription in red enamel which reads "Greater love hath no man than this, that a man lay down his life for his friends". Inside is a screen of five miniature portraits on mother-of-pearl by Zuiev of members of the Imperial family, all in Red Cross uniform. These two objects are worlds away from the flamboyant days that had gone before and have a seriousness appropriate to the time, reflecting two of the deep interests of Empress Alexandra Feodorovna: the Church and the Red Cross.

The monogram of the Empress Alexandra Feodorovna.

.

It has to be said that solemnity and seriousness are not ideal conditions for the creation of an *objet de fantasie*. The Steel Military Egg of 1916 is a depressing object, made of steel in recognition of the war effort, standing on four miniature shells on a nephrite base. Inside the egg is a small easel supporting a gold frame which had a miniature painting by Zuiev of Nicholas and his son with the generals at the Front. The two final Imperial eggs, said to have been made of Karelian birch and lapis lazuli respectively, are lost and may never have been delivered as the Tsar's family moved towards their tragic and violent end.

Although the eggs are Fabergé's greatest achievement for the Imperial family, he did also provide beautiful examples for a few favoured patrons. One of these was the fabulously rich Siberian gold magnate Alexander Kelch, who commissioned seven eggs for his wife, Barbara, between 1898 and 1904. The first of these was a more elaborate version of the first Imperial egg of 1885. The exterior makes no pretence to any kinship with the humble hen egg: it is enamelled deep red on a guilloche pattern and is circled with rose diamonds. The egg opens to show enamelled yellow gold, which contains a surprise of a gold hen in various colours of enamel; inside that is a further surprise of a tiny easel which folds inside the hen. The portrait now is of the Tsarevitch Alexis, but the original was of Barbara Kelch. The substitution is thought to have been made during the 1920s, while the egg was in France. The Chanticleer Egg, once thought to have been the Easter gift of Nicholas II to his mother, is now identified by scholars as a Kelch egg. It is a magnificent work, a larger and slightly different version of the Cuckoo Egg of 1900. The egg and the panels in the base are enamelled a marvellous deep blue on a guilloche ground; seed pearls

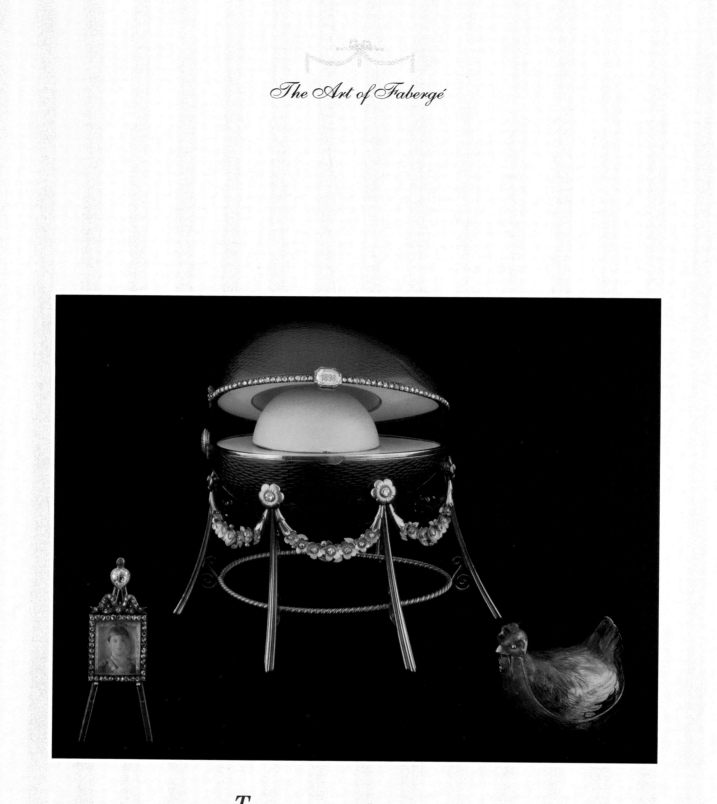

*T*he Hen Egg, workmaster Michael Perchin, made for
Mrs Barbara Kelch in 1898. It is a copy of the First
Imperial Egg but on a much more lavish scale. The shell
is gold, enamelled a deep strawberry red. There are a
number of surprises: a hen in a nest of suede, which in
turn contains a tiny easel with a miniature of the
Tsarevitch Alexis.

.

and gold leaves encircle the egg and there are gold swags hanging from a gold grille at the top which conceals the surprise.

The surprise, activated by a clockwork mechanism, is a splendid golden cockerel enamelled in natural colours, its feathers set in diamonds, rising from the interior on the hour to crow, head bobbing, beak opening and wings flapping. The white enamelled clock face has blue numerals and the hands are of gold. The whole thing is somewhat more restrained than the earlier Imperial egg of 1900: Louis XVI rather than Louis XV.

The Pine Cone Egg, dated 1900, is a simple, beautifully crafted object: it is made up of crescents of rose-cut diamonds on an enamelled royal blue ground, with the date set in diamonds at one end. The surprise is a tiny elephant with ivory tusks carrying a mahout in enamelled colours seated upon a red and green guilloche enamel saddlecloth fringed with gold. When wound with the original gold key, the animal moves forward, lowering its head and swishing its tail. Because the elephant is seen in the armorial bearings of the Danish Royal Family, it was thought that the egg must have been presented to Marie Feodorovna, because she was Danish.

The Apple Blossom Egg, probably from 1901, has the same natural theme, with the shell made of nephrite, the feet of the base forming branches which spread over the egg, the branches in green and red gold with buds and fruit of pink diamonds in enamel. The design is regarded as less successful than that of the Pine Cone Egg, certainly by Geza von Habsburg, who dismisses it as resembling "the products of a chocolate factory".

Confusion about the provenance of some of the Kelch eggs arose because the monogram of the owner, BK, had been removed and replaced with a miniature (supposedly of the Empress Alexandra Feodorovna), which led to incorrect connections with the Imperial family being made. One possible way of establishing the provenance of dubious eggs is to see if any similarity exists between them and other Imperial eggs. If it does, the egg in question is less likely to be authentic, because Fabergé made it a cardinal rule that there should be no repetition in his work for the Tsar. It does appear, however, that he was prepared to create versions of the Imperial eggs for patrons who were not of the Imperial family: the Kelch Hen Egg and the Chanticleer Egg are variations on previous designs.

The Kelch eggs disappeared after the Revolution but reappeared in Paris when they were acquired by La Vieille Russie. They were identified in the 1920s by Alexander Fabergé as having been made for the Siberian gold millionaire and were later dispersed in the United States, where some were given an Imperial provenance, probably to increase their value; not only is greater glamour attached to objects made for the Imperial family but the Imperial eggs are considered to be superior to any work done for other patrons.

At the same time as he identified the Kelch eggs, Alexander Fabergé identified the Nobel Ice Egg, made for Emanuel Nobel. This egg has frost patterns engraved on the shell and contains a pendant watch on a

A photograph of the Tsarevitch is now in the frame, but it is thought that a miniature of Barbara Kelch was the original occupant.

. .

The hen is beautifully enamelled in naturalistic colours.

. .

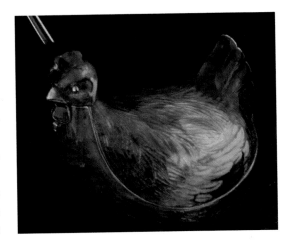

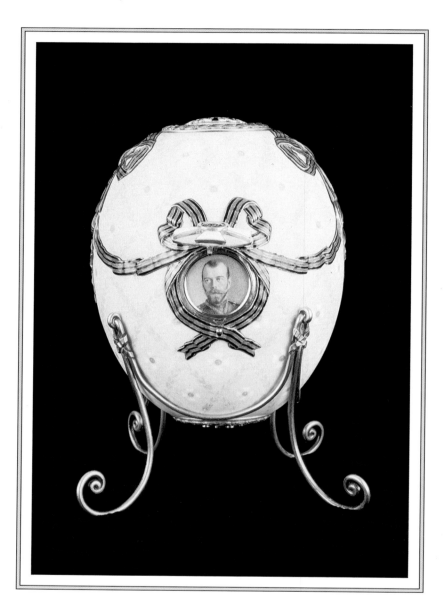

Above: The Cross of St George Egg, signed Fabergé, presented by Nicholas II to his mother, the Dowager Empress, in 1916 (8.4cm/3⅜in). In recognition of the need for economy because of the war, the shell is made of silver enamelled opalescent white. The crosses of the Order of St George spring up when a button is pressed, revealing miniatures of Nicholas II (as above) and of his son, Alexis.

.

Right: The Chanticleer Egg, workmaster Michael Perchin, presented to Barbara Kelch, probably in 1904. The shell and the four panels of the base are enamelled brilliant sapphire blue on a guilloche ground. Gold swags hang from the grille at the top from which a colourful cockerel emerges to crow the hour.

.

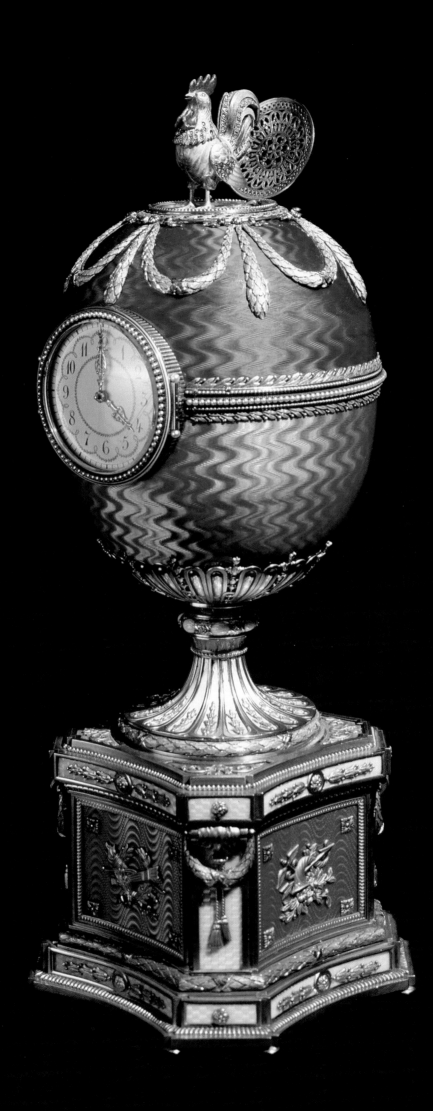

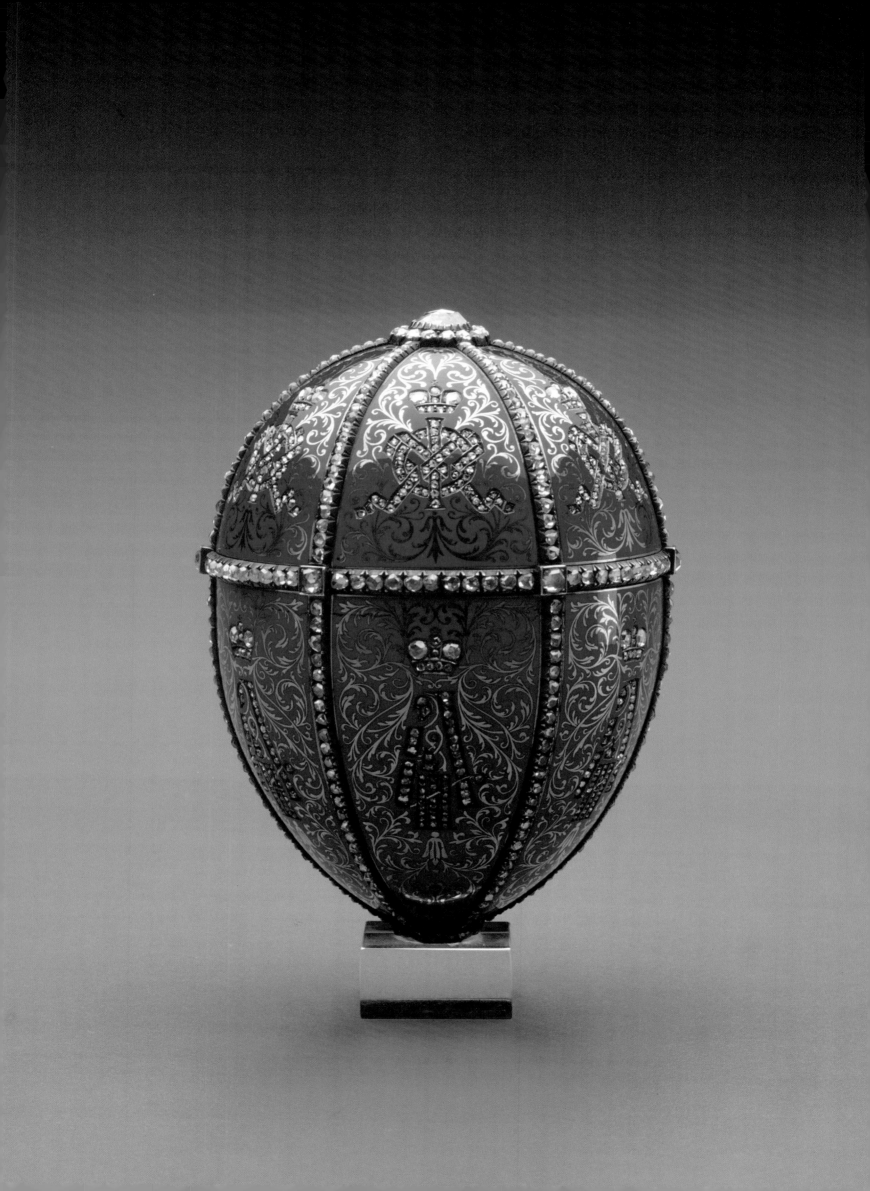

rock crystal cushion set with ice motifs in diamonds. The wintry theme echoes that of the Winter Egg of 1913, presented to the Dowager Empress Marie by Nicholas II, a stunning creation made from a block of rock crystals which contains a basket of snowdrops made of nephrite, olivine and gold. It was designed in the Holmström workshops by the talented Alma Teresia Pihl.

Another variation of an Imperial egg is the Duchess of Marlborough Egg of 1902, which was commissioned by the Duchess from Fabergé's St Petersburg branch when she and her husband visited Russia in 1902. The Duchess, formerly Consuelo Vanderbilt, of the enormously wealthy railway family, had been steered by her mother into a marriage with the aristocratic Duke of Marlborough. While in Russia, the couple were received by the Dowager Empress and may well have seen the Serpent Clock, which had been the Easter gift of Alexander III to his wife, probably in 1889, and which must have been the inspiration of the Duchess of Marlborough's egg as it is almost identical. The principal differences are that it is enamelled pink rather than blue and is slightly larger. Encircling the egg is a white enamel band which is set with diamond numerals. A diamond serpent coiled around the base reaches up to the band, its golden tongue ticking off the hours. In the style of Louis XVI, it is decorated with roses in four-colour gold and surmounted by a diamond-studded pineapple. The panels of the base, in translucent white enamel, carry motifs of Science and War and the Duchess's monogram in rose diamonds.

Also in the Louis XVI style is the egg commissioned by Prince Felix Youssoupov in 1907 for his wife, Zenaide, on the occasion of their 25th wedding anniversary. This, too, is an elaborate clock, with a white enamel band set with Roman numerals in diamonds, and in this version the diamond-studded serpent looks down from the dome of the egg. It is in gold and raspberry enamel, richly embellished with laurel swags linking three medallions, which now contain the gold letters M, Y and S – the initials of the collector Maurice Y. Sandoz – but which originally held miniatures of the Prince and his two sons, Nicholas and Felix.

The Imperial eggs are a truly remarkable achievement and it is difficult to imagine anyone making them in today's conditions, which may explain why the modern world is so fascinated by them. For more than 30 years Fabergé had the annual challenge of creating some new delight, unhindered by considerations of cost, free to draw on any source, use any material, every skill, expend as many hours as necessary, to produce something the only purpose of which was to bring pleasure, creating a moment of delighted surprise on an Easter morning.

It should be remembered, too, that these objects, which required so much effort to create and which loom so large in the imagination, were often miniatures. The first Imperial egg of 1885 is only 6.3cm (2½in) wide; the Coronation Egg of 1897, with its surprise of a fabulous coach, is a mere 12.7cm (5in) high; and even the more lavish eggs which came later rarely exceeded 25cm (10in) – the largest by quite a margin is the Uspensky Cathedral Egg of 1904 – 35cm (14in) high.

Left: The Twelve-Monogram Egg, workmaster Michael Perchin, presented by Tsar Alexander III to his wife, the Empress Marie Feodorovna, probably in 1892. Made of gold, it has six guilloche panels in which the monograms of the Tsar and his wife, MF and A III, are set in rose-cut diamonds with a large diamond above and below. It is believed the piece marked their Silver Wedding Anniversary in 1892.

Catalogue of Fabergé Eggs

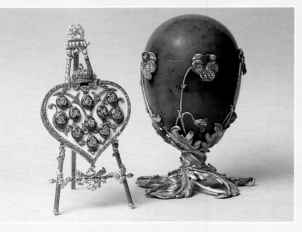

Presented by Alexander III to his wife, the Empress Marie Feodorovna

**THE HEN EGG
(FIRST IMPERIAL EGG)**
Probable date 1885, unmarked.
Present location: Forbes Col-
lection, New York.

BLUE ENAMEL RIBBED EGG
Possible date 1887 or 1890,
workmaster M. Perchin. Pres-
ent location: Stavros Niarchos
Collection, Paris.

**DANISH SILVER JUBILEE
EGG**
1888 (unmarked). Present
location: unknown.

THE SERPENT CLOCK EGG
Possible date 1889, workmaster
M. Perchin. Present location:
private collection, Switzerland.

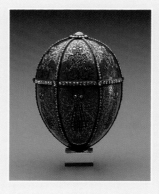

**THE TWELVE-MONOGRAM
EGG**
Probable date 1892, work-
master M. Perchin. Present
location: Marjorie Merriweather
Post Collection, Hillwood
Museum, Washington, DC.

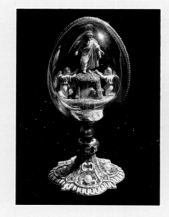

THE RESURRECTION EGG
Probable date 1886, work-
master M. Perchin. Present
location: Forbes Collection,
New York.

THE *PAMIAT AZOVA* EGG
Dated 1891, workmaster M.
Perchin. Present location:
Armoury Museum, Moscow.

**THE DIAMOND TRELLIS
EGG**
Probably 1892, workmaster A.
Holmström. Present location:
Private collection, England.

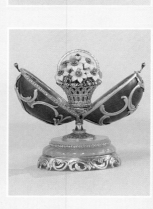

THE SPRING FLOWERS EGG
Possible date 1890, workmaster
M. Perchin. Present location:
Forbes Collection, New York.

THE CAUCASUS EGG
Dated 1893, workmaster M.
Perchin. Present location:
Matilda Geddings Gray Found-
ation Collection, New Orleans.

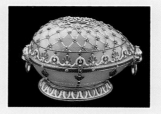

THE RENAISSANCE EGG
Dated 1894, workmaster M.
Perchin. Present location:
Forbes Collection, New York.

Presented by Nicholas II to his mother, the Empress Marie Feodorovna

THE DANISH PALACE EGG
Dated 1895, workmaster M. Perchin. Present location: Matilda Geddings Gray Foundation Collection, New Orleans.

THE PELICAN EGG
Dated 1897, workmaster M. Perchin. Present location: Lilian Thomas Pratt Collection, Virginia Museum of Fine Arts, Richmond.

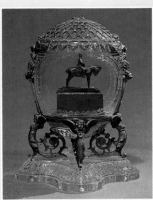

THE CUCKOO CLOCK EGG
Dated 1900, workmaster M. Perchin. Present location: Forbes Collection, New York.

THE GATCHINA PALACE EGG
Dated 1901, workmaster M. Perchin. Present location: Walters Art Gallery, Baltimore.

ALEXANDER III COMMEMORATE EGG
1904 (unmarked). Present location: unknown.

THE LOVE TROPHY EGG
Probable date 1905. Workmaster H. Wigström. Present location: Private collection, U.S.A.

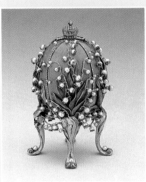

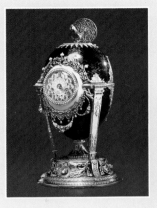

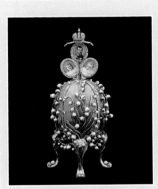

THE LILIES OF THE VALLEY EGG
Dated 1898, workmaster M. Perchin. Present location: Forbes Collection, New York.

THE PANSY EGG
Dated 1899, workmaster M. Perchin. Present location: Private collection, USA.

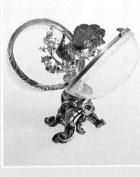

THE PEACOCK EGG
Dated 1908, workmaster H. Wigström. Present location: Maurice Sandoz Collection, Le Locle, Switzerland.

THE DANISH JUBILEE EGG
Probable date 1906 (unmarked). Present location: Unknown.

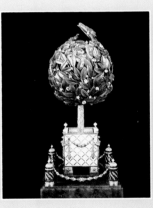

THE ALEXANDER III EQUESTRIAN EGG
Dated 1910, signed Fabergé. Present location: Armoury Museum, Moscow.

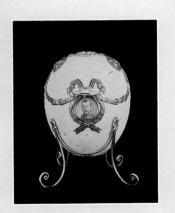

THE ORANGE TREE EGG
Dated 1911, signed Fabergé. Present location: Forbes Collection, New York.

THE NAPOLEONIC EGG
Dated 1912, workmaster H. Wigström. Present location: Matilda Geddings Gray Foundation Collection, New Orleans.

THE WINTER EGG
Dated 1913 (unmarked). Present location: unknown.

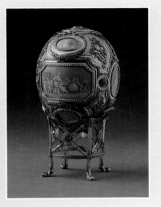

THE GRISAILLE EGG
Dated 1914, workmaster H. Wigström. Present location: Marjorie Merriweather Post Collection, Hillwood Museum, Washington, DC.

THE RED CROSS EGG WITH PORTRAITS
Dated 1915, workmaster H. Wigström. Present location: Lilian Thomas Pratt Collection, Virginia Museum of Fine Arts, Richmond.

THE CROSS OF ST GEORGE EGG
Dated 1916, signed Fabergé. Present location: Forbes Collection, New York.

Presented by Nicholas II to his wife, the Empress Alexandra Feodorovna

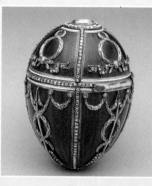

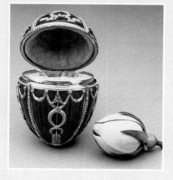

THE MADONNA LILY EGG
Dated 1899, workmaster M. Perchin. Present location: Armoury Museum, Moscow.

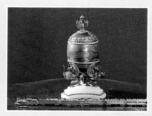

THE TRANS-SIBERIAN EGG
Dated 1900, workmaster M. Perchin. Present location: Armoury Museum, Moscow.

THE CLOVER EGG
Dated 1902, workmaster M. Perchin. Present location: Armoury Museum, Moscow.

THE ROSEBUD EGG
Dated 1895, workmaster M. Perchin. Present location: Forbes Collection, New York.

THE EGG WITH REVOLVING MINIATURES
Probable date 1896, workmaster M. Perchin. Present location: Lilian Thomas Pratt Collection, Virginia Museum of Fine Arts, Richmond

THE PETER THE GREAT EGG
Dated 1903, workmaster M. Perchin. Present location: Lilian Thomas Pratt Collection, Virginia Museum of Fine Arts, Richmond.

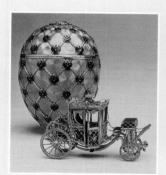

THE CORONATION EGG
Dated 1897, workmaster M. Perchin. Present location: Forbes Collection, New York.

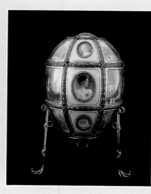

THE COLONNADE CLOCK EGG
Probable date 1905, workmaster H. Wigström. Present location: English Royal Collection.

THE USPENSKY CATHEDRAL EGG
Dated 1904, signed Fabergé. Present location: Armoury Museum, Moscow.

THE SWAN EGG
Dated 1906 (unmarked). Present location: Maurice Sandoz Collection, Le Locle, Switzerland.

THE ROSE TRELLIS EGG
Dated 1907 (unmarked). Present location: Walters Art Gallery, Baltimore.

THE ALEXANDER PALACE EGG
Dated 1908, workmaster H. Wigström. Present location: Armoury Museum, Moscow.

THE STANDART EGG
Probable date 1909, workmaster H. Wigström. Present location: Armoury Museum, Moscow.

THE LOVE TROPHY EGG
Probable date 1910 (unmarked). Present location: Private collection, USA.

THE FIFTEENTH ANNIVERSARY EGG
Dated 1911, workmaster H. Wigström. Present location: Forbes Collection, New York.

THE TSAREVITCH EGG
Dated 1912, workmaster H. Wigström. Present location: Lilian Thomas Pratt Collection, Virginia Museum of Fine Arts, Richmond.

THE ROMANOV TERCENTENARY EGG
Dated 1913, workmaster H. Wigström. Present location: Armoury Museum, Moscow.

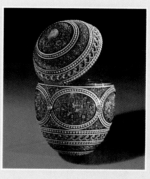

THE MOSAIC EGG
Dated 1914, signed Fabergé. Present location: English Royal Collection.

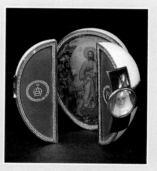

THE RED CROSS EGG WITH RESURRECTION TRIPTYCH
Dated 1915, workmaster H. Wigström. Present location: India Early Minshall Collection, The Cleveland Museum of Art, Cleveland.

THE STEEL MILITARY EGG
Dated 1916, workmaster H. Wigström. Present location: Armoury Museum, Moscow.

The Kelch Eggs

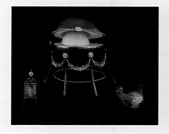

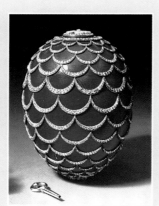

THE APPLE BLOSSOM EGG
Probable date 1901, workmaster M. Perchin. Present location: Private collection, USA.

THE ROCAILLE EGG
Dated 1902, workmaster M. Perchin. Present location: Private collection, USA.

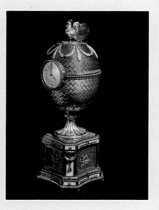

THE HEN EGG
Dated 1898, workmaster M. Perchin. Present location: Forbes Collection, New York.

THE TWELVE-PANEL EGG
Dated 1899, workmaster M. Perchin. Present location: English Royal Collection.

THE PINE CONE EGG
Dated 1900, workmaster M. Perchin. Present location: Private collection, USA.

THE BONBONNIÈRE EGG
Dated 1903, workmaster M. Perchin. Present location: Private collection, USA.

THE CHANTICLEER EGG
Probable date 1904, workmaster M. Perchin. Present location: Forbes Collection, New York.

Other Eggs

THE HEN EGG FROM THE QUISLING COLLECTION
1899–1903, workmaster M. Perchin. Present location: Unknown.

NICHOLAS II EQUESTRIAN EGG
1913, workmaster Victor Aarne. Given by Empress Alexandra Feodorovna to Nicholas II.

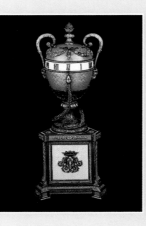

THE YOUSSOUPOV EASTER EGG
Dated 1907, workmaster H. Wigström. Present location: Maurice Sandoz Collection, Le Locle, Switzerland.

THE NOBEL ICE EGG
1914–16 (unmarked). Present location: Unknown.

THE DUCHESS OF MARLBOROUGH EGG
Dated 1902, workmaster M. Perchin. Present location: Forbes Collection, New York.

THE HOOF EGG
Undated, workmaster M. Perchin. Present location: Forbes Collection, New York.

The Style Fabergé

The flower studies are among the most charming works created by the House of Fabergé, their simple naturalism revealing a different expression of Fabergé's art. Yet this simplicity is achieved by the qualities to be seen in the whole of the craftsman's œuvre: discriminating choice of materials, the highest possible standards of workmanship, a devotion to every detail and an unerring feeling for that mysterious ingredient, style.

Ripe and unripe raspberries carved from rhodonite and jade with leaves of nephrite (15cm/6in).

.

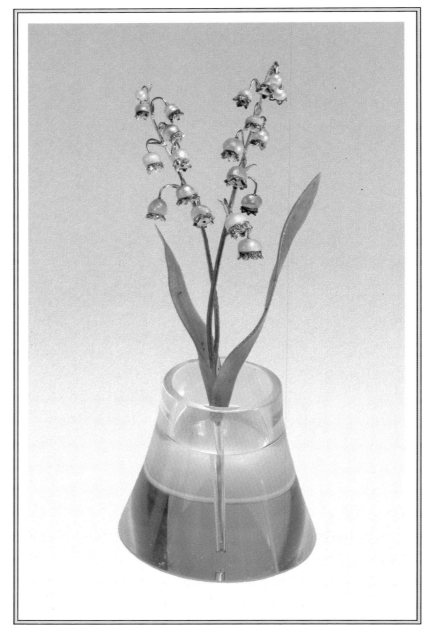

A lily of the valley, with flowers of pearl and rose diamonds, leaves of carved nephrite and a gold stem.

.

For many people Fabergé's greatest achievement as a goldsmith and jeweller was not the fabulous Imperial Easter eggs but the artificial flowers, which are so different from the Imperial creations. Where the eggs are the result of flights of imagination and technical ingenuity, the flowers are simple studies from nature, executed in precious materials.

Flowers in spring have a special significance in Russia, with its long, bitter, seemingly endless winters. In the heyday of the Romanovs, flowers were brought in by train to St Petersburg from abroad to adorn the Imperial palaces. In 1922 Lili Dehn, who had been a great favourite of Empress Alexandra, recalled from her home in England (where she and her Swedish husband had escaped to after the Revolution): "In springtime

and winter the air was fragrant with masses of lilac and lilies of the valley, which were sent daily from the Riviera."

The Empress was particularly fond of lilies, magnolias, wistaria, rhododendrons and violets, and of these lilies of the valley were her special favourites. It was therefore appropriate that the first flower study known to have been created by Fabergé should have been a basket of lilies of the valley presented to the Empress in 1896 at her Coronation. The nine sprays of lilies have engraved green-gold stalks and carved nephrite leaves, with flowers of pearl and rose diamond. The basket is of yellow gold and under it is written, "To Her Imperial Majesty, Tsarina Alexandra Feodorovna, from the Ironworks management and dealers in the Siberian iron section of the Nijekorodoski Fair".

Although they are painstakingly accurate in most cases, Fabergé's flowers are not simply botanical specimens in precious materials. Some-

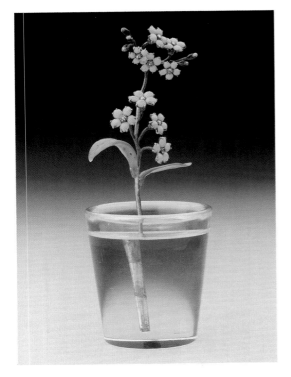

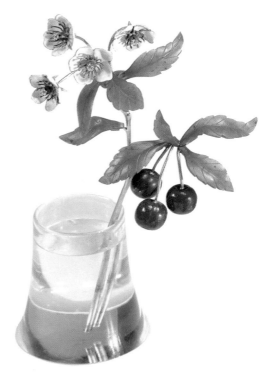

Left: A forget-me-not spray, with flowers of blue enamel and rose-cut diamonds, standing in a rock crystal vase which appears to contain water but is cut from a block of crystal in a trompe-l'œil *technique.*

.

Right: Cherries in carved purpurine, the blossoms enamelled opaque white with diamond centres.

.

times the rules of nature are ignored: a cornflower may grow from the same stem as a buttercup and a sprig of wild cherry may display both blossom and fruit. In these cases, Fabergé was attempting to express the essence of the plants, and once again his choice of materials depended on their suitability for his purpose rather than their intrinsic value. Sacheverell Sitwell mused on the flower studies in these words:

"Fabergé's sprays of flowers are beautiful in themselves and remarkable in that they raise the problem in aesthetics as to how, and why, a spray of gypsophila, of all plants, standing in a little jade jar, should be the complete expression of a particular period, even a decade in time. The sprays of flowers are lifelike and naturalistic in style, though done under the Chinese influence, yet they contrive to be entirely Russian."

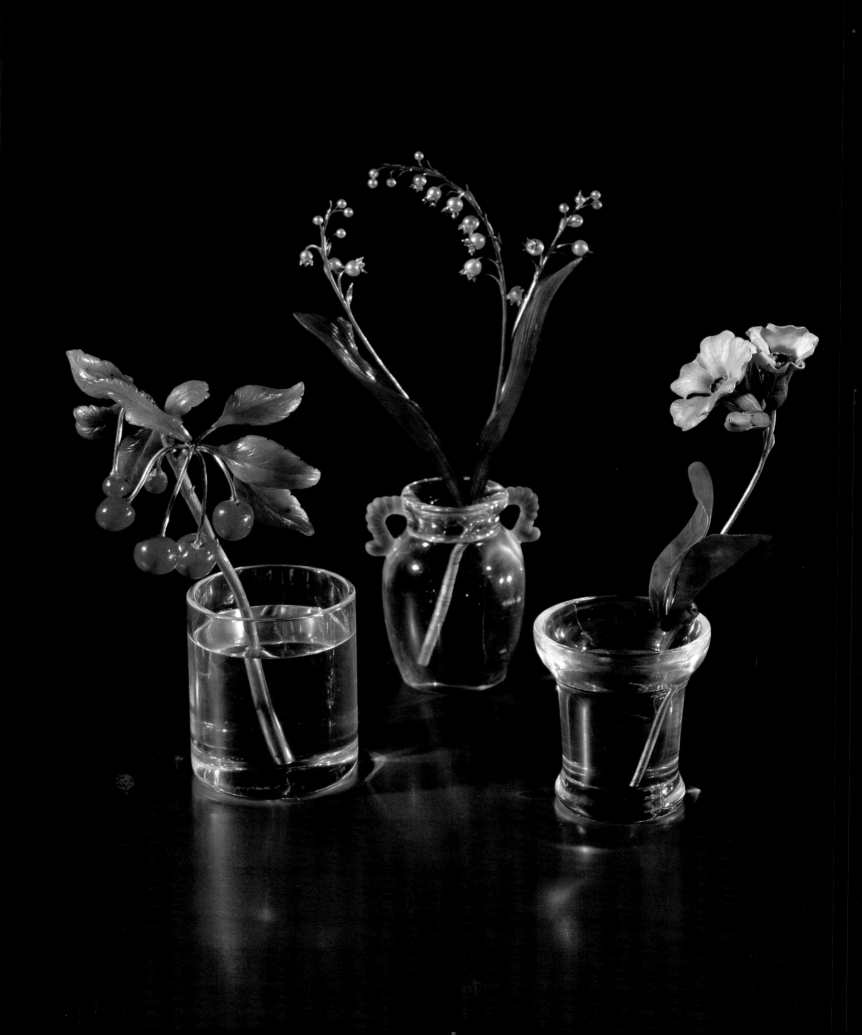

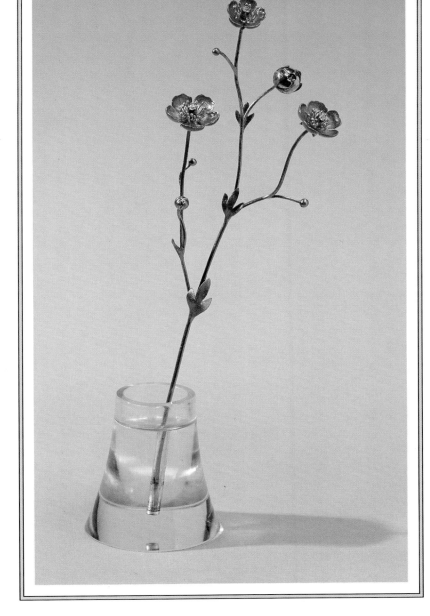

There is a delightful example of gypsophila in the Wernher Collection at Luton Hoo, England, which consists of a single gold stalk with many shoots, set with tiny diamonds, growing from a vase of nephrite. It is as fragile as the original in nature, trembling, says the curator, Una Kennedy, "when you breathe on it". The Wernher Collection also has flower studies of lilies of the valley with nephrite leaves and diamond flowers, and forget-me-nots with turquoise clusters for the flowers, with diamonds at the centre.

Only slightly less popular as subjects for Fabergé's flowers were forget-me-nots, as the life-sized drawing of one in the Holmström stock-books of 1909–15 suggests. Kenneth Snowman has described how the

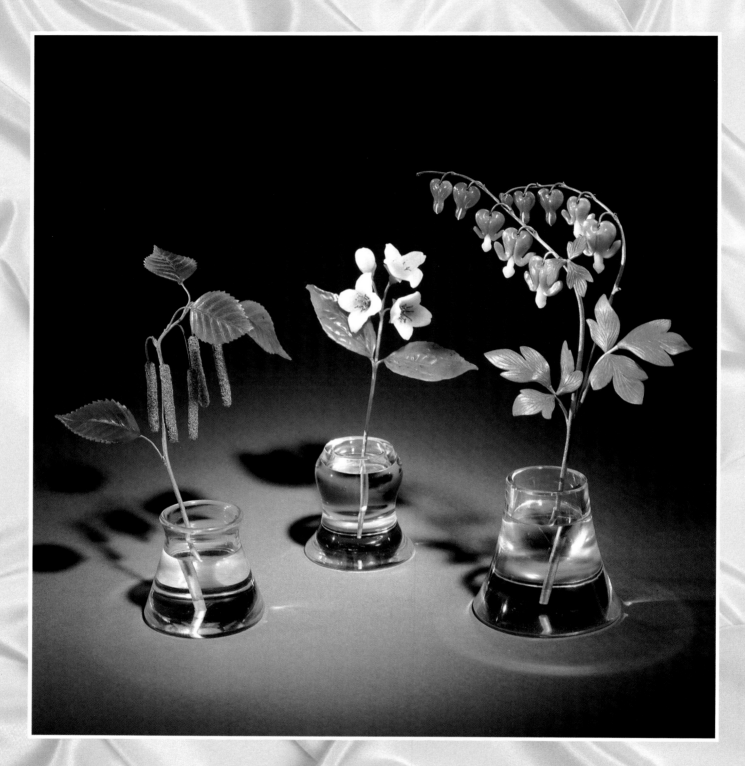

*T*he catkins are formed
from spun green gold in
the study on the left, white
quartz has been used for
the mock orange flowers
and rhodonite for the
flowers of bleeding heart.

.

An exquisite study in which buttercups and cornflowers share the same stem (22.8cm/9in). The cornflower petals are enamelled in blue translucent enamel with diamond centres and the buttercups have yellow guilloche petals and rose-cut diamond centres.

.

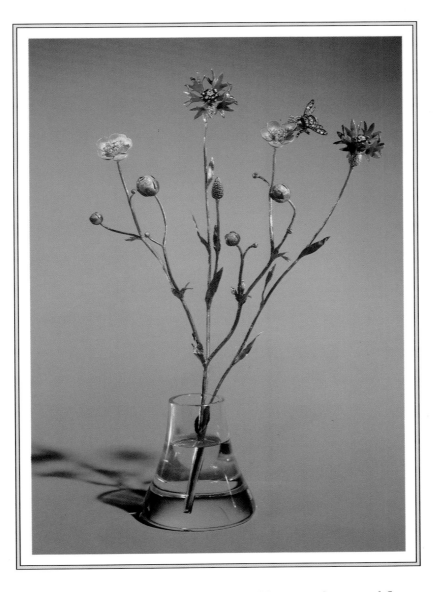

A brilliant touch is the gold bee in rose-cut diamonds with ruby eyes.

.

flower was made: with nephrite leaves, gold engraved stem and flowers of turquoise and rose diamonds.

There are many different types of flowers in the 60-odd works known to exist today, although there is some duplication. These different flowers required special materials: a sprig of mistletoe has moonstones to create lifelike berries; a dandelion on a gold stem with nephrite leaves has a seed-head daringly made of strands of asbestos fibres, spun platinum and rose diamonds; lapis lazuli is called on for use as blueberries: rhodonite for raspberries; purpurine for strawberries; various shades of enamel for japonica, gentian, pansy and others. One of the most striking of Fabergé's floral studies is a cornflowers and ranunculus spray with gold stem and leaves. The cornflowers have translucent blue enamel blossoms with diamond centres and the ranunculus has petals of yellow guilloche enamel with diamond centres and buds of green enamel. The final touch in this scene from nature is a gold bee set with rose-cut diamonds and ruby eyes. Also striking, but not quite

*P*ansies with enamelled
petals, diamond centres
and nephrite leaves
appear to be set in a vase
of water, which is, in fact,
solid rock crystal.

.

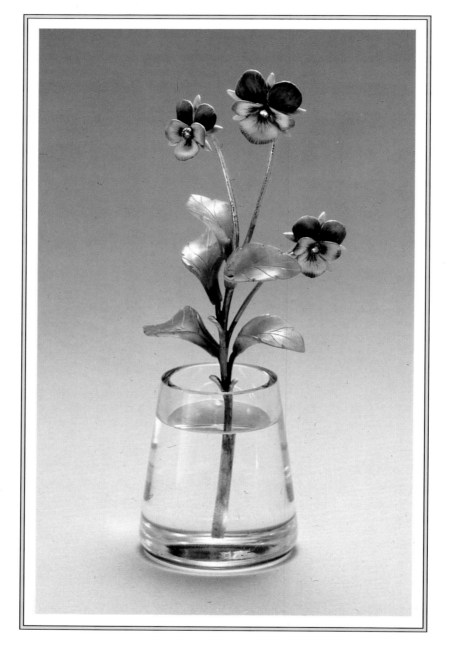

as simple, is a study of a pansy, the petals of which can be turned to
reveal a miniature in a diamond border of each of the Romanov children.
This was given to the Empress by the Tsar in 1904 to celebrate their
10th wedding anniversary.

Perhaps the most cunning aspect of these studies is not the flowers
but their containers, which appear, at first sight, to be humble jars
half-filled with water, a prosaic setting for the jewelled flowers. They
are, in fact, skilfully carved from single blocks of rock crystal, a
trompe-l'œil technique that astonishes now as it did in Fabergé's day.

In some cases, the containers are not of rock crystal but of materials
such as agate or nephrite. In the past these have been regarded with
suspicion by experts but modern scholars believe they give no grounds

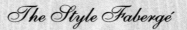
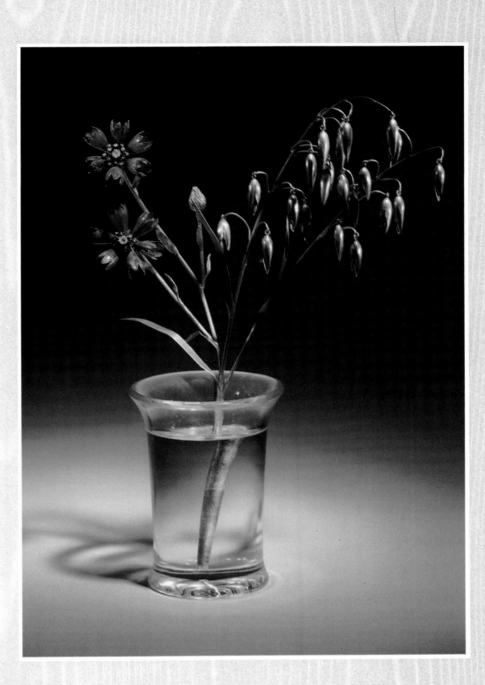

Cornflowers with blue enamel petals and rose-cut diamond centres combine with oats to form a realistic study, even if their joint stem would not be found in nature (20cm/7¹⁵⁄₁₆in).

. .

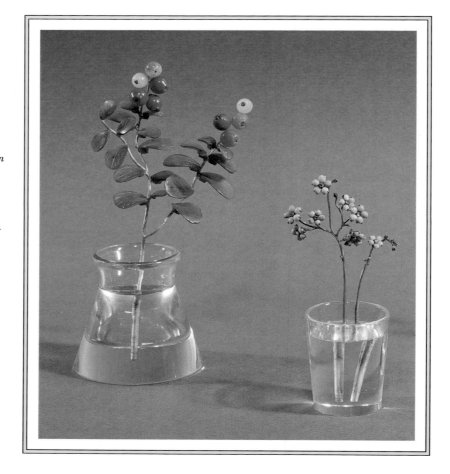

The cranberries on the left are made of chalcedony, shading from red to white, with leaves of nephrite. The forget-me-not blossoms are formed from five round turquoises around a rose-cut diamond.

.

for doubt. Sacheverell Sitwell refers to gypsophila in a jade jar and there is the gypsophila in a nephrite jar already mentioned, in the Wernher Collection at Luton Hoo.

The work involved in these flower studies is so delicate that it is best studied with the help of a microscope. The leaves are made of paper-thin slices of nephrite (just occasionally of gold) and the veins on the surface are repeated on the back. The golden stems are engraved with tiny lines.

Fabergé's inspiration for the flower studies probably came from the magnificent flower arrangements in precious stones which were made in the 18th century. There are several examples in European museums and three in the Hermitage Museum which would have been known to him. They are more exotic, less naturalistic, than those he made, but the relationship is clear. A jewelled bouquet in the Hermitage has flowers and leaves of diamonds, emeralds, topazes, garnets and corals. It is the work of Jérémie Pauzie (1716–79), who was born in Geneva and opened a workshop in St Petersburg in 1740, working as Court Jeweller until 1764. Another of his works in the Hermitage is a magnificent madonna lily which has three gold flowers studded with seed pearls and rose diamonds.

Typically, Fabergé did not draw his inspiration from a single source. Sitwell was correct in identifying Chinese influence, because there

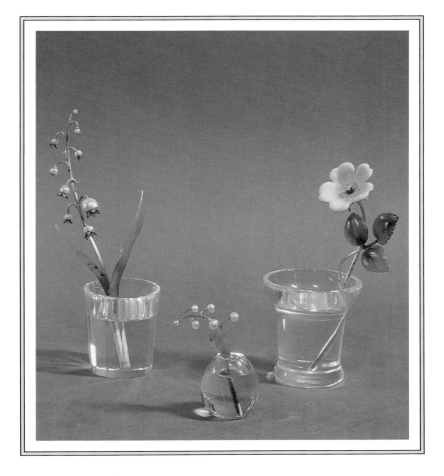

*M*ore lilies-of-the-valley, which are among the most popular of the flowers made by Fabergé. The larger blossoms are made of pearls to which a band of silver, set with rose-cut diamonds, has been attached. The smaller blossoms are just small pearls. The attractive wild rose has petals enamelled in opaque pink with darker pink veins and a diamond centre.

.

A delicately-carved nephrite leaf from the wild rose above.

.

does seem to be a connection with similar Chinese works of the late 18th century, studies which aim for a more naturalistic effect, especially in the carving of the nephrite leaves. The Japanese art of flower arranging, *ikebana*, is also seen as an influence in a number of the flower studies. Alexander von Solodkoff, in his work on Fabergé, points to flowers in the Japanese style described in the ledgers of Fabergé's London branch for 1907–8, particularly a Japanese pine, a Japanese cherry and a Japanese flower in bamboo. He adds that the rarity of the flower studies is demonstrated by the fact that only 35 were sold by the London branch in the period from 1907 to 1917, a time when some 10,000 items in total were sold. The types of flowers are diverse, including pansies, cherry, daisy, roses, violets, jasmine, daffodils, bluebells, crocuses and sweet peas, but not, curiously, the lilies of the valley which were so popular in Russia.

Given the popularity of the flowers, it is a little surprising that only 60 genuine examples are known to exist today. It may be that many of these delicate objects have not survived; it may be that there are more which have yet to be discovered, perhaps in the Soviet Union. Examples of the flower studies can be seen in collections throughout the world: Her Majesty Queen Elizabeth has a major collection of 20 and there are several others in leading American museums. A number of the flowers on display in American museums are of doubtful authenticity, how-

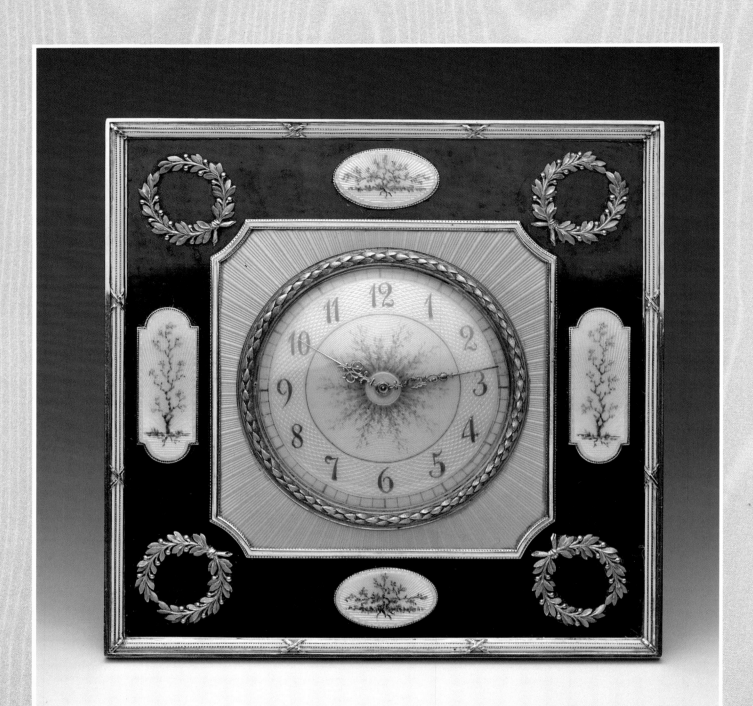

*F*abergé made a wide range of clocks and this is a
stunning example of his work. The nephrite frame is 19 ×
14cm (7½ × 5½in), decorated with trees painted on
opalescent enamel panels.

· · · · · · · · · · · · · · · · · · · ·

ever, many being the result of the thriving business of supplying "Fabergé" flowers to an eager world from workshops in France and Germany long after the Fabergé empire had gone.

One of the attractions of Fabergé flowers for those wishing to copy them is that they do not usually bear any identifying marks because the stems are too delicate to accommodate them. Of the 20 flowers in Queen Elizabeth's collection, only two have maker's marks; these are of head workmaster Henrik Wigström. The first known example of Fabergé's work on flowers, the basket of lilies of the valley which was presented to the Empress Alexandra by the management of the Siberian iron industry in 1896, did bear a mark, that of the master jeweller August Holmström.

The fact that marks are generally absent from the flowers has led to the conclusion that their existence on certain examples may be evidence of forgery. There are some clues, though, which can be followed to help establish authenticity. Fabergé's flowers always had gold stems and these stems are almost always at an angle in their containers, leaning towards the edge, while the flowers of imitators often have silver stems, with the flowers tending to stand upright. There are also differences in the quality of craftsmanship. The patient skill of Fabergé's craftsmen – seen to perfection in the fine lines engraved on the stems and the delicacy of the thin nephrite of the leaves – is not easy to duplicate. Often, too, the forgers choose the flowers which posed fewest technical problems: for example, the raspberry.

Many flowers produced in other workshops are not copies of Fabergé's works but personal creations, often influenced by Japanese art and Art Nouveau. Boucheron, Lalique and Cartier all produced fine studies: for example, a lily of the valley by Cartier with chalcedony blossoms, nephrite leaves and enamelled stems which stands in an agate pot. Fabergé's sons Eugène and Alexander also produced flowers in the 1920s in Paris, when they were operating as Fabergé & Cie.

But all these competitors produced work which, whatever the standards achieved, did not possess that elusive but recognizable element which is the *style Fabergé*. The Fabergé flowers are unique and it is tempting to think they were special to their creator, perhaps a more sympathetic subject, because of their innate simplicity, than some of the more extravagent items that came from his workshops.

The flowers and the Imperial eggs are quite different expressions of Fabergé's art but both share the distinction of being superb expressions of his creative genius. More typical of the works produced by Fabergé are the functional objects, a vast range of items produced in the St Petersburg workshops to cater for almost every domestic need: parasol and cane handles, scent bottles, crochet hooks, letter openers, glue pots, stamp dampers, ashtrays, cigarette cases, boxes of all kinds, desk sets, clocks, photograph frames, electric bell pushes, snuff boxes, lorgnettes, opera glasses, thermometers, barometers and more. What is extraordinary about these things is not their diversity but the care which was lavished on each one of them. A crochet hook is made with

*B*ell pushes were part of the range of items produced by the House of Fabergé. Here is an amusing example in bowenite with a turtle motif.

.

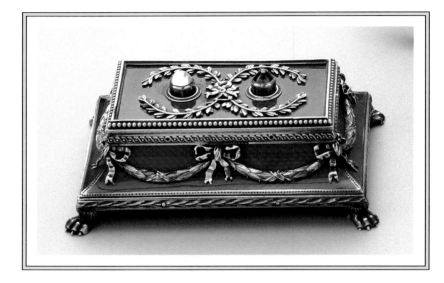

the same degree of craftsmanship as something vastly more extravagant, carved in nephrite, one end embellished with white enamel on a guilloche ground and edged with a rose-cut diamond border. A glue pot is made in bowenite, shaped like an overripe pear, complete with dark spots and a golden worm, the brush enamelled green and brown and set with a diamond. It is this devotion to quality that distinguishes the objects made by Fabergé from similar objects of today.

Members of the large families of the period liked to be reminded of their close and distant relations by means of painted or photographed likenesses. Before the introduction of photography, the wealthy had family portraits painted by miniaturists such as Vassily Zuiev and Johannes Zehngraf, both of whom worked for Fabergé and much of whose work survives. Two charming miniatures by Zehngraf of two princesses of the Bulgarian Royal Family in Fabergé frames were exhibited at the Munich exhibition of 1986–7. The frames were typical of the period: translucent raspberry enamel over guilloche sun-ray patterns, with a gold border and tiny pearls encircling the miniature. A miniature by Zuiev of the wife of the rubber factory owner Othmar Neuscheller has a frame of gold and white guilloche enamel, with a green border inset with rose diamonds and pearls.

Photography started to become popular with the arrival of the hand-held camera towards the end of the 19th century. Every fashionable home had its ranks of photographs in splendid frames, a phenomenon which opened up new business opportunities for Fabergé. He responded with typical flair, calling on all the skills of his craftsmen: the enamellers produced beautifully deep colours against guilloche backgrounds; the goldsmiths created laurel bands and flower garlands in different colours of gold; the jewellers worked with rubies, diamonds and pearls to embellish these functional objects. Materials used included rock crystal, nephrite, bowenite and wood; ivory was used for the backing.

The frames are superbly executed, marvels of Fabergé craftsmanship, with the usual meticulous care taken with every detail. The Forbes

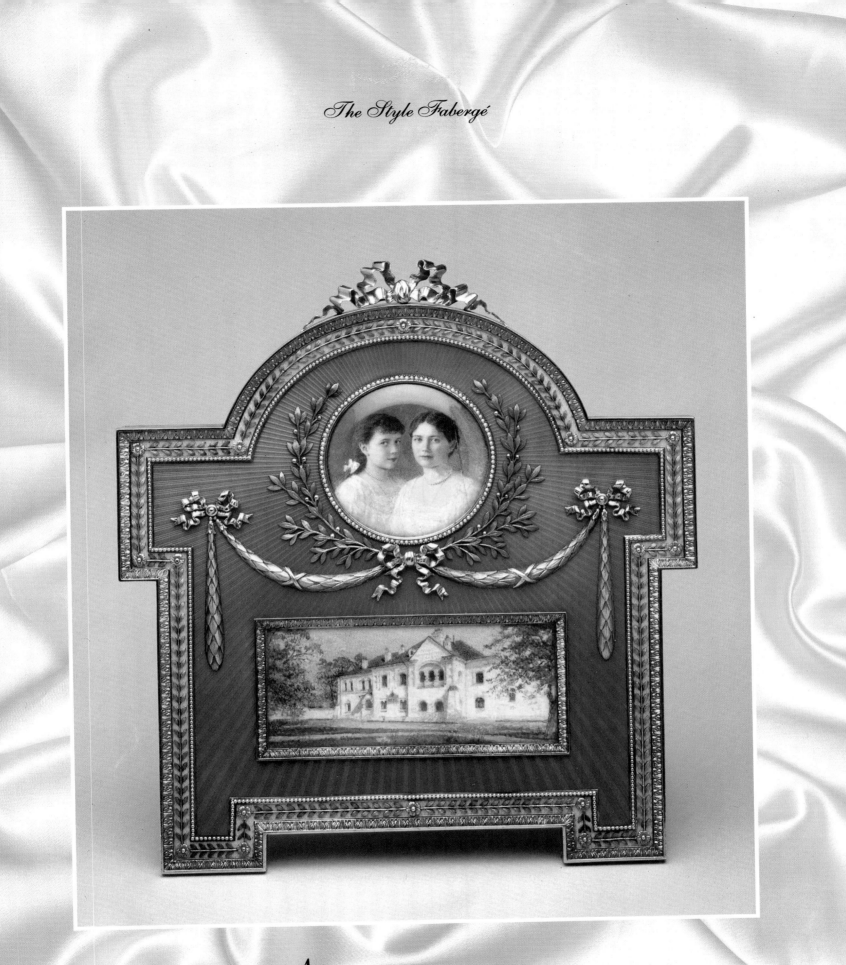

A miniature frame by Fabergé in pink enamel for two paintings by Vassily Zuiev: the Grand Duchesses Marie and Anastasia and the nursing home where they helped with nursing.

. .

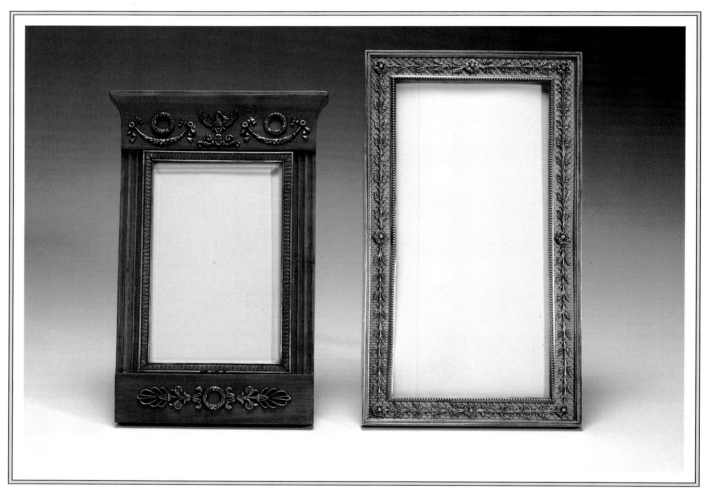

Two photograph frames by Fabergé: the example on the left is wood with silver garlands and swans; the one on the right is gold-mounted silver and enamel.

.

Collection in New York has some splendid examples, such as a rock-crystal frame with lavish decoration of flower swags in two colours of gold, topped by a flower basket in four colours with a diamond-set and ruby tassel at the bottom. Another in the same collection is a sumptuous double frame in gold, fashioned as a Louis XV firescreen in which opalescent white enamel over a guilloche ground is decorated with swags in four colours of gold, surmounted by gold laurel leaves and flower swags, with columns of white enamel and pearl finials.

What is striking about Fabergé frames is their diversity: they are square, circular, octagonal, lozenge-shaped, heart-shaped; the colours range from pale green, pale blue and strawberry to turquoise, salmon pink and lime green. In the Forbes Collection there is a heart-shaped gold frame, an extravagant piece in scarlet guilloche enamel, the heart of which opens into a three-leaf-clover, each leaf carrying a miniature: Nicholas II, his Empress and their daughter Tatiana. Another, even more fantastic, idea is a frame in the shape of an X, attached to which are a number of heart-shaped and rectangular frames containing photographs of Grand Duke Michael Michailovitch and his three children. The frame is a celebration of the 10th anniversary of the marriage of the Grand Duke to Sophie, Countess Merenberg, in 1891.

It is, of course, fascinating to examine the faces that peer from these gilded frames: glimpses from the sunny days of pre-Revolutionary Russia; grand dukes and princesses by the dozen, Tsar Nicholas II and Empress Alexandra surrounded by their children and other relations at formal and informal occasions. Some are reminders of political influences: a silver-gilt frame with a photograph of an imperious Kaiser Wilhelm II (thoroughly disliked by the amiable Nicholas II) is in the Forbes Collection, New York. Some reflect the spread of Fabergé's empire: a silver-gilt frame in lime-green enamel with floral swags in the collection of the

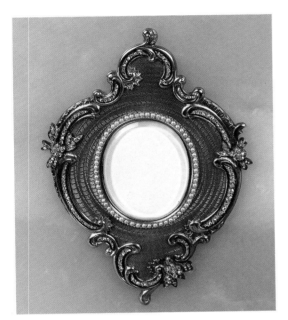

Beautiful examples of the workmanship of Fabergé's craftsmen. The frame on the left is in the rococo style with superb guilloche enamelling, and the one on the right is positively sumptuous with its gold embellishments.

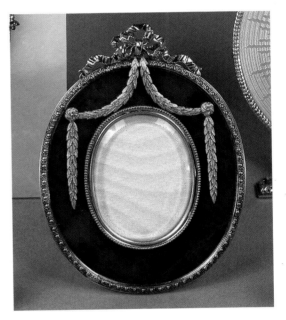

King of Thailand is an example. Royalty seems to have been susceptible to the charms of Fabergé's work and King Chulalongkorn of Siam was no exception. He had met Nicholas II, before he became Tsar, in 1890, when Nicholas was on his world tour in the cruiser *Pamiat Azova*, and visited St Petersburg in 1897, when he was presented with a cigarette case by Fabergé. The King was evidently a great admirer of all things Russian. One of his sons, Prince Chakrabongse, was educated in St Petersburg and became colonel of a Russian regiment. It was through him, according to Bainbridge, that Fabergé was invited to visit Siam, and a string of commissions from the Court in Bangkok resulted. These included many items in nephrite, including bowls, candlesticks and a number of images of Buddha, which can still be seen in the Thai royal collection. It is interesting that these works are far from the miniature world so familiar to Fabergé: the images of the Buddha were calculated by Bainbridge to be between 50-66cm (1½ and 2 feet) high, and one magnificent bowl in nephrite, supported by mythological figures in gold, to be 40cm (1¼ feet) in diameter.

Boxes are the most typical of Fabergé's output, although the term is quite inadequate to describe the variety of containers made by the firm for every conceivable object: pills, cigarettes, cigars, stamps, face

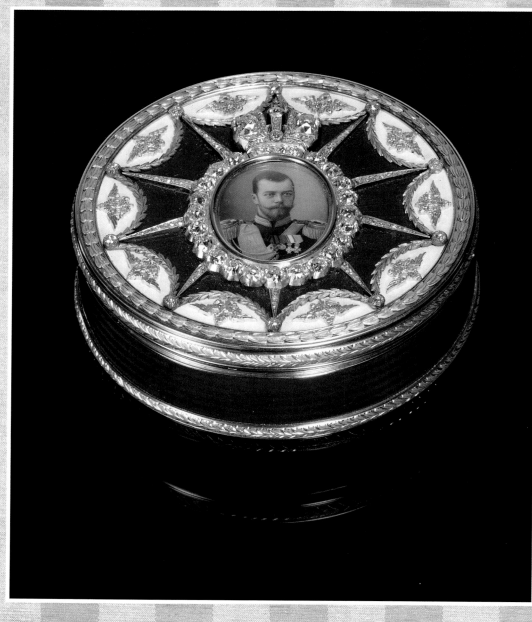

*A jewelled, gold and enamel Imperial presentation box,
workmaster Michael Perchin. The miniature is of Tsar
Nicholas II enclosed within a diamond frame,
surmounted by a diamond-set Imperial crown and
surrounded by nine diamond-set rays on a translucent
blue enamel ground. The gold edge is bordered with
opaque white enamel crescents, each containing a gold-
crowned, double-headed eagle. The diameter of the box is
9cm (3½in).*

.

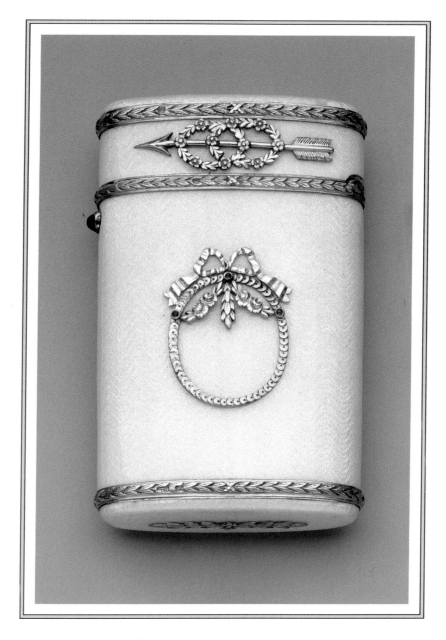

A lady's cigarette case in two-colour gold and enamel. The enamel is opalescent white over a wavy ground, decorated with laurel-leaf bands and arrow-linked wreaths.

.

powder and more. They range from superb ceremonial gifts to elegant trifles for a lady's dressing-table.

A good example of the more sumptuous kind is the Banker's Box, made of nephrite and bordered with gold, which has the inscription: "1613–1913, To His Imperial Majesty to be used at his Serene discretion for purposes of charity, dutifully presented by the bankers of St Petersburg and Moscow". Inside the box, which has the monogram of Nicholas II, was a cheque for 1 million roubles. Another fine example was the Balletta Box, a delightful vanity case in gold and blue enamel with a trelliswork of rose diamonds and the monogram EB, the initials of the owner, the famous ballerina Elizabeth Balletta of the Imperial Michael Theatre, St Petersburg. She was greatly admired – on and off the stage – and this vanity case, which contains a gold pencil, lipstick tube and

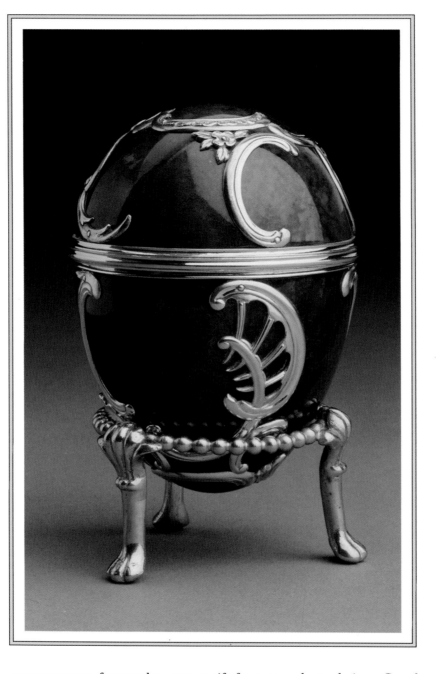

An egg-shaped bon-bonnière, some 7.6cm (3in) tall, in a beautiful mottled brown agate, decorated with gold flower swags and scrolls. It is thought to have been inspired by a bon-bonnière of the George II period.

.

compartments for powder, was a gift from an ardent admirer, Grand Duke Alexei Alexandrovitch, brother of Tsar Alexander III. An inveterate womanizer, he was Admiral-in-Chief of the Russian navy during the débâcle against the Japanese navy in 1905; it was said of him that he preferred "slow ships and fast women". A ceremonial gift was the Freedom Box, now in the Wernher Collection at Luton Hoo, which was presented by Nicholas II to the Earl of Pembroke when the Tsar visited Balmoral in 1896. It is typical of dozens of such pieces for the Court: a casket in nephrite, decorated with bands of laurel leaves and two-colour swags, the dome surmounted by an impressive double-headed eagle with a gold crown.

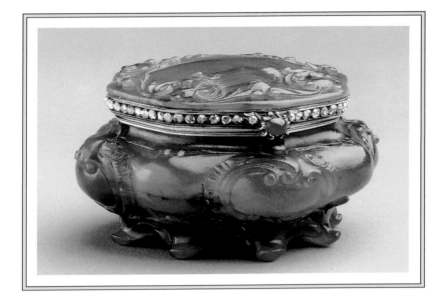

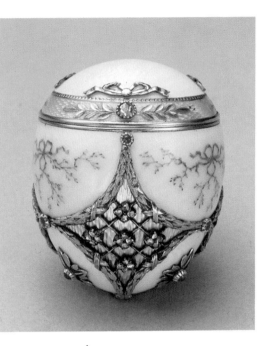

*A*bove: an egg-shaped
bon-bonnière only 48mm
(1⅞in) high, beautifully
enamelled in white, sepia
and pale blue enamel,
decorated with gold
bands and set with
diamonds and rubies.

.

*L*eft: an interesting bon-
bonnière showing a
strongly Chinese
influence. Carved of
nephrite, it is set with
rose-cut diamonds around
the mount and has a
cabochon ruby
thumbpiece.

.

The limitations of the form seem to have spurred the imagination of Fabergé's designers, who varied materials and shapes to provide an extraordinary diversity of boxes. Materials used include rhodonite, agate, nephrite, smoky quartz, rock crystal and bowenite, and the designs are inspired by many sources. In the Forbes Collection there are a number of informative examples, including a box shaped like a reliquary casket in the Gothic style: carved of nephrite, with six gold turrets and gold Gothic-style decoration, this wonderfully detailed piece is only a little more than 5cm (2in) long. In the Marjorie Merriweather Post Collection in Washington, DC, there are other examples: a nephrite bonbonnière in the Chinese style, delicately carved, with gold mount set with rose diamonds and a *cabochon* ruby thumbpiece; and a bon-bonnière in mottled brown agate with gold scrolls and flower swags which was inspired by a George II piece.

The two objects described above are miniatures, little more than 2.5 and 7.5cm (1 and 3in) high respectively. Two further examples of these miniature marvels are to be found in the Hermitage Museum, Leningrad. One is a bonbonnière in the form of a Louis XVI table; it has dark-brown agate for the wood, is embellished with ornate acanthus, is extraordinarily detailed and is under 7.5cm (3in) long. The other is a bonbonnière in an oval shape; it has a lapis lazuli top, set with stars and a crescent moon in diamonds, inside a border of half-pearls and is just over 5cm (2in) long. Both pieces carry the mark of the talented head workmaster Michael Perchin.

A bonbonnière in agate, shaped like a snail, is said to have been inspired by an 18th-century original. The agate is dark brown and the gold cover has blue and white enamel stripes with a panel of moss agate with a rose-diamond border and a diamond thumbpiece. A delightful bonbonnière in the shape of a bulldog's head is thought to have been inspired by an English or Dresden 18th-century box: it is a wonderfully lifelike piece in grey-brown banded agate with white and orange stripes.

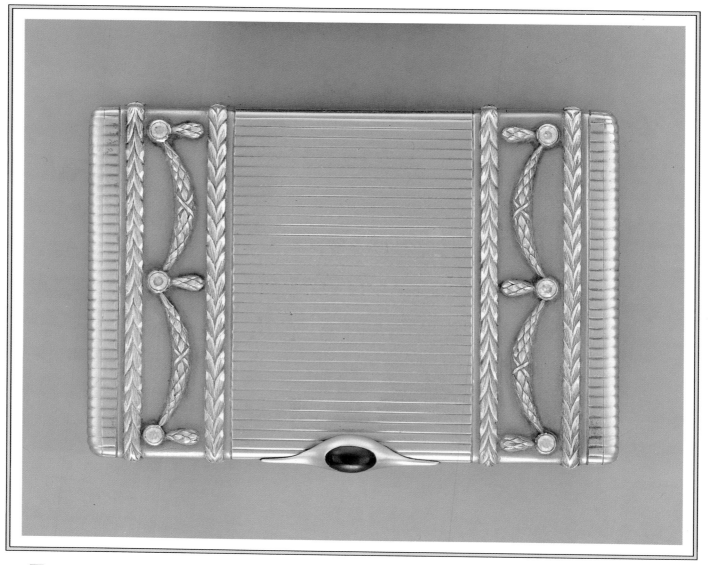

This superb gold cigarette case is decorated with laurel wreaths and swags of contrasting gold, set with diamonds.

.

The shape of these bonbonnières come from all manner of sources: scallop shells, a horse's hoof, even a fish's head.

Of all the boxes made by Fabergé, the most famous and the most characteristic are the cigarette cases. They are often regarded as Fabergé's equivalent of the magnificent snuffboxes made in 18th-century France and it is certainly true that they share a common elegance and craftsmanship. However, the products of the French goldsmiths express the spirit of their time in the richness of materials used and in the decorative style. What is particularly striking about Fabergé's cigarette cases is their restraint and simplicity, the stripping away of excess embellishment to reveal the essence of the object in a way that foreshadowed the style of the 1920s. As ever, he was ready to assimilate a variety of influences but to use them only as a starting-point for his own expression. Where he does copy, the source is obvious, as we have seen in numerous examples of his work.

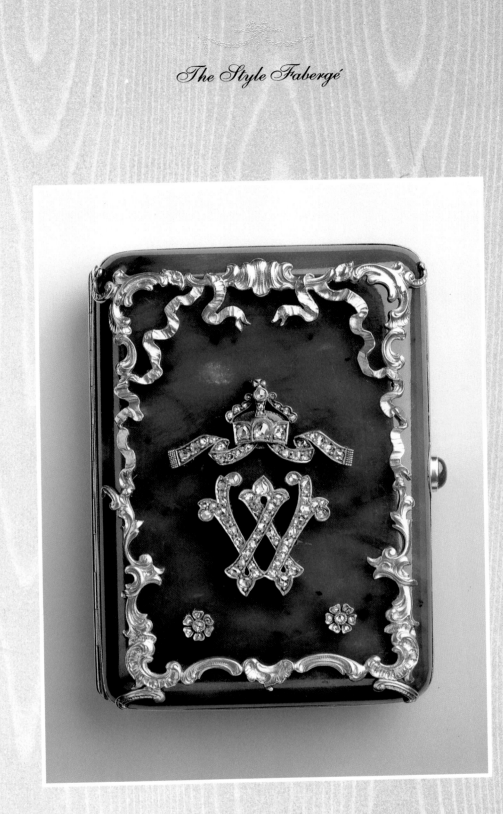

*T*his nephrite and gold Imperial presentation
cigarette case was given by Tsar Nicholas II to Kaiser
Wilhelm and bears the Kaiser's monogram.
.

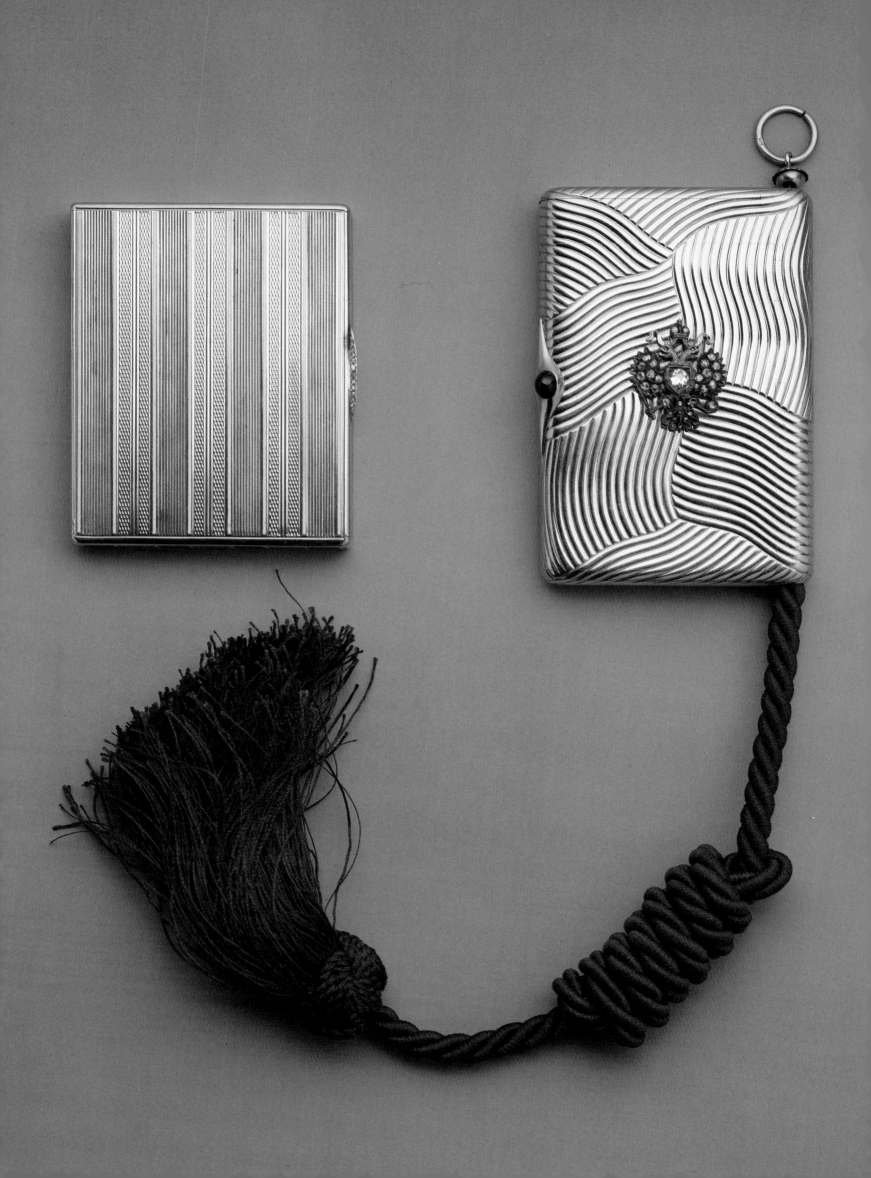

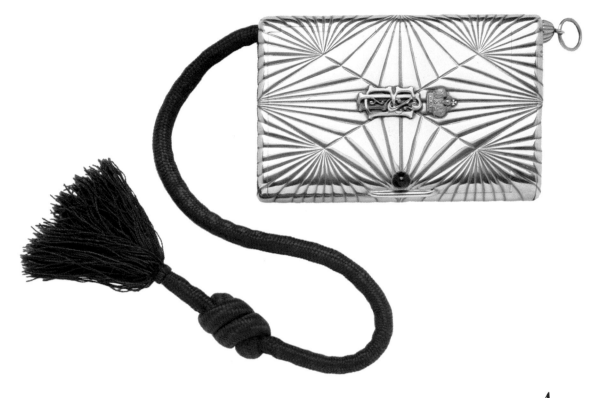

Left: Two examples of cigarette cases which the well-dressed gentleman in Russian or English society would be expected to carry. The one on the left has a classic simplicity with its ribbed pattern in different colours of gold. The one on the right has an unusual woven pattern and comes with a tinder cord. It also has a typical cabochon sapphire thumbpiece.

.

The cigarette cases are the ultimate in the *style Fabergé*, the embodiment of chic from the time they were made to this day. They were an integral part of the evening wear of the gentlemen of society in Russia before the Revolution and in Edwardian England, possessions which said all that needed to be said about the owner's taste. They are technically superb and often incorporate new or revived working methods, such as the use of four-colour gold so much favoured by 18th-century goldsmiths. The use of different colours gives variety to the design, as does the use of different patterns and surfaces. The cases have reeded, banded and basket-weave designs, fan motifs or waved triple bands. These effects place considerable demands on the skill of the goldsmiths, especially the basket-weave effect, which is achieved by intertwining strips of red gold, platinum and green gold, or where the design uses alternating waved and reeded triple bands of red and yellow gold. Often the cases are decorated with monograms or flowers or other motifs.

Brilliant colours are often obtained: deep, lustrous scarlets, greens, blues in enamel against guilloche backgrounds of moiré, sunbursts and wave patterns. A superb example is the gold case with a blue translucent enamel which has a band of diamonds on both sides in the form of a serpent. This was a gift from the Edwardian beauty Mrs Alice Keppel to her lover, King Edward VII. Mrs Keppel, a regular visitor at Sandringham, was called to the dying King's deathbed and the love gift was returned to her by Queen Alexandra as a keepsake. She later gave it to Queen Mary so that it could be kept with the rest of the Fabergé collection at Sandringham.

A silver cigarette case with the monogram of Grand Duke Vladimir Alexandrovich. Deeply engraved, it has a blue tinder cord and a compartment for matches.

.

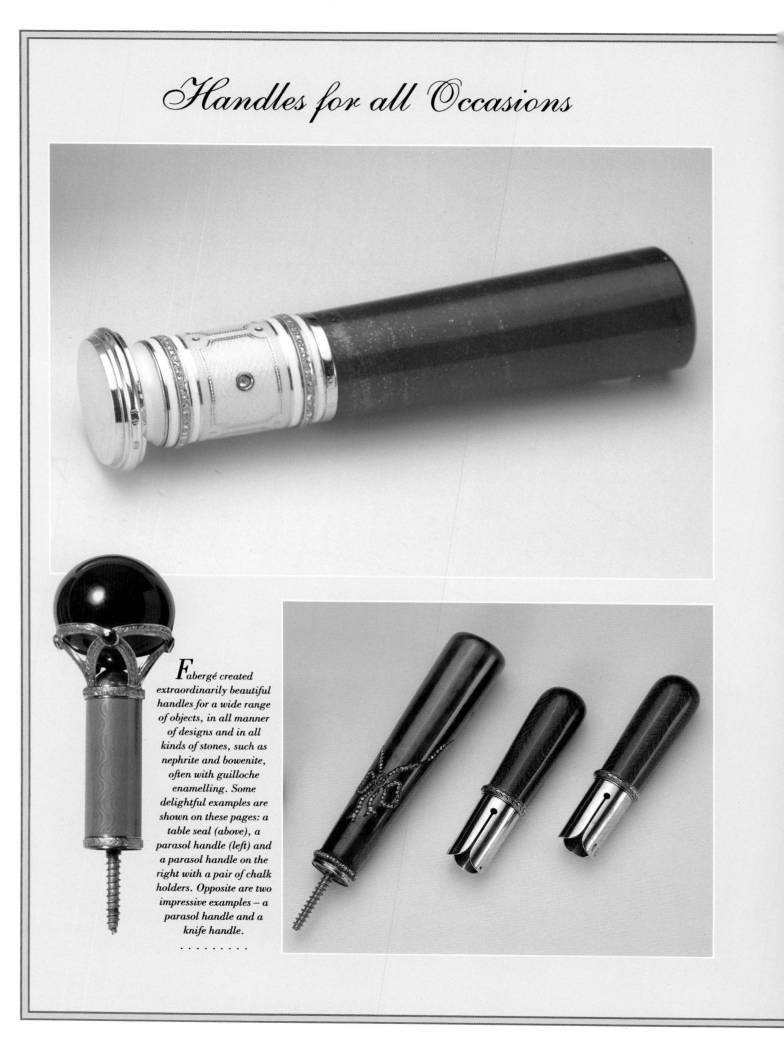

*F*abergé created extraordinarily beautiful handles for a wide range of objects, in all manner of designs and in all kinds of stones, such as nephrite and bowenite, often with guilloche enamelling. Some delightful examples are shown on these pages: a table seal (above), a parasol handle (left) and a parasol handle on the right with a pair of chalk holders. Opposite are two impressive examples – a parasol handle and a knife handle.

.

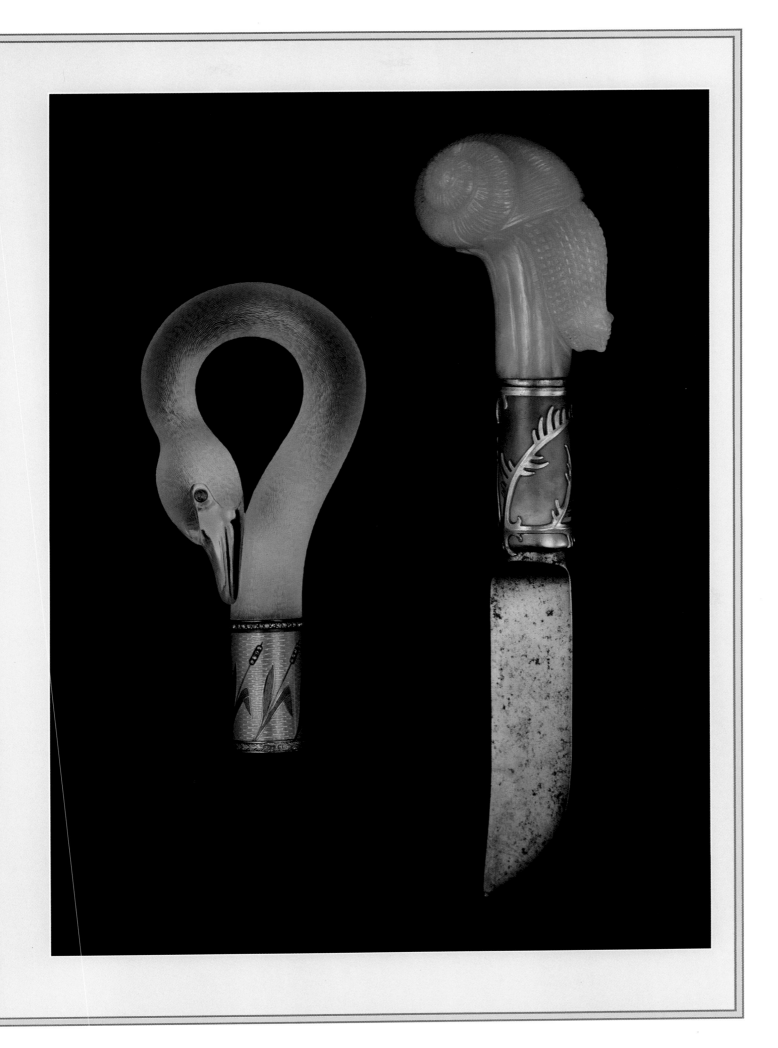

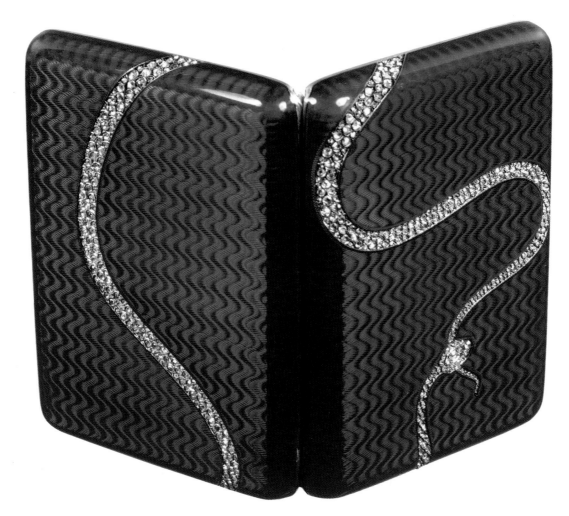

One of the most famous and spectacular cigarette cases made by Fabergé, it also has a fascinating history. The case was given by Mrs George Keppel, mistress of Edward VII, to the King in 1908, returned to her after his death, but later donated by Mrs Keppel to the Royal collection. It is superbly enamelled in translucent dark blue over a wavy guilloche ground, with a snake in rose-cut diamonds on both sides.

.

Features of the cigarette cases which especially excite the admiration of modern craftsmen are the hinges and the catches. The hinges are invisible, of a quality rarely seen today, and the cases close perfectly at the touch of the catch, which is usually a single *cabochon* sapphire.

Art Nouveau influences are evident in many of the cases: one has a head of Daphne with flowing hair surrounded by foliage and branches; another has voluptuous water-lily patterns. Particularly unusual but highly effective is an Art Nouveau example made in 1900 of a gold case decorated with blue and white enamelled dragonflies. Even more unusual and modernistic is a gold cigarette case in the Forbes Collection which has a white guilloche enamel background covered with small circles in different colours of enamel, each with a rose diamond at the centre, a colourful and surprising piece.

It is characteristic of Fabergé that he did not restrict himself to precious metals when designing his cigarette cases. There are a number of examples in beautifully polished palisander wood, often decorated with gold scrolls, sometimes with a rouble from the reign of Catherine the Great (a decoration used in a number of Fabergé objects).

The classic, however, the one that exudes the spirit of Fabergé, is the simple case in silver or gold, stripped of ornamentation, a delight to the hand and eye. It is an essay in understatement and one that was

much copied by later goldsmiths, generally unsuccessfully because they were unable to achieve the right weight of precious metals to size: in other words, they were simply too heavy.

Cane and parasol handles are also vivid examples of Fabergé's ingenuity, especially in the use of materials and techniques to provide a quite bewildering range of effects and an extraordinary degree of craftsmanship. A cane once belonging to the King of Bulgaria is a T-shape carved of nephrite and has a silver-gilt mount with delicate pink guilloche enamel. A parasol once in the possession of Alfred, Duke of Edinburgh (son-in-law of Tsar Alexander II), has a bloodstone handle in an egg shape which is inlaid with the initial A in gold and has a reeded gold mount. A cane owned by Grand Duke Alexei, son of Alexander II, has a handle of bloodstone which is inlaid with his monogram, AA, in gold and has a fluted mount in polished gold. There are some exquisite examples, with typically beautiful guilloche enamel, in the Wernher Collection at Luton Hoo. A parasol handle is carved from a block of aquamarine set in a gold base which is in pink and white enamel, surrounded by festoons of diamonds and rubies; another is made of pearly pink *orletz* with a mount in white enamel decorated with diamonds. An object of special charm is a complete parasol, once the property of Lady Zia Wernher, which can be seen next to a photograph of Lady Zia as a child at Wiesbaden, sitting in a cart pulled by goats accompanied by her pet dog and the same parasol.

Little wonder that these canes and parasols were part of the dress of members of society, carried with pride on the streets of St Petersburg, Moscow and London.

*T*hree elegant cigarette cases, two in nephrite and one in guilloche enamel.
.

"Fabergé in Wonderland"

"A wonderland" was how Fabergé's first biographer,
Henry Charles Bainbridge, described the London branch of
the Fabergé empire. It was a pleasure to be at the centre of
things, to deal with the rich and famous, to be "the keeper of
the cave with every kind of thing to delight the fancy and the
eye, made by the greatest craftsman of his day".

A carpenter and a balalaika-playing peasant, part of
Fabergé's series of national characters. Different types of
stone have been used to represent parts of their bodies and
clothing.

.

It is not surprising that Fabergé should have become such a favourite of the British Royal Family. Long before there was any commercial traffic in his work, it was known to them from the gifts selected by the Romanovs and sent to mark the various anniversaries of their many relations, including, of course, Queen Victoria, who was at the centre of an intricate network that connected all the royal houses of Europe. Following the marriages of the Danish princesses Alexandra, to Edward, Prince of Wales, in 1863, and her sister Marie, to the future Alexander III of Russia, in 1866, the ties were strengthened. The two sisters were close and intimate friends for the whole of their lives.

After Fabergé was made Court Jeweller a selection of his work was kept in a special room at the Winter Palace. An appropriate gift would be chosen from here for visitors or for visits to foreign branches of the family. Trips to Balmoral and Windsor would always be made with a number of Fabergé items, which could be presented as and when necessary. Once a month, Fabergé or one of his sons would visit the Imperial Cabinet, as it was known, to check on what had been taken, to replenish stocks and prepare invoices.

It is, perhaps, more surprising that the Russian craftsman should have become so successfully established in Edwardian England that his work almost seems to symbolize that glittering era. The first commercial presence was at the Berners Hotel, London, when Arthur Bowe, Fabergé's partner, sent his brother, Allan, with a selection of articles to England. A branch of the Moscow business was later opened at 32 Old Burlington Street, but after the dissolution of the partnership in 1906 Fabergé took a direct hand in matters, opening a branch at 48 Dover Street, which was later transferred to 173 New Bond Street. The London branch was managed by Fabergé's son, Nicholas, and Henry Charles Bainbridge. It is significant that London was the only place in which Fabergé chose to open a permanent branch and it became the centre for his European and international operations. Every Christmas and Easter Nicholas Fabergé or Bainbridge made journeys from London to meet fashionable customers in Paris, Rome and on the French Riviera, and it was from London that commissions for India, China, Siam and the United States were handled.

Bainbridge remembered the Dover Street premises as modest and out of the way, with a simple sign carrying the name Fabergé but no other indication of what was to be found on the first floor. He recalled, too, the distinguished customers who called in from time to time: "ambassadors, maharajahs and magnates of all kinds, gay lords, grave lords, law lords, lords of the Daily Press, together with the throng of Edwardian Society".

The names of the wealthy customers who called to browse in the Dover Street shop, searching for some appropriate gift, are a roll call of the select members of Edwardian society: lords, earls, dukes, barons, ambassadors, and those without title but possessing immense fortunes. Then there were their ladies, the recipients of the gifts of Fabergé: great figures such as Lady Randolph Churchill; Consuelo, Duchess of

This figure of a Chelsea Pensioner has a coat of purpurine and a hat of black onyx.

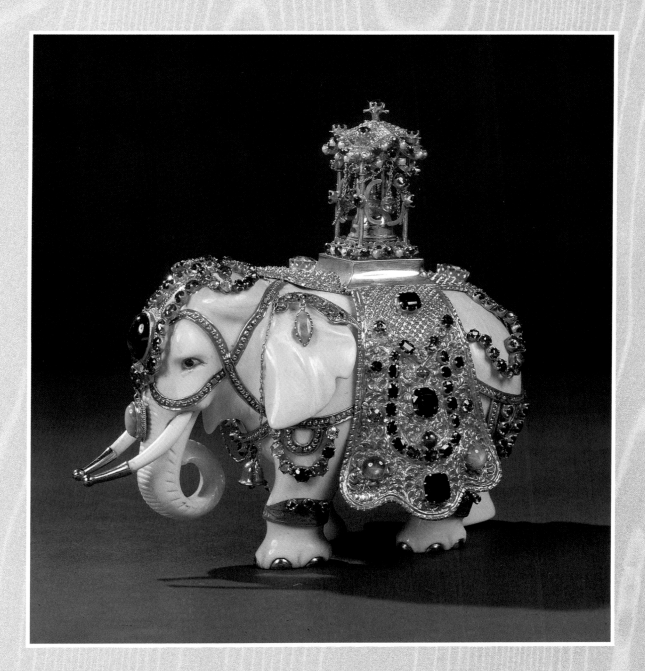

*A fabulous elephant, richly caparisoned in trappings
studded with many precious stones such as sapphires,
rubies and emeralds. Fabergé had many wealthy
maharajahs among his patrons and it may have been
specially commissioned by one of them.*

*A*bove: *a sturdy John Bull figure in a coat of purpurine.*

. .

*B*elow: *a massive* izvoschik *(driver of a public vehicle) in a nephrite coat.*

. .

Marlborough; the Duchess of Westminster; the Duchess of Devonshire; the Marchioness of Londonderry; the Countess of Suffolk; Lady Curzon of Kedleston. Heading this group, in terms of patronage of Fabergé, were Lady de Grey, Mrs Keppel, Mrs de Rothschild, Lady Paget, Mrs Sackville-West, the Countess of Torby and the Grand Duchess Marie Pavlova.

Above all, the London branch was at the service of Queen Alexandra, who was so enthusiastic about the things Fabergé created that she treated him as her unofficial Court Jeweller. There were calls from visiting royalty – the King and Queen of Norway, the King of Greece, the King of Denmark, even the very old but still charismatic Empress Eugénie – and also regular visits by various members of the British Royal Family.

It is not certain whether Fabergé visited England on his Grand Tour as a student, but he was certainly in the country on 29 January, 1908, when a curious incident was witnessed at first hand by Bainbridge. Queen Alexandra had told him that Fabergé should be presented to her when he visited England and Bainbridge had imagined that the Russian would be delighted to accept the honour. When he brought up the subject on the first day of Fabergé's visit, the reaction was unexpected: Fabergé was unwilling, uneasy, claimed he did not have the proper clothes and was simply passing through the city. Bainbridge tried to persuade him but Fabergé was adamant, demanded the train times for Paris and departed within half an hour.

Bainbridge was left in what he called his own "Fabergé in Wonderland", a place he delighted in, as he later recorded:

"It was good to be in London then on a sunny June morning . . . Nobody can ever have had such a delightful job, so easy, so fortunate. To be the keeper of the cave into which cigarette cases, fluted and ribbed in all manner of shades of gold, in mint condition, and by the dozen, and every kind of thing to delight the fancy and the eye, made by the greatest craftsman of his day and dropped daily as it were from heaven."

More light was cast on Fabergé's empire at this time with the discovery in the 1970s of the sales ledgers of the London branch for the period 1907 to 1917. In these ledgers every sale is recorded in elegant, copperplate handwriting, as evocative of the period as the objects described. The name of the purchaser is given, a description of the purchase, the stock number, the selling price in sterling and the cost price in roubles.

On 24 December, 1912, Queen Alexandra made a number of purchases costing £79 5s ($127.20)*, which included a silver bracelet with moonstones, an enamelled light-blue fan with gold mounts and rubies, cufflinks decorated with blue Mecca stones and a purpurine elephant. On the same day the Dowager Empress bought goods to the value of £41 ($65.60), which included a diamond pendant, a blue enamelled pencil cutter and a locket. The purchases sound like Christmas gifts and Christmas and Easter were the best times for business at the London branch. Other customers in this Christmas period included

*all dollar price conversions in this chapter at £1 = $1.60.

King Manuel of Portugal, who bought an oval cigarette case enamelled in light pink for £22 ($35.20).

Almost 10,000 items were sold by the Dover Street branch between 1907 and 1917: cigarette cases, photograph frames, miniature Easter eggs, flower studies, clocks, pieces of jewellery, animal carvings. Each item had an inventory number, which was usually scratched on the base, except where it was impossible to find a space for the marks or where marks would disfigure the material used.

Also recorded in the ledgers are the sales of four stone figures: a Chelsea Pensioner bought by Edward VII in November, 1909, for £49 15s ($79.60); a John Bull to Mr S. Poklewski in November, 1908, for £70 ($112); an Uncle Sam to Mrs W. K. Vanderbilt in September, 1909, for £60 ($96); and a sailor to Mme Brassow in October, 1913, for £53 ($84.80). These are among the rarest items in Fabergé's output and are probably the most controversial. Bainbridge estimated that only 50 were made but later scholars, such as Alexander von Solodkoff, believe the total may be closer to 80.

The figures are principally of Russian types, figures of non-Russian origin being the exception. The Russian types are realistic depictions from daily life in St Petersburg: a burly carpenter, a jaunty street sweeper, a massive coachman, a haughty cavalry officer. Some were not generic but of individuals: Nicholas II is said to have commissioned a figure of Pustinikov, the Cossack bodyguard of the Dowager Empress Marie, who accompanied the Empress on all her journeys by car or sleigh. The Cossack had to "sit" for his portrait, as it were, attending the Fabergé studios to be modelled in wax before the stone model could be made.

Another and more romantic example of a portrait figure is the brooding figure of a gypsy woman, Varya Panina, who was a celebrated singer in Russia in the years before the Revolution. She sang nightly at a restaurant at Yar, a village near Moscow, which was notorious for wild parties held by officers of the Imperial Guard. Varya Panina became more famous for her tragic end than her beautiful singing voice when she fell victim to unrequited love: spurned by a member of the Imperial Guard, she took poison and died on the stage in front of him while singing 'My heart is breaking . . .'

Many admirers of Fabergé's work draw the line at the figures, particularly the carvings of Russian types, which are often condemned as mawkish and kitsch, inviting comparisons with garden gnomes or plaster ducks. They were popular at the time, however, serving as table decorations in pre-Revolutionary Russia, and were much admired by many English patrons. Lady Sackville had a mascot of a Russian driver of public vehicles (izvoschik) and took it everywhere.

The figures of Fabergé continued a tradition which had been popular in Russia for years. Porcelain figures produced in the first half of the 19th century were usually humorous, drawing their inspiration from literature, but in the second half of the century they became more realistic, under the influence of the Peredvizhnki ("Vagrants"), who

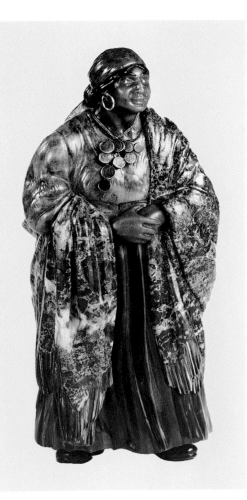

*A*bove: the gypsy, *Varya Panina.*

. .

*B*elow: a dancing mujik *(peasant).*

.

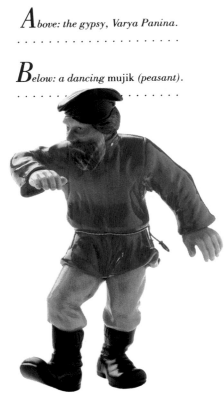

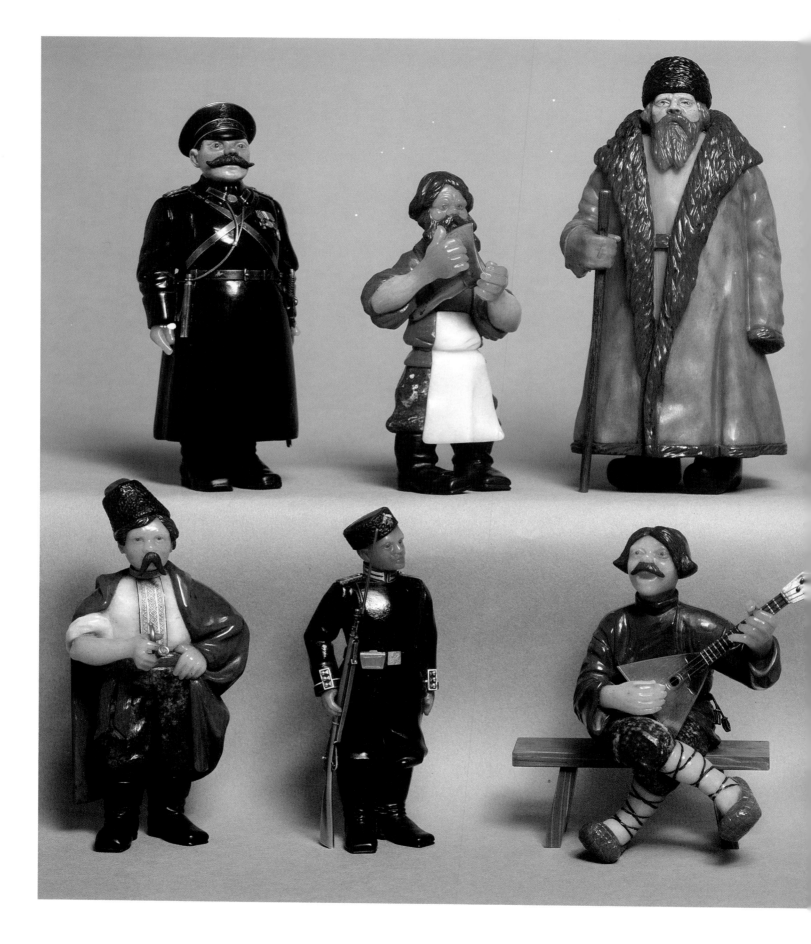

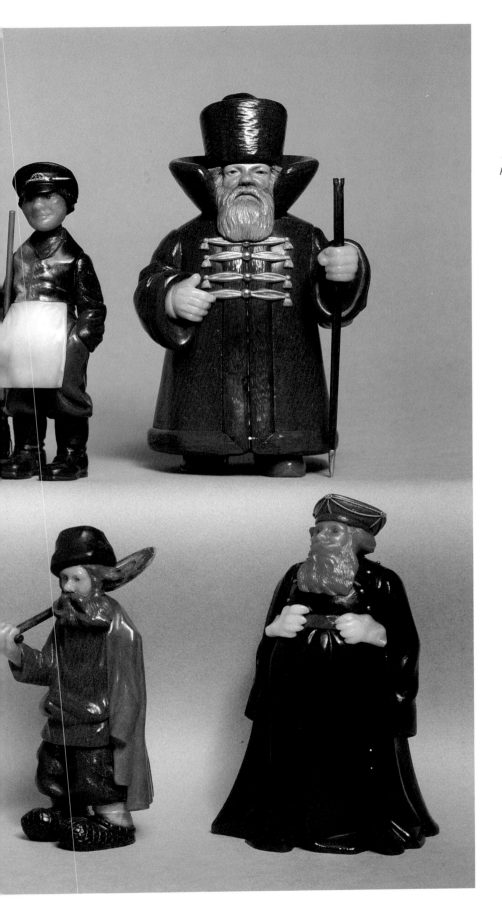

A gallery of Russian characters. Top row, left to right: policeman, carpenter, peasant, houseboy and nobleman. Bottom row, left to right: Ukrainian peasant, soldier of the Preobrazhénsky Regiment, peasant with silver-gilt balalaika, labourer with silver-gilt shovel, coachman.

.

insisted on the social significance of art and organized travelling exhibitions to introduce art to the people. The firms producing the figures moved towards characters from national life, creating workers and peasants which became very popular and were known as "concierge figures", because they were often seen in porters' lodges.

Fabergé is said to have begun the series of figures as the result of a commission from the Grand Duke Nicholai Nicholaivitch for a carving of Queen Victoria which was carried out in jade. He then had the idea that they might be more attractive and more acceptable to his clientele if they were made of different and more valuable materials. Whatever may be thought of the finished objects, it is impossible not to admire the skill with which they were made: the careful selection of semiprecious stones and the perfect way they were assembled, so it is almost impossible to detect that they are actually made up of different parts.

This finely chased gold tassel is an example of the meticulous workmanship of these carved figures.

.

The overcoat on the figure of the Dowager Empress's bodyguard, for example, used green jasper which was bordered with brown obsidian and braided in gold; the hat and boots were in black jasper and gold; the belt in purpurine; the hair, beard and moustache in grey jasper; the eyes of sapphires and the face and hands in a material called cacholong, which was used in later figures to give a more realistic, lifelike impression. In earlier figures, such as that of Varya Panina, the face and hands were in a harder stone, a pink quartz, which had a polished surface. The rest of the gypsy figure is made up of nephrite skirt, red purpurine headdress, black jasper hair and shoes, mottled green stone blouse and red-brown marble for the patterned shawl. Brilliant diamonds are used for the eyes, gold for the earrings and silver for the coins attached to a necklace.

Most of the figures were unique, as might be expected of pieces which were of such value. Some were duplicated but even these were not simply copies but had some unique feature. The John Bull series is a good example: the one owned by the King of Siam had a nephrite jacket while another, formerly in the collection of Sir William Seeds, had a coat of purpurine. Sir William, a former British Ambassador to Russia, was a great collector of Fabergé figures and had acquired a set of 11 from Wartski which the jewellers had bought some years previously for £1,100 ($1,760) in Leningrad.

Another great Fabergé enthusiast, Swedish tycoon Emanuel Nobel, is known, with his brother, to have ordered a large number of the figures. It is to this source that many of the figures now in the museums of the world can be attributed.

Fabergé's name can be found on most of the figures, usually under a foot, sometimes with inventory number and date. They often carry the mark of the head workmaster HW (for Henrik Wigström), but this must not be taken to mean Wigström had any hand in the carvings. He was in control of the workshops but the work of the modelling was carried out by individuals who remain anonymous.

It is thought that Fabergé's inspiration for using different kinds of semiprecious stones for the figures may date back to the European tour

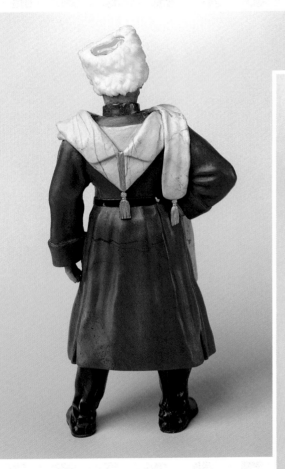

*T*wo views of a Cossack, complete with niello dagger on
his belt. The eyes are cabochon sapphires and the face is
made of cachalong, a fairly soft kind of stone which
enabled the modellers to give their creations more realism
than was possible when pink quartz was used.

.

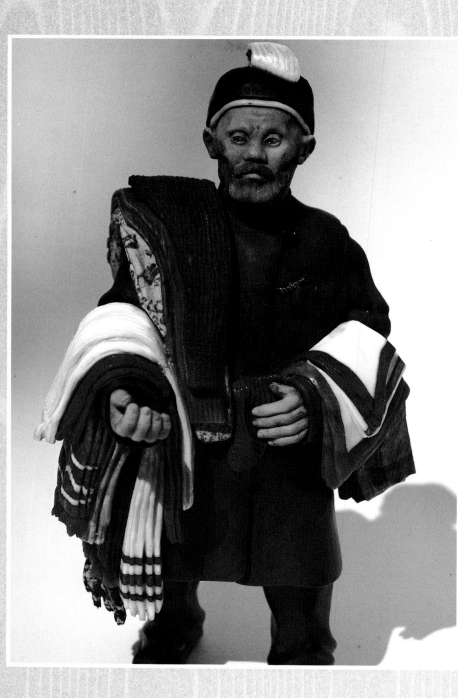

A street vendor figure which shows the variety of stones
used by the modellers. The materials held by the vendor
are in quartz, lapis-lazuli, rhodonite and nephrite.
. .

of his youth. He would almost certainly have seen religious figures made of different stones in Italy, especially Florence, where the Opificio delle Pietre Dure, the hardstone-cutting centre founded by the Medici family and still in existence today, was based. Examples of hardstone objects from Florence and elsewhere were on display in the Hermitage, so Fabergé would have been able to study these too. Russia also had its own tradition of hardstone carving, based at Ekaterinburg and Peterhof, and there was a thriving centre in Dresden, where Fabergé had studied. In his search for expert cutting of the harder stones Fabergé made use of the skills of the craftsmen of the small town of Idar-Oberstein in Germany, and later bought a hardstone-cutting factory in St Petersburg, near the Obvodny Canal.

The most brilliant use of Russia's store of semiprecious stones can be seen in Fabergé's carvings of animals, where the stones were carefully chosen to match the appearance or personality of the animal. Polished green nephrite was used for frogs, velvety black obsidian for seals,

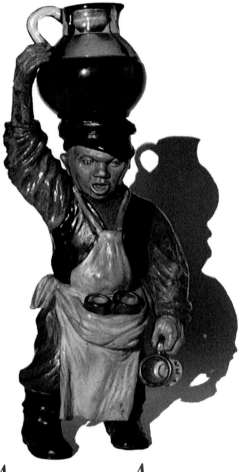

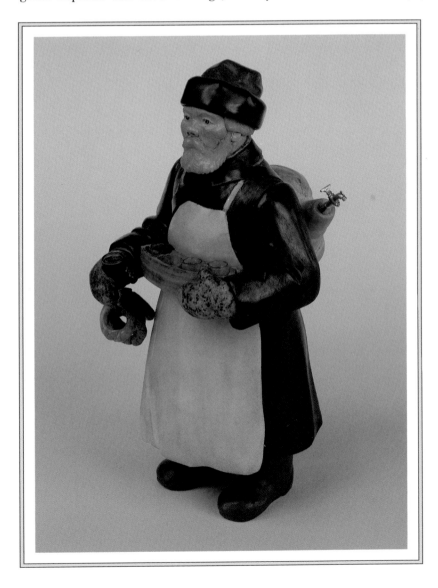

*A*nother street vendor figure, made from a variety of stones — a chalcedony apron, jasper boots, grey granite mittens and an obsidian and lapis lazuli hat.

.

A marvellously lifelike figure of a vendor specializing in the sale of drinks.

.

pink aventurine quartz for horses, various shades of agates for dogs and cats. The care taken with the selection of the stones is matched by the technical brilliance of the carvings, although the designers and modellers of the carvings cannot be identified because they did not sign their works. There are no marks of any kind on carvings made only of semiprecious stones and the markings that do appear on silver or gold parts, such as the beaks or legs of birds, are of the head workmaster. The best modellers, however, known from other sources, were Boris Froedman-Cluzel, Grunberg-Salkaln and George Malycheff.

The artists who created the animal carvings did not strive to achieve a perfect replica of the animal, although they are usually convincingly realistic. The intention was to capture the essential character of the subject, which is achieved by portraying it in a characteristic pose, often with a touch of humour. A duck waddles, a goose eyes the world warily, a dog savours a delicious scent, a cat sits impassively. The range of animals is wide and might well have strained Noah's hospitality: there are pigs, swans, monkeys, baboons, chimpanzees, owls, elephants, crocodiles, bats, cockerels, hippopotamuses, mice, even a pterodactyl. Some are caricatures – for example, a laughing hippopotamus – and others are in strikingly unusual colours, such as red elephants. These forerunners of Disney often earn the disapproval of many who generally enjoy Fabergé's work. There is an equally pained reaction to the few examples of animal studies which are made of different coloured stones in the manner of the figures.

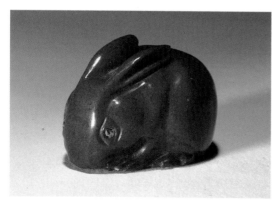

Left: A rabbit in purpurine. Right: An elephant in nephrite. Both animals show the influence of Japanese netsuke carvings which greatly interested Fabergé who had a large collection of them.

.

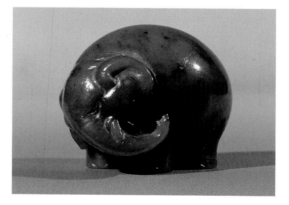

There is a strong Japanese influence in many of the animal carvings, some of which closely resemble netsuke. Fabergé was an admirer of Japanese art, which was so influential at the time, and the netsuke-inspired animals are, perhaps, the happiest of his carvings, more subtle than the naturalistic ones. An almost spherical elephant in purpurine with rose-cut diamond eyes, in the collection of Queen Elizabeth, is immediately likeable, delighting the eye and crying out to be handled, thus fulfilling the intention of the carver.

The largest collection of animal carvings belongs to Queen Elizabeth and its origins are well known. The idea for the collection was born when Mrs Keppel, Edward VII's mistress, suggested to Bainbridge that

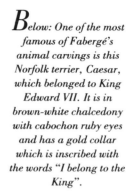
a few carvings of some of the favourite animals at Sandringham might make an excellent birthday gift for Queen Alexandra. Bainbridge applied for royal permission and the next day received a telegram: "The King agrees." He travelled to Sandringham to make the arrangements, expecting that the subjects for carving might be Persimmon, the King's Derby winner, Caesar, his favourite terrier, and perhaps a couple of the Queen's pet dogs. The King had gone a little further, however, and wanted the "whole farmyard" to be done: shire horses, pigs, cows, bulls, hens, every single animal on the farm. It was a considerable commission, disturbing even Bainbridge's sang-froid, since he was afraid it might be beyond the scope of the Fabergé organization. A team of modellers was despatched from Russia, headed by Boris Froedman-Cluzel and augmented by Frank Lutiger, a Swiss who was based at the London branch. They stayed for months and became something of an attraction on the estate, being escorted around Sandringham by the King.

The modelling was completed by December, 1907, and Bainbridge was present for the unveiling ceremony, hidden behind a hedge for some mysterious reason, a vantage point from which he observed the King leaving Sandringham House surrounded by his guests, "dressed in a tight-fitting overcoat and what looked like a small cricket cap". In this unlikely garb the monarch led the procession to the Queen's Dairy, where all the finished wax models had been set and where the modellers stood by their creations awaiting the royal verdict, which was that the King was most pleased and thought the work splendid.

*B*elow: One of the most famous of Fabergé's animal carvings is this Norfolk terrier, Caesar, which belonged to King Edward VII. It is in brown-white chalcedony with cabochon ruby eyes and has a gold collar which is inscribed with the words "I belong to the King".

.

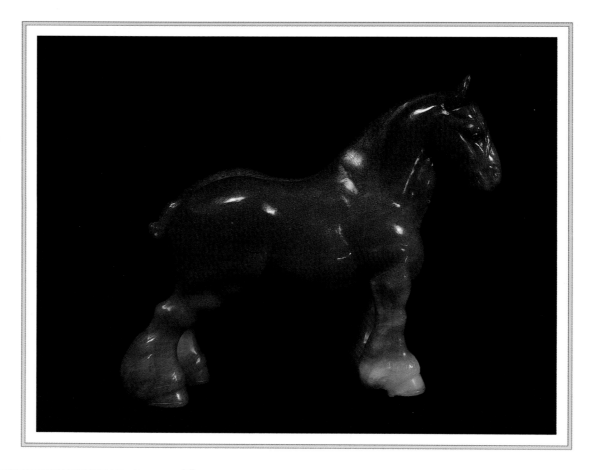

The splendid shire horse, Marshall, was one of the animals modelled at Sandringham in 1907 and was part of the collection of farmyard animals given by King Edward VII to his wife. It is of aventurine quartz with cabochon sapphire eyes.

.

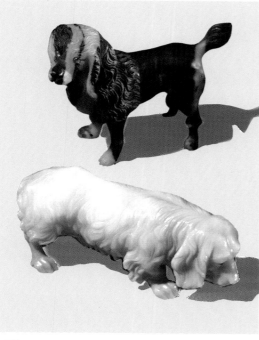

The poodle is grey and white banded agate with yellow stained chalcedony eyes; the spaniel is chalcedony with cabochon ruby eyes.

.

The models were sent to Russia and carved in semiprecious stones as near as possible in colour to those of the originals, with the exception of Persimmon, who was cast in silver. The completed carvings were returned to England and presented by the King to Queen Alexandra to add to her collection of Fabergé objects, a collection which is now in the possession of Queen Elizabeth.

It became the fashion for anyone wanting to make a personal gesture to the King to buy something from Fabergé, something light, elegant, amusing, worlds away from the official plate or furniture with which he was presented while on his official duties. Fabergé's work perfectly met that need, for the King and the rest of Edwardian society. The period between the death of Queen Victoria and the First World War and the Russian Revolution was a time for indulgence, a golden age of peace and plenty, without a dark cloud in the sky. With the succession of Edward to the throne there came an easing of the sterner values of the Victorian period, an awakening of the appetite for the good things of life, a sensual spirit that emanated from the character of the King himself, giving the period its distinctive, racy charm, with its rich combination of elegant ladies, great houses, crowded house parties and the leisurely pursuit of pleasure.

At a time when all the rich were exchanging lavish gifts with enthusiasm, one of the most exceptional of their number was Stanislas Poklewski-Koziell, a counsellor at the Russian Embassy. He must

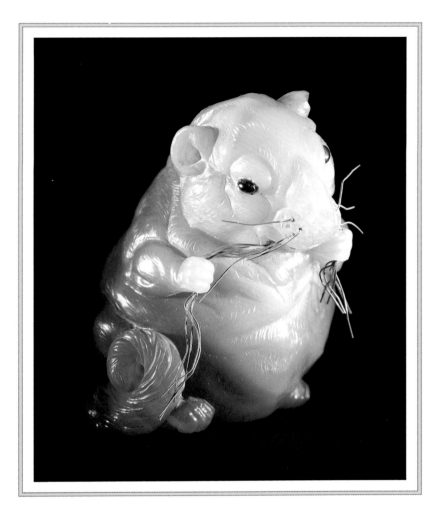

Above: a family group of pigs: a somnolent sow and one of her sleepy offspring are in bowenite. The two piglets at the top of the picture are of brown quartz and the one at the bottom is of pale pink quartz. All have gold-set diamond eyes.

.

Left: a dormouse in brown chalcedony enjoying a nibble of gold straw. It has cabochon sapphire eyes and platinum whiskers.

.

have been welcomed with cries of joy at the country house parties he attended, because he had a habit of taking two large suitcases crammed with trinkets from Fabergé for the ladies of the party. He was a great friend of the King, clearly sharing something of Edward's approach to life. Bainbridge remembers a nice story about them playing cards one night: Poklewski-Koziell lost and found himself short by a pound when settling up; the King made a jocular reference to the debt when they parted and Poklewski-Koziell settled it later with a box made by Fabergé in which the pound was set.

Another splendid giver of gifts was Leopold de Rothschild, again a friend of the King's. He ordered from Fabergé a series of objects in his racing colours of dark blue and yellow which he would give to friends as keepsakes. At the other end of the scale of his generosity was the beautiful vase in rock crystal, mounted in gold and studded with *cabochon* rubies, emeralds and sapphires and decorated with various enamels, which he gave to King George V and Queen Mary on their Coronation on 22 June, 1911. On the morning of the Coronation the head gardener arrived from the Rothschild house at Gunnersbury with fresh orchids from the glasshouses, which were arranged in the vase before it was sent to the palace.

Carved Animals

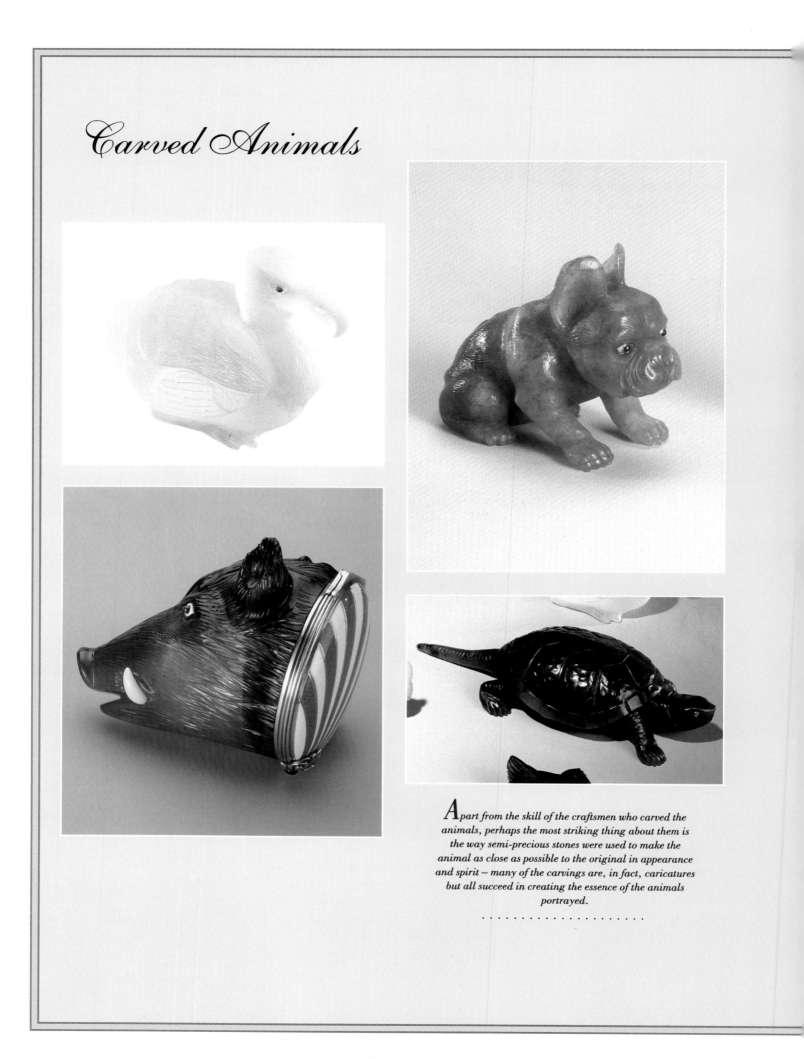

Apart from the skill of the craftsmen who carved the animals, perhaps the most striking thing about them is the way semi-precious stones were used to make the animal as close as possible to the original in appearance and spirit — many of the carvings are, in fact, caricatures but all succeed in creating the essence of the animals portrayed.

.

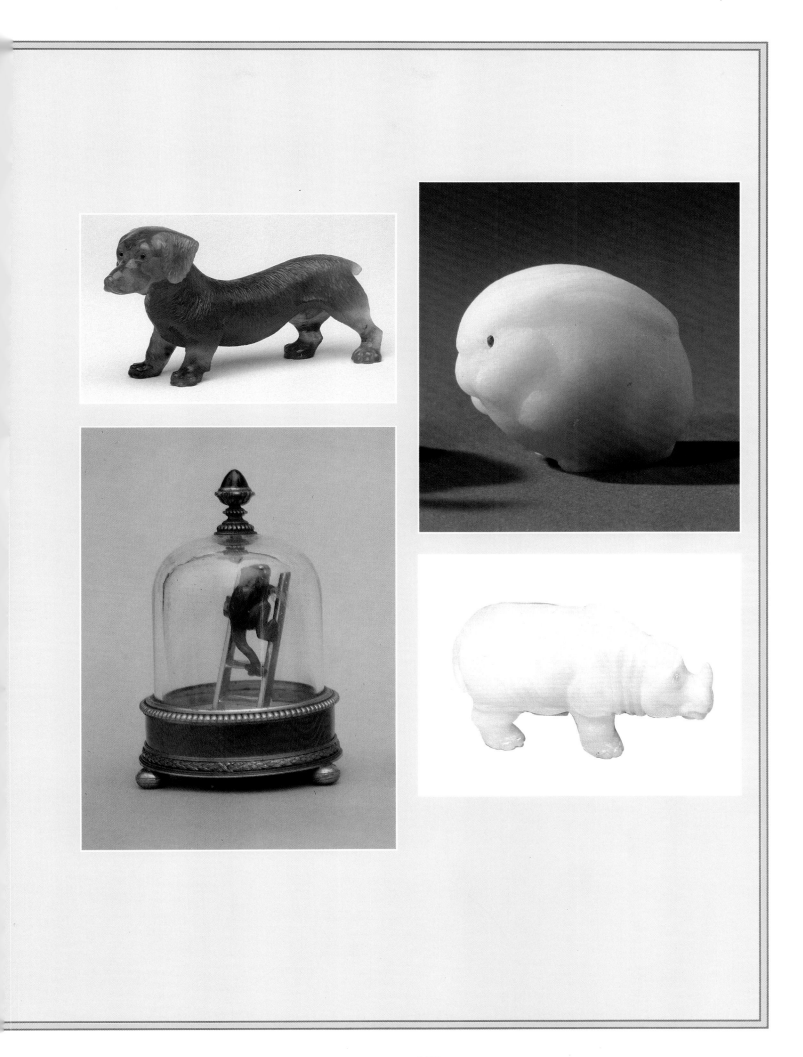

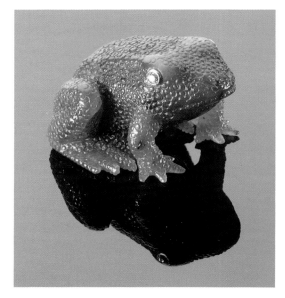

*A*bove: *A carving of a frog in nephrite with gold mounted rose diamond eyes. Right: A superb rock crystal vase in the Renaissance style. Ruby and sapphire cabochons alternate in the band at the top and at the base and it is engraved with the British coat of arms and the date, June 22, 1911. It was a gift from Leopold de Rothschild on the Coronation of King George V and Queen Mary and was sent to them full of fresh orchids from the glasshouses at Gunnesbury Park.*

. .

There was a squall in that balmy Edwardian summer, however, when Fabergé found himself at odds with the Goldsmiths' Company of London, which is concerned with hallmarks and the quality of precious metals imported and sold in England. Their charter of 1327 pointed to the need to prevent fraud by "private merchants and strangers from foreign lands who counterfeited sterling, kept shops in obscure streets, made jewellery in which they set glass of divers colours, covered tin with silver so subtilely and with such sleight that the same could not be separated, and otherwise misbehaved themselves".

In July 1908 the customs authorities intercepted a postal package from Russia to Dover Street, the usual method of transporting goods. The package, which contained cigarette cases and several matchboxes in gold or silver, all of which were enamelled, was sent to the Goldsmiths' Company, who decided that the articles should carry the English hallmark before they could legally be sold in England. The problem for Fabergé was that these finished objects in enamel could not be hallmarked without damaging them, so the ruling was tantamount to ordering they should be returned to Russia. Furthermore, the silver used by Fabergé as a base for enamelling was lower than that permitted to be sold in England: 88 *zolotniks* rather than 91 *zolotniks*. The lower quality was not an attempt at economy but provided a better base for enamelling because the lower-quality material could be brought up to the very high temperatures necessary for the best translucent enamelling while the higher-grade material could not.

Fabergé brought a test case against the Goldsmiths' Company which was heard before Mr Justice Parker in November, 1910. The grounds for Fabergé's case were that the articles he imported for sale were not gold or silver plate and that the gold or silver used was only a small part of the whole; thus the articles should be regarded as jewellery and, therefore, exempt from the need for assaying and hallmarking. The judge was not persuaded and Fabergé lost the case, which meant that articles to be enamelled had to be sent in the rough to London for assaying, an expensive and time-consuming necessity, before returning to Russia for completion.

The worst feature of the case for Fabergé was the problem of having to use higher-grade silver for enamelled objects destined for the English market, a problem which was never properly solved, as can be seen in the enamelled work on English articles after 1910. They never achieved the excellence of enamelling on silver of the lower grade. Supporters of Fabergé felt the Goldsmiths' Company had behaved in a parochial, legalistic manner, but it is difficult to see how it could have acted differently, given its responsibility for maintaining the standard of all gold and silver sold in England. Those on the side of the Goldsmiths' Company thought that Fabergé had taken the action he did believing that, because of his relationship with the Royal Family, he would win the day. This could well have been so had the case been heard in Russia, where Fabergé was Court Jeweller to the Tsar, but royal patronage did not have similar influence on the workings of the English court.

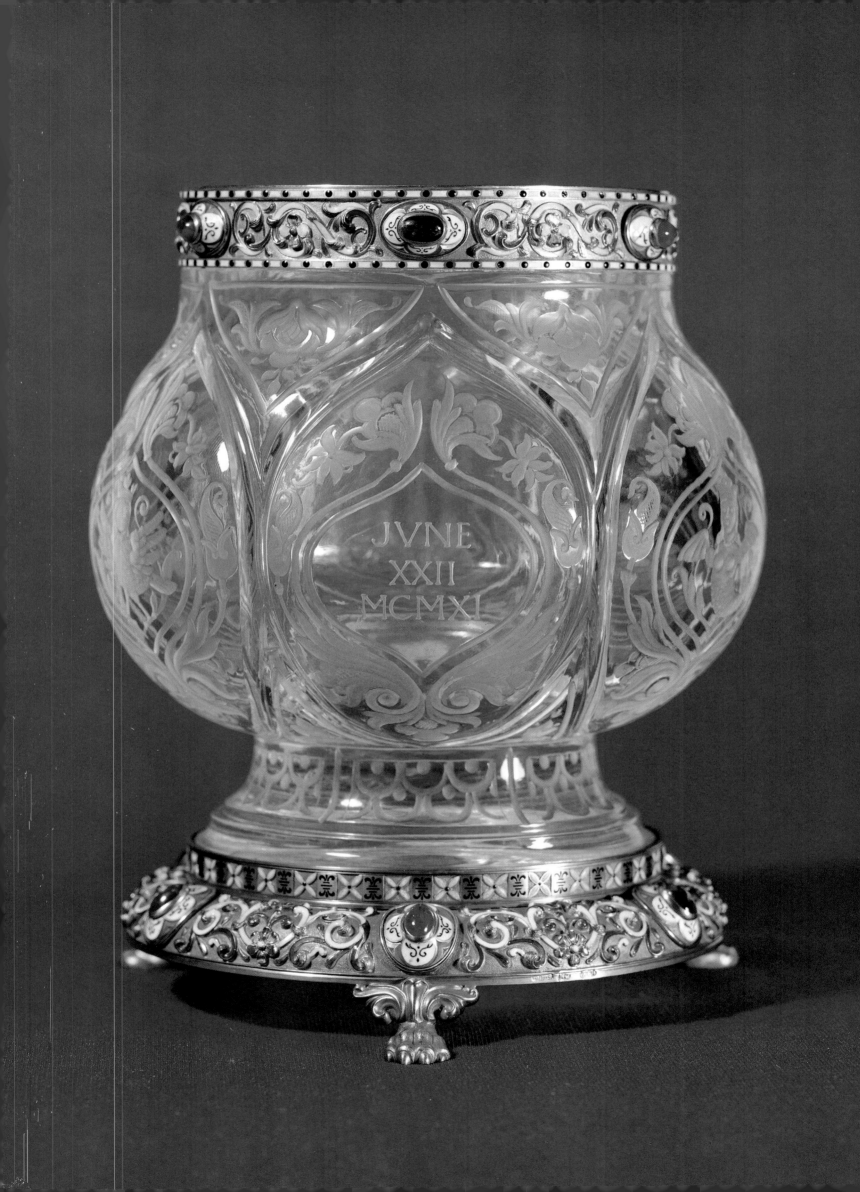

Collecting Fabergé

*Fabergé aimed to give pleasure and to celebrate some
special occasion with a beautiful gift. His creations were
often, perhaps usually, given by men to women: by the Tsar
to the Tsarina, King Edward to Queen Alexandra, a Russian
officer of the Imperial Guard to an admired ballerina or an
Edwardian gentleman to a social beauty. No-one during his
lifetime would have thought of amassing a collection of
Fabergé objects; his creations were of the moment, pleasing
indulgences. However, times have changed as have tastes.
One might ask whether the modern interest in Fabergé is
based on admiration for his work, or the fact that it
commands ever-increasing prices in the world's salerooms.*

*A major piece by Fabergé – a nephrite tray in the
Renaissance style. The gold handles are enamelled in
various colours and set with large diamonds. It was given
by the Dutch colony of St Petersburg to Queen
Wilhelmina of Holland to mark her wedding in 1901.*

.

THE CONCEPT OF CREATING COLLECTIONS of Fabergé's work was almost unknown during his lifetime. Many, perhaps most, of the charming objects he created were given to mark some ephemeral occasion with a moment of pleasure. The hundreds of items made for the Imperial Court were not amassed with the intention of forming a collection but as gifts for members of the Romanov family or to be presented to important state visitors. Generally, they were acquired to be given away — non-Imperial patrons such as Emanuel Nobel ordered in quantity so he could liberally bestow items on friends, as did Leopold de Rothschild.

There were exceptions, though. Barbara Kelch was a serious collector for whom Fabergé made more extravagant Easter eggs than any other non-Imperial patron. Countess Torby, wife of Grand Duke Michael Mikailovitch, had a weakness for Fabergé's elephants and her collection was added to by her daughter, Lady Zia Wernher. Most notably there was Queen Alexandra, whose collection was enlarged by the many gifts from her husband and was added to later by members of the British Royal Family, notably Queen Mary. This collection is the largest, consisting of some 450 pieces, and finest in the world.

American interest in Fabergé's work, which increased markedly after the Russian Revolution and between the First and Second World Wars, had in fact begun around the turn of the century when the yachts of the leading financial families of the United States would occasionally make an appearance in Russian waters, anchoring in the Neva and taking in the sights of St Petersburg, including Fabergé's establishment there. J.P. Morgan Jr. bought a miniature sedan chair with pink guilloche panels and rock crystal windows, inlaid with mother-of-pearl, for his legendary father, a man who had the wealth to buy almost anything he desired. Another wealthy visitor was Henry Walters of Baltimore, who arrived off St Petersburg in 1900 aboard his massive 500-ton yacht

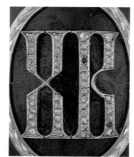

A Fabergé egg (left) of two-colour gold and nephrite. The nephrite body is overlaid with a trelliswork of red gold and the central band is chased with gold leaves. The letters (above) are set in diamonds; they are initials for the Russian words "Christ has Risen".

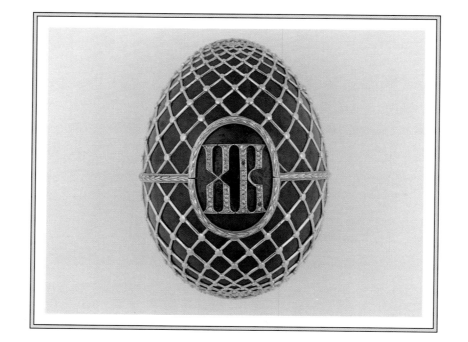

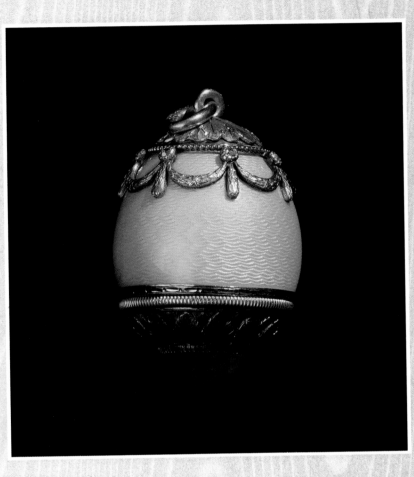

*A scent flacon egg – an occasion when a Fabergé egg
had a functional use. The egg would be worn on a
pendant or a bracelet so the wearer could use the scent
easily. The stopper is set with a moonstone, the egg itself
is enamelled a beautiful shade of delicate blue with
garlands and swags of gold set with diamonds around
the loop where the egg would be attached.*

. .

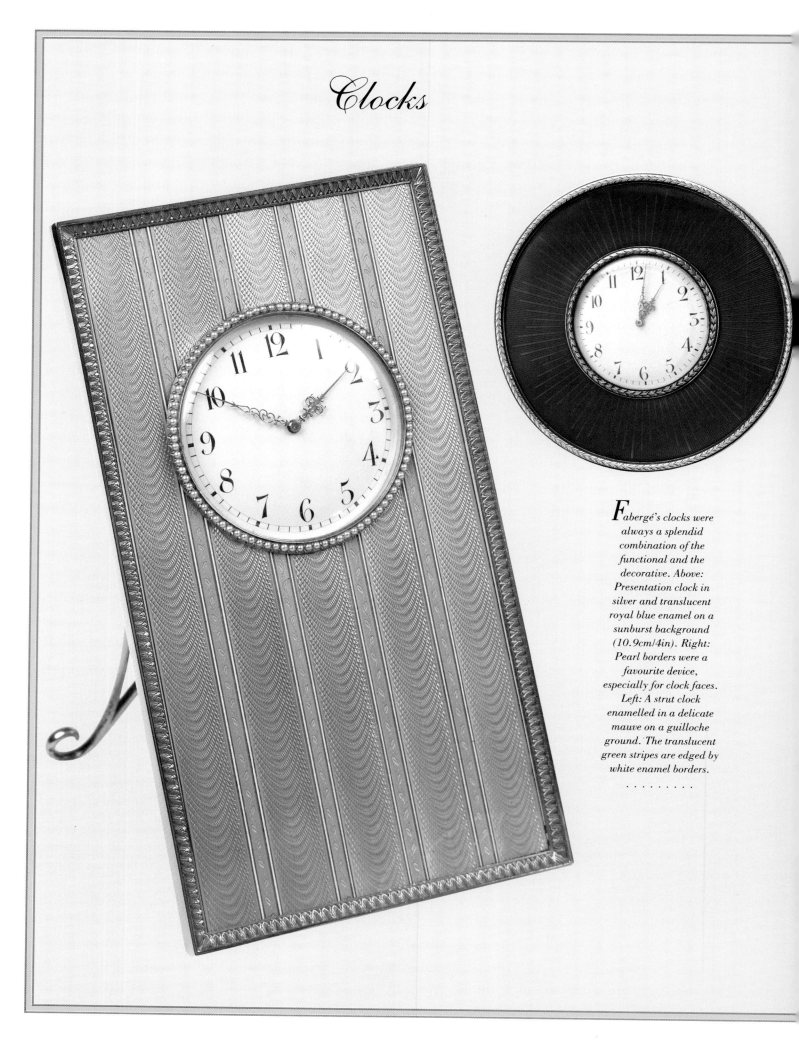

*F*abergé's clocks were always a splendid combination of the functional and the decorative. Above: Presentation clock in silver and translucent royal blue enamel on a sunburst background (10.9cm/4in). Right: Pearl borders were a favourite device, especially for clock faces. Left: A strut clock enamelled in a delicate mauve on a guilloche ground. The translucent green stripes are edged by white enamel borders.

.

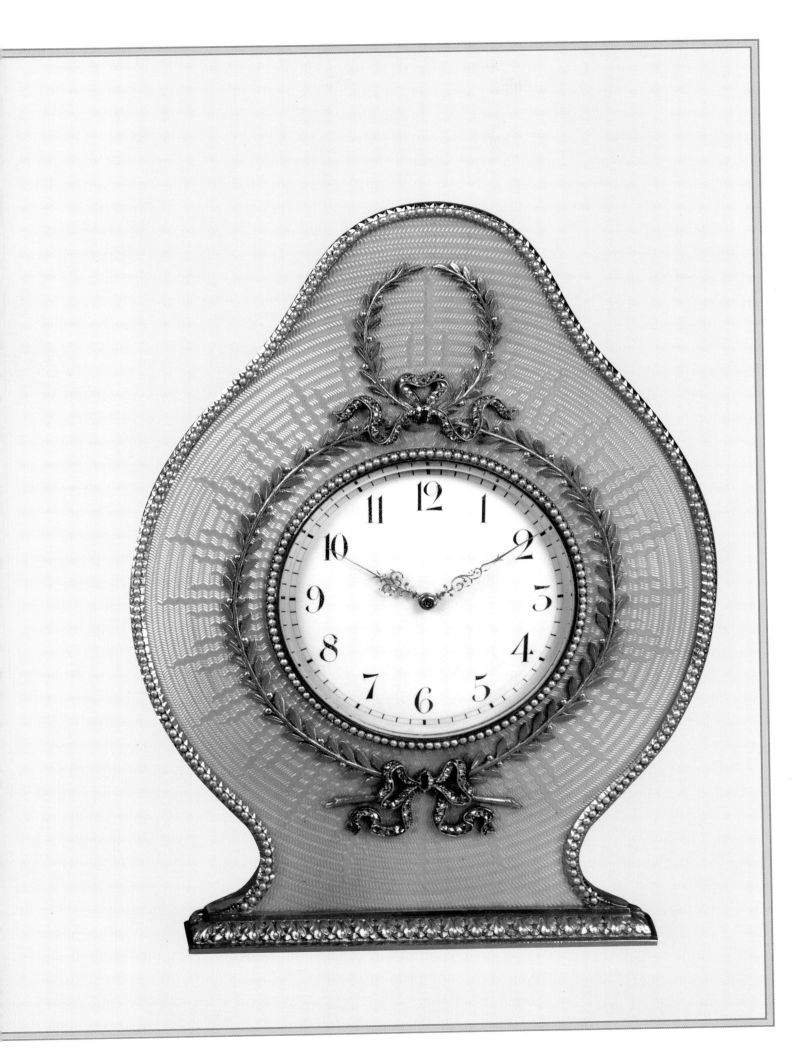

Nerada and bought a few trinkets from Fabergé's showrooms, including some carved animals and parasol handles for members of his family.

The American-born Duchess of Marlborough was an early customer of Fabergé's St Petersburg showrooms. Her visit to St Petersburg with her husband when she was received by the Dowager Empress, Marie, seems to have inspired the commission of her egg, based on the Empress's Serpent Clock.

Widespread interest in Fabergé's works was stimulated in the West after the Revolution by enterprising businessmen such as Armand Hammer in the United States and Emanuel Snowman in London, who brought large quantities out of Russia with them. Hammer's collection was sold off during the Depression, apparently with some difficulty, and many items are now in the leading American collections of Fabergé, most of which were assembled at that time. These include the India Early Minshall Collection in Cleveland; the Lilian Thomas Pratt Collection in Virginia; the Marjorie Merriweather Post Collection in Washington, DC; the Matilda Geddings Gray Collection in New Orleans; and the Walters Collection in Baltimore. All these collections contain some of Fabergé's finest work, including the Imperial eggs.

This miniature egg with a red cross reflects the interest taken in the Red Cross nursing organization during the First World War. The egg (top) has a popular motif – the Imperial eagle.

.

The honour of having the greatest number of Imperial eggs goes to magazine publisher Malcolm Forbes, who began his indefatigable pursuit of Fabergé objects in the 1960s and has now amassed a collection of almost 300 Fabergé pieces, including 11 of the eggs. Other American collectors have included leading socialites such as Mrs Vincent Astor, Mrs Barbara Hutton, Mrs Henry Ford and Mrs Evelyn Lauder and at least one personality from the world of show business, Mrs Bing Crosby, who made an unsuccessful bid for the Chanticleer Egg, now in the Forbes Collection. She is said to have wanted it for two reasons: it sang and the colour of the blue enamel was the same as her husband's eyes.

Kenneth Snowman has written about his father's travels to Russia in the 1920s in search of works by Fabergé. The precious fruits of these journeys were displayed by Wartski in the 1927 exhibition, the first of a number of important exhibitions put on by the jewellers.

The exhibition of Russian art at Madame Koch de Gooreynd's home in Belgrave Square in 1935 created more interest, especially among the press, as it contained Fabergé pieces from all the leading English collectors, including Queen Mary.

Wartski has always been at the centre of trade in Fabergé's work. Its customers have included all the principal collectors, including members of the Royal Family.

Among the pieces acquired by the firm in Russia was the Rosebud Egg, presented by Nicholas II to Empress Alexandra in 1895. This was later bought by the eccentric and irascible Englishman Henry Talbot de Vere Clifton, who at one point is said to have hurled it at his wife, damaging the delicate object (history does not record the extent of the damage inflicted on the lady). The Rosebud Egg was lost for a time but was finally tracked down by Christopher, the determined son of Malcolm Forbes, as described in *Art and Antiques*:

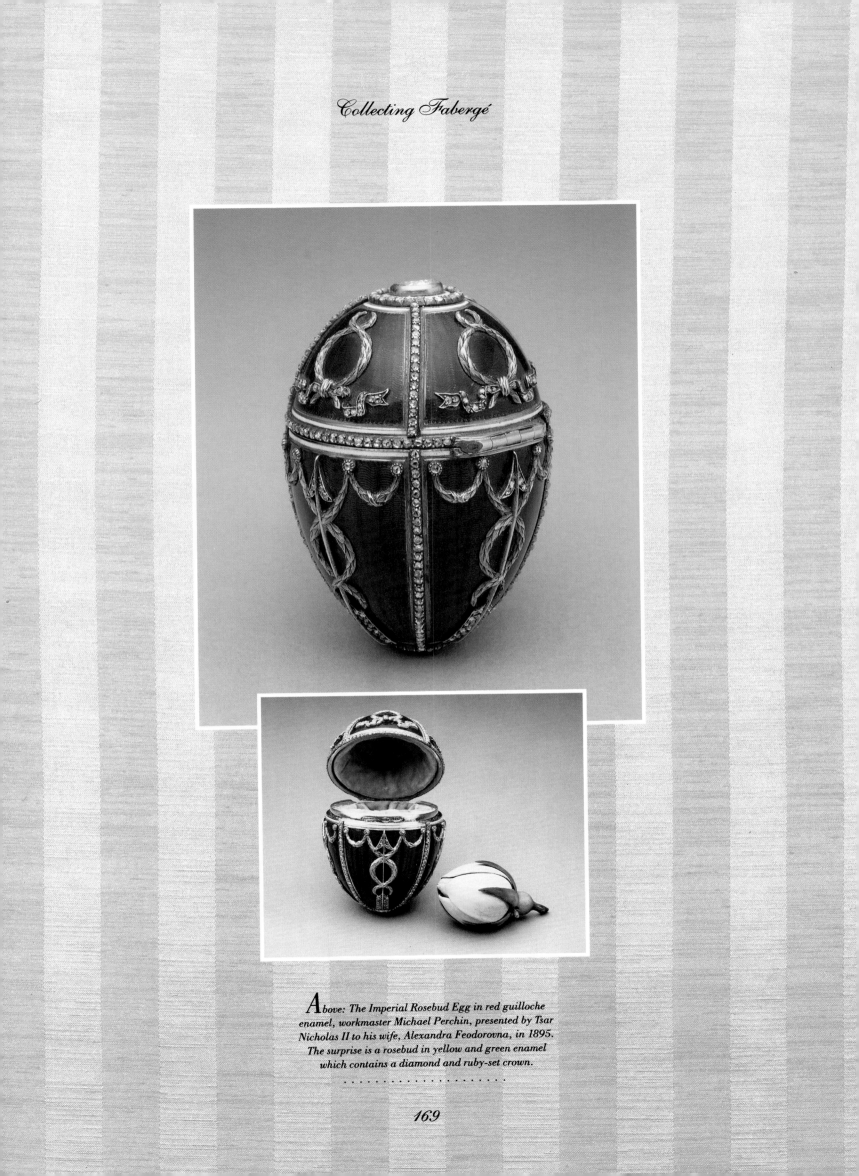

Above: The Imperial Rosebud Egg in red guilloche enamel, workmaster Michael Perchin, presented by Tsar Nicholas II to his wife, Alexandra Feodorovna, in 1895. The surprise is a rosebud in yellow and green enamel which contains a diamond and ruby-set crown.

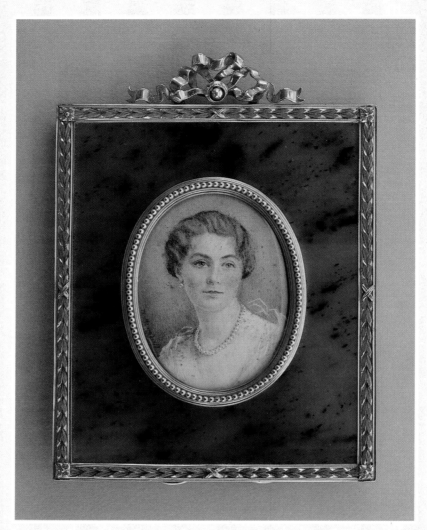

A miniature frame in nephrite and two colour gold by Fabergé, workmaster Michael Perchin. The border is chased in laurel leaves and the oval frame has a beaded surround. The identity of the lady is not known.

.

"One photograph of the egg survived in the Wartski archives and was published in 1952. Subsequent editions of The Art of Carl Fabergé *(by A. Kenneth Snowman) record it as 'present whereabouts unknown'. And so it was until a few months ago when leading jewellery dealer Paul Vartanian heard a colleague say, casually, that a friend of his had a Fabergé egg: would Paul like to see a snapshot? Good friend and neighbour that he is, Paul called me. After Byzantine negotiations I confirmed that it is the egg given by Nicholas II to his bride in 1895 (And, yes, it has been damaged in a way that suggests it was either dropped . . . or thrown.)"*

Now repaired, the Rosebud Egg can be seen with other treasures in the Forbes Collection in New York.

A major European collector was the Swiss Maurice Sandoz, who collected some of Fabergé's most exquisite pieces, including the Swan Egg, the exterior of which is in a beautiful shade of mauve enamel and which contains a surprise of a swan that can be made to swim on an aquamarine lake, and the equally magnificent Peacock Egg, which has a surprise of a bejewelled peacock which struts in appropriately proud fashion. Both pieces are now in the collection of the heirs of Maurice Sandoz at the Musée de l'Horlogerie, Le Locle, Switzerland.

Another wealthy collector of Fabergé's work, and much else besides, was King Farouk of Egypt, who gathered together a huge collection which was then sold at auction after he was forced to abdicate in 1954.

Although Fabergé made some objects that were relatively inexpensive when compared with his most luxurious pieces, nothing was ever cheap and his customers were seldom other than rich. The sales ledgers for the London branch in the early 1900s show that it was possible to buy a

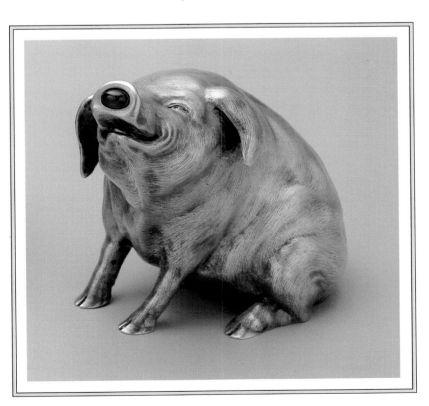

A silver bell push in the form of a seated pig, his snout mounted with a cabochon ruby push piece.
.

A nephrite pen with reeded gold mounts and two diamond-set snakes with cabochon ruby heads.
.

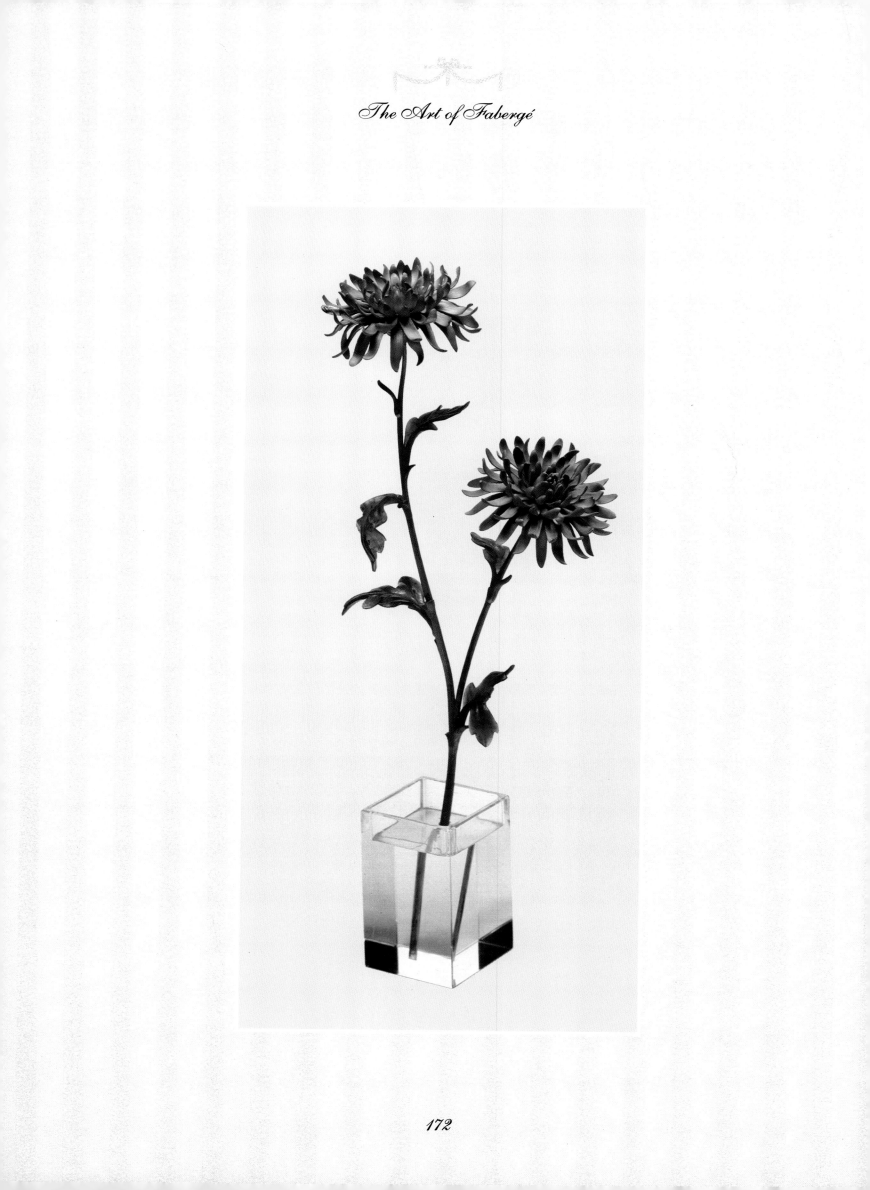

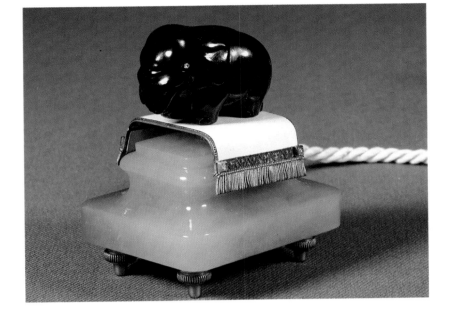

An electric table-bell push in the form of an obsidian elephant on a bowenite base.

.

Left: A chrysanthemum flower which was sold for £117 ($187) in 1908. Above: The flower is delicately enamelled, the thin petals in pink and yellow.

.

standard silver cigarette case for £7 ($11.20)*, but cases which were enamelled or made of semiprecious stones could cost up to £80 ($128) and gold cases were more than £100 ($160). The small carved animals were expensive trifles at £25 ($40). The flower studies could be bought for as little as £20 ($32), but the most expensive of the sales recorded in the ledgers is of a beautiful, deceptively simple chrysanthemum sold to Mrs S. Poklewski for £117 ($187) in 1908. Enamelled photograph frames could cost as much as £30 ($48); frames in wood could be bought for about £4 ($6.40).

Comparisons of prices at the time give some indication of the relative value of Fabergé objects. Dinner at the popular Cuba Restaurant in St Petersburg could be had for 3 roubles (approximately 6s ($0.80)); a room at Claridge's Hotel in London cost about 10s 6d ($1.20); a dock worker in regular employment in London could earn between £1 and £1 5s ($1.60 and $2.30) a week; a competent cook in domestic service might expect £30 ($48) a year; and the maids of a modest establishment would receive £16 to £22 ($25.60 to $35.20) a year.

Special commissions were more expensive, of course. The Imperial eggs cost about £3,000 ($4,800) on average and diamond necklaces were up to £5,000 ($8,000). A pearl necklace given by Tsar Nicholas to his Empress cost £25,000 ($40,000). A massive silver table service in the Gothic style for the mansion of Barbara Kelch on fashionable Sergeevskaya Street in St Petersburg cost £12,500 ($20,000).

There was a drop in the market value of Fabergé's work after the First World War. This was largely caused by the number of pieces on the market (sold by impoverished émigrés to obtain currency and the new Soviet Union to prop up its shaky finances) but also because fashion had changed and his style was no longer in such demand. Prices remained low for some time. The records of Wartski in the 1920s show that Fabergé animal carvings were sold for between £1 and £5

*all dollar price conversions at £1 = $1.60.

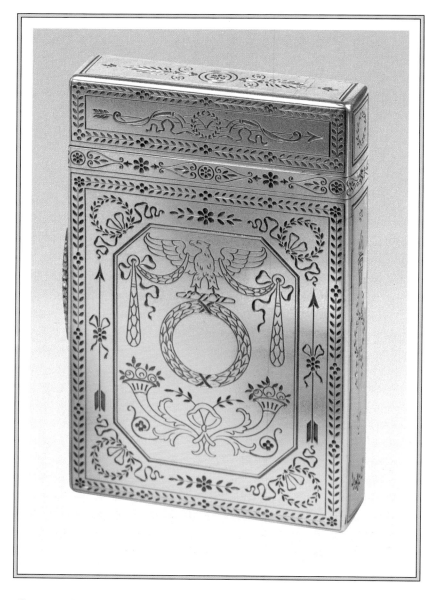

This gold cigarette case with its elaborate design is a fine example of the meticulous workmanship produced by the Fabergé workshops.

.

($1.60 and $8) and that Queen Mary, an eagle-eyed spotter of a bargain, bought the Colonnade Egg from the firm in 1929 for £500 ($800). A number of Imperial eggs were sold by Wartski between the First and Second World Wars, including the Orange Tree Egg in 1934 for £950 ($1,520). Christie's sold the first Imperial Easter egg at auction in 1934 for £85 ($136) and the Resurrection Egg for £110 ($176).

Prices began to increase in the 1930s as serious collectors of Fabergé began to emerge. In general, people became more aware of Fabergé as more information on his art became available.

The next major opportunity to assess Fabergé prices came after the Second World War with the sale of King Farouk's collection by the Egyptian government in 1954. The event caused considerable interest at the time, not only among collectors but among a general public that had been starved of luxury during the war. The auction of some 150 objects realized the then substantial sum of £32,000 ($51,200) and

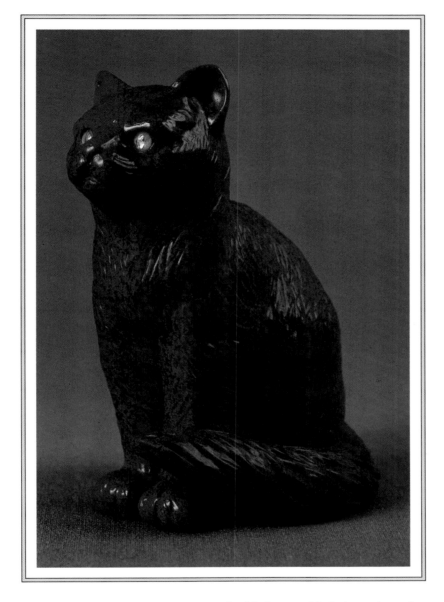

One of Fabergé's best-known studies, this purpurine cat has rock crystal eyes with yellow and black enamel pupils.

.

many of the items that came up doubled or trebled the prices they would have obtained before the war. Much excited comment was made at the prices the Easter eggs fetched: £5,800 ($9,280) for the Swan Egg of 1906 and £3,800 ($6,080) for the Hen Egg of 1898 made for Barbara Kelch.

Further evidence of the increase in value of Fabergé's work came in 1958 with a sale organized by Christie's at which animal carvings made more than £1,500 ($2,400) and flower studies were sold for £900 ($1,440). Fabergé's carving in purpurine of a cat with rock-crystal eyes tells a similar story and this must have caused satisfaction to successive owners: it was sold by Wartski in the late 1920s for £75 ($120), made £1,732 ($2,771.20) in 1959 and had leaped to £19,643 ($31,428.80) when it was sold by Christie's in Geneva in 1974.

The 1916 St George Egg was sold for £11,000 ($17,600) in 1961. The 1900 Cuckoo Clock Egg made £80,000 ($128,000) when it was sold in

1973 but had climbed to a dizzy £1.1 million ($1.76 million) when it was acquired by Malcolm Forbes in 1985.

The dispersal of the Fabergé collection of the American Lansdell K. Christie in New York in 1967 saw the continuing spiral of prices, as 66 lots realized more than £100,000 ($160,000), with a diamond Imperial presentation box making £13,400 ($21,440) as did a piece of miniature furniture.

The trend continued at a series of sales held by Christie's in Geneva in the mid-1970s. The Balletta Box (presented to the famous ballerina Elizabeth Balletta by one of her many admirers, the Grand Duke Alexei Alexandrovitch), which had been sold for £10,700 ($17,120) at the Lansdell Christie sale, made £24,700 ($39,520).

The carved Russian figures, which had been realizing under £10,000 ($16,000) in 1960, also increased in value, with the figure of Varya Panina, the tragic gypsy singer, fetching £26,000 ($41,600) at Christie's in Geneva in 1974. A figure of the caretaker (the Dvornik) at Fabergé's St Petersburg branch at 24 Morskaya Street, which had been sold by Wartski in 1937 for £300 ($480), reached £35,000 ($56,000) at Sotheby's in Zurich in 1978.

At these prices, it is clear that buying the work of Fabergé is a serious business involving serious money. Times have changed since the days when a gentleman would spend a little pleasurable time in Morskaya Street in St Petersburg or Dover Street in London selecting some expensive trinket for the lady of his choice. Buying Fabergé is now an investment, and an excellent one, as prices appear to be rising inexorably. It would be a very rich individual indeed who bought solely for pleasure, calling on Wartski today to pick up such treasures as a beautifully made cigarette case in different colours of gold for some £23,000 ($36,800); a carving of a pigeon showing the influence of netsuke for £86,000 ($137,600); a boar in quartz-aventurine for £57,000 ($91,200); or perhaps a spray of lilies of the valley for £160,000 ($256,000).

The upward trend in prices continued at the most important sale of Fabergé objects in recent years, held at Christie's, Geneva, on 10 May, 1989, when the Pine Cone Egg made for Barbara Kelch in 1900 was sold for £1.9 million ($3.04 million) – a fabulous price for a fabulous object. More than 100 lots were snapped up at the sale and prices reflected the usual trend. A gold-mounted nephrite cigarette case, discreetly luxurious, was sold for £16,500 ($26,400); a gold-mounted enamel and nephrite photograph frame made £28,300 ($46,980); a gold-mounted, jewelled carving of a tortoise £51,000 ($81,600).

Interest in Fabergé is not restricted to the luxurious objects made by the firm but includes anything that provides information about the man and his works. The discovery of the two volumes of jewellery designs from Albert Holmström's workshop for the period 1909–15 provided fascinating insights into the way the firm operated, as did the sales ledgers for the London branch for the period 1907–17. Another valuable source of information came to light with the sale of designs from the

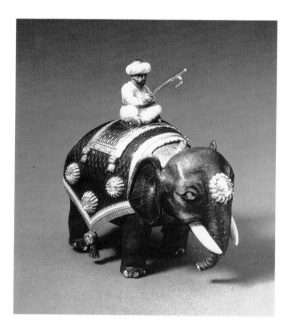

The splendid Pine Cone Egg, workmaster Michael Perchin, given by Alexander Kelch to his wife, Barbara, in 1900. The body is of a magnificent translucent royal blue enamel over a sunburst guilloche ground, encrusted with rose-cut diamond crescents. At the top four diamonds form a quatrefoil enclosing the date 1900. The surprise is as magnificent as the egg – an elephant automaton in oxidized silver carrying an enamelled mahout seated upon a gold fringed red and green guilloche enamel saddlecloth. When wound with a gold key, the elephant lumbers forward, swishing its tail.

.

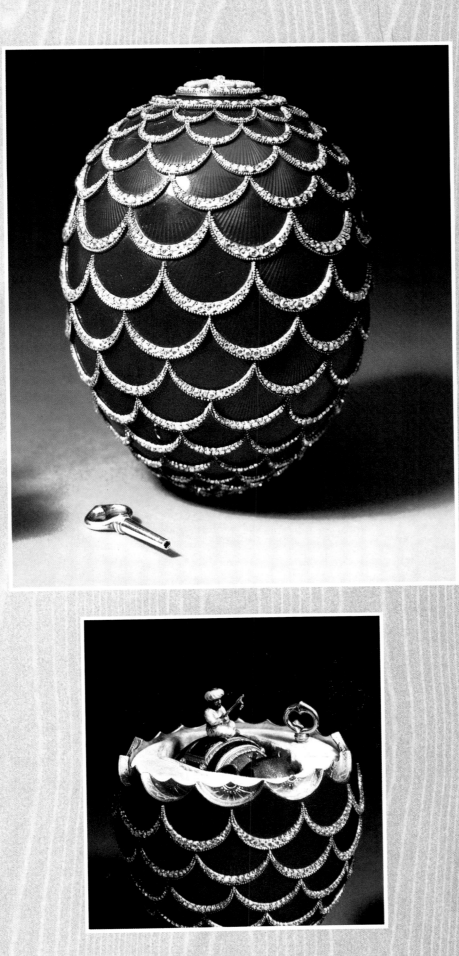

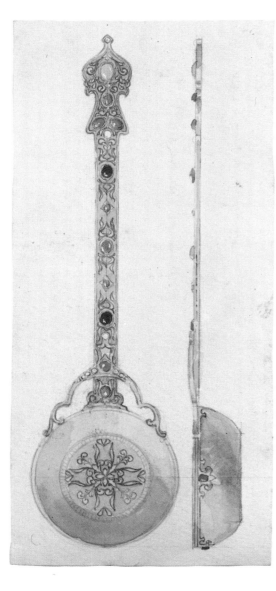

*A*bove: *Jewelled Caucasian wine spoon. Below:*
Enamelled dragonfly ornament.

House of Fabergé held by Christie's of London in April, 1989. These were 128 lots of pencil, pen and ink, and watercolour studies of sketches of a range of Fabergé productions. Most of the designers are anonymous but some are known to us thanks to Bainbridge, whose position as manager of the London branch meant he knew or met many of the Russian employees during his visits to Russia during the early years of the 20th century.

Bainbridge identified Zosim Kritsky as a Russian who designed objects of fantasy in silver, and the designs on offer included several examples of his work, notably a number of drinking vessels decorated with sea-monsters, mermaids and animals. Another designer he named was Eugène Jacobson, a Balt, who designed all kinds of silver objects and whose work was represented by a number of designs in the sale.

The drawings date from 1880 to 1915 and show a typically wide variety of influences: Renaissance, Baroque, French 18th century, 19th-century Empire and Art Nouveau. They also indicate the range of Fabergé's day-to-day production, as it were, with designs of toilet sets, silver tea services, drinking vessels of many kinds, desk sets, table ornaments, lamps, photograph frames and jewellery.

Many of the designs have historical connections, such as those for the magnificent silver gilt *kovsh* (traditional drinking vessel) commissioned by Tsar Alexander III and his Empress to mark the golden wedding anniversary of the Empress's parents, King Christian IX and Queen Louisa of Denmark. The completed object was made by Julius Rappoport, Fabergé's leading silversmith, in 1892 in St Petersburg and is now in the Royal Movable Property Trust, Copenhagen. The most striking feature of the design is a large silver elephant with gilt tusks mounted on the handle. The elephant is a familiar theme in Fabergé's work, probably because of its armorial associations with the Danish Royal Family. The two designs made £4,950 ($7,920) at Christie's.

A series of designs of drinking vessels and bowls, ranging from an elaborate gilt and enamelled tankard to a heart-shaped pink bowl with green enamel rim, made £13,200 ($21,120). The designs are especially significant when the resulting objects can be traced, as they can in two instances: a tapering vase resting on a classical tripod was sold by Christie's, Geneva, in 1985 and a beautiful shaped bowenite bowl on a base of entwined snakes was sold by the same firm in 1984.

A beautifully executed series of drawings of bowls, dishes and urns was sold for £18,700 ($29,920) and again, the resulting objects could be identified in some cases, notably a circular enamelled bowl with red, white and green scales and a nephrite *kovsh* with a decorated handle.

The drawings have an innate charm and also, in their precision and elegance, typify the spirit of Fabergé. A lovely drawing of a silver-gilt cloisonné enamel coffee pot in the Old Russian style, but in more muted shades than similar work by Fabergé's contemporaries and probably made by Fedor Ruckert, was sold for £2,860 ($4,576). A delicate watercolour of a silver tablelamp in rococo style with a fluted body and elegantly scrolled arm holding the shade realized £4,180 ($6,688) and another

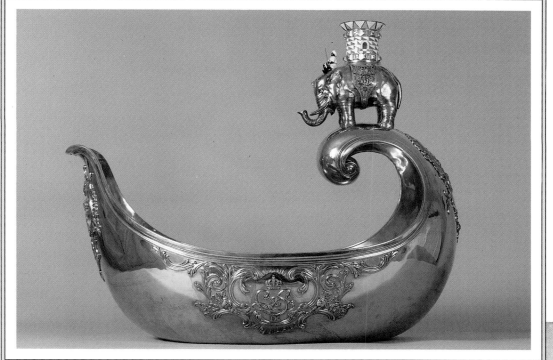

A magnificent silver-gilt kovsh was given by Tsar Alexander III and Empress Marie Feodorovna to mark the golden wedding anniversary of her parents, King Christian IX and Queen Louisa of Denmark in 1892. The workmaster is Jules Rappoport. The date of the anniversary is inscribed on the side and

on the handle is a large silver elephant with gilt tusks bearing a red and white enamelled tower. The original designs omit the tower, which was added because it was part of the Danish Order of the Elephant – the elephant symbolizes chastity and defence of Christianity.

.

drawing of a tablelamp, an Art Nouveau inspiration with a vase-shaped glass body enclosed by vines, set with red *cabochon* stones in which the vines form the base, made £1,115 ($1,784).

Art Nouveau is the influence in a delightful watercolour design of a glass *brûle-parfum*, the purple pear-shaped body decorated with foliage with the leaf motif continuing in the cover and handles, which fetched £2,420 ($3,872). Among the most enchanting as a work of art in its own right was an oviform blue vase with a cylindrical waisted neck around which two snakes are entwined, with three snakes forming the base. The design, which is signed C. Fabergé in Cyrillic characters was sold for £13,750 ($22,000). A similar completed version carrying the marks of Fabergé and workmaster Johan Victor Aarne, a specialist in very fine goldsmith's work, was sold by Christie's in New York, 1988.

Of particular interest are the drawings for jewellery, more remarkable for its lively and imaginative design than its intrinsic value. The brooches, pendants and pins depicted were often relatively inexpensive and revealed Fabergé's taste for combining different materials: semi-precious stones such as moonstones were often used with diamonds, various coloured *cabochon* stones and enamel in a variety of shapes – stars, ribbons, serpents, flowers, geometric forms, fish, clover, berries.

None of the pieces shown in the designs are known to exist. One explanation is that objects being disposed of by Russian émigrés after the Revolution were often broken up and sold for the value of their stones alone, not because they were by Fabergé. Another explanation is given in the 1899 catalogue of the firm's Moscow branch, quoted by Kenneth Snowman in his 1962 study of Fabergé: "It has always been

Design for an oviform blue vase with cylindrical waisted neck and two entwined snakes. Three further entwined snakes form the base. It is signed in Cyrillic K. Fabergé.

.

The head of each snake forms a foot of the base.

.

our endeavour – and our clients can see this for themselves – to offer to the public the greatest possible number of entirely new forms and designs. Goods which have gone out of fashion will not remain in our shop: once a year they are collected and melted down."

The jewellery designs, which were probably for the Moscow workshops are therefore of special value to Fabergé experts: they show the sort of items that were being produced and will be a means of identifying any objects which come to light in the future. This is particularly important as jewellery was often not hallmarked due to its fragility or to lack of space.

Drawings were not only used in the different departments of the organization but were sent to customers to give an indication of what was available or could be made. Christie's were told by a lady named Dagmar de Rehren, who had read about the 1989 sale that as a young girl she had often visited Fabergé's premises on Morskaya Street with her father, who knew the shop well, to discuss commissions. "A few days later an envelope with a few drawings would arrive for us to choose from . . . all private orders were unique."

Given the increasing value of Fabergé's work, it is not surprising that unscrupulous individuals have seen the possibilities of forgery. Bainbridge mentioned the problem in the 1930s and referred to it again, and more fully, in his 1949 book. He pointed in particular to a number of flower studies attributed to Fabergé which he had seen but knew to be forgeries, despite the fact that they carried Fabergé's sig-

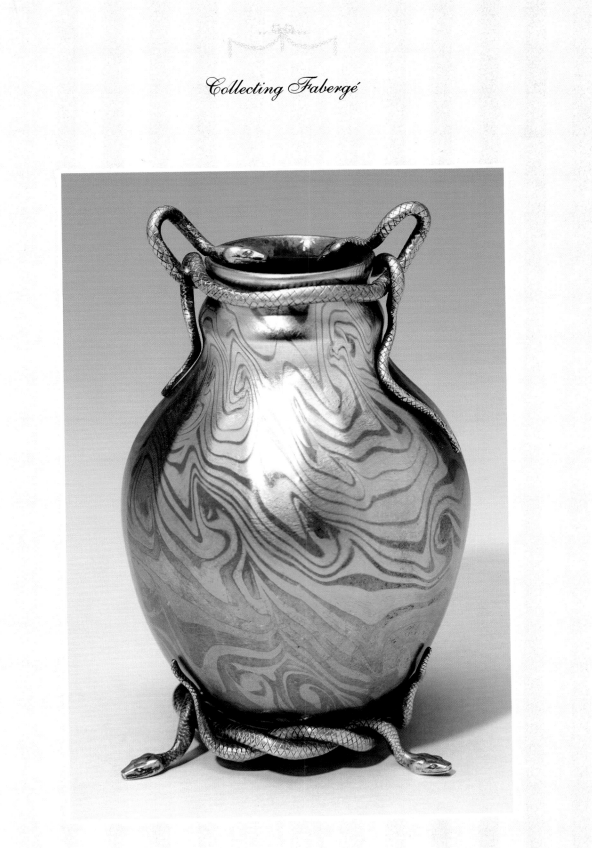

*B*eautifully realized, this stunning vase, signed
Fabergé, workmaster Victor Aarne, was sold at Christie's
New York, in 1988.
.

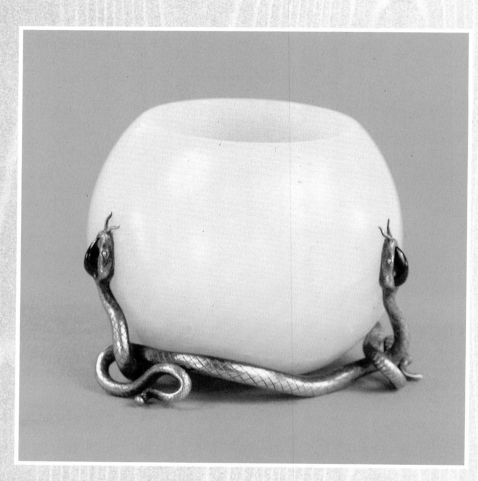

A beautiful bowl in shaped bowenite on an entwined
snake base, the raised heads set with purple stones.
.

The design for the bowl opposite. It is fascinating to be able to compare the two side by side and to see how similar they are.

.

nature and Russian state hallmarks. As we have seen, in the case of the flower studies a lack of hallmarks can be a sign of authenticity, because there was often nowhere to put a mark, and anyway, Fabergé had a somewhat casual attitude towards such things.

Experts warn that marks should be used only as confirmation of probable authenticity rather than as proof, because marks are fairly easy to copy. Often, though, forgers make too much of the marks, using every possible stamp to achieve credibility. as Bainbridge remarked:

"The more indistinct the marks, provided they are clear enough to be recognized, the greater their value. Their indistinctness is almost certain proof of their authenticity and for this reason. They are almost invariably stamped on objects of gold and silver when they are in the rough, and before they are in a finished state, enamelled, chased, etc., a good deal of work has to be done, and in the course of this finishing the marks are subjected to wear and may in some cases quite easily be nearly polished out altogether."

Original hallmarks of this sort are flush with the surface but fake ones are more clear, stamped with greater force into the metal, and often cause an indentation on the reverse side.

A further problem with the flower studies is that some examples which have been incorrectly labelled as Fabergé are not forgeries as such but legitimate works made by contemporaries, such as Cartier of Paris, who was making them in the early years of the 20th century. Even so, there are many intentional forgeries of flowers and other objects proudly displayed as authentic Fabergé in collections throughout the world.

After the Revolution, Eugène Fabergé, with his brother Alexander and Andrea Marchetti, a silver expert who had been manager of the Moscow branch, set up Fabergé & Cie in Paris, repairing and producing a number of items.

Right: A meticulous miniature pianoforte about 7.5cm (3in) long. It is of nephrite and is chased with gold lyres, rosettes and sphinxes. The lid is hinged and forms the lid of a box.

.

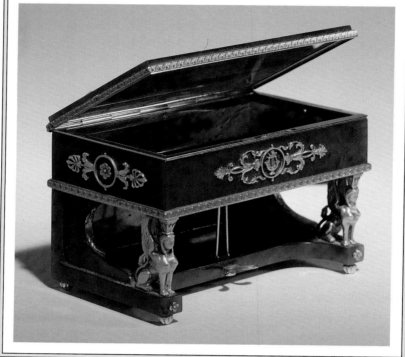

Right: A rather strange piece, but genuine Fabergé – a silver smoker's compendium in the form of a dacha. *The roof lifts to reveal a cigarette compartment with dispenser and the tip of the cigarette is moistened by water from the pump.*

.

Problems can occur because some objects carry the mark A. Fabergé, which is thought to have been either the signature of Fabergé's brother, Agathon, or his son Agathon. A further group of objects carry the mark Th. Fabergé in Cyrillic characters and are the work of one of Fabergé's grandsons, Theo Fabergé, who created works for the Geneva jeweller Lombard. Some of his creations are marked simply Fabergé.

The most difficult forgeries to detect, and those which are therefore the most attractive to forgers, are the animal carvings, which usually do not carry marks for aesthetic and technical reasons (except in some cases where the animal has a gold beak or legs on which hallmarks can be stamped). Establishing the authenticity of the carvings can be done only by experts, who through experience of handling such objects can identify those which are genuine.

The best guide to Fabergé's work of all kinds is its quality, the depth of colour, the finish of the enamel and, where applicable, the perfection of the hinges. This quality is something which even the most brilliant forgers find difficult to match and there is a certain "feel" about authentic work which is immediately recognizable to those who have studied Fabergé. In general, Fabergé avoided repetition in his work, so copies should be examined with care.

Among the most common forgeries are those which were made in Fabergé's style by his contemporaries, genuine copies, so to speak, which were never intended to be passed off as Fabergé's own but which were subsequently given false markings and attributed to him to increase their value. The market in fake Fabergé increased as the flow of genuine objects dried up. Many of the copies are creations of considerable

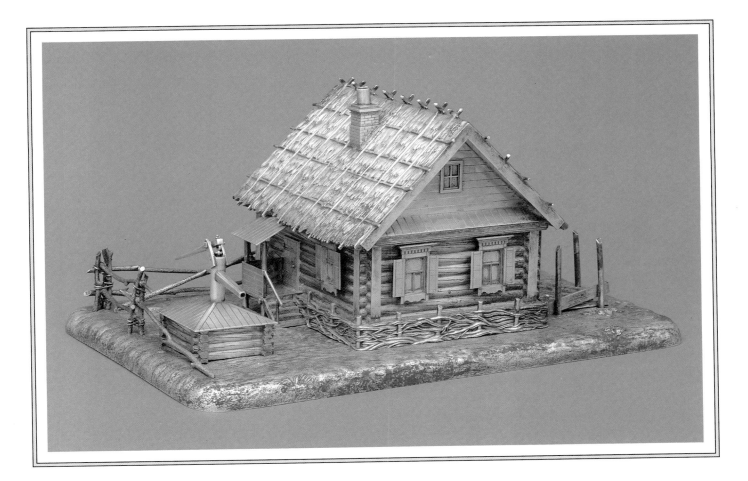

quality: Marucelli and Stiquel in Paris produced some impressive work in the style of Fabergé and enterprising entrepeneurs appeared in the Soviet Union, particularly after the Second World War, with a ready supply of Fabergé "bargains", which tourists were gulled into buying. Clandestine meetings were often arranged with individuals attached to foreign embassies at which more Fabergé copies were acquired and smuggled out of the country through diplomatic channels. Many of these are now gracing homes and museums in various parts of the world, admired as genuine but the work of skilled forgers, some of whom paid a high price for their crimes – at least one was sentenced in a Soviet court to six years' hard labour for faking Fabergé's work.

It must be admitted that Fabergé's work is not universally admired. Some dislike it because it seems to them to reek of a world of privilege; they find something irredeemably vulgar in what they see as the ostentatious display of wealth by the possession of luxurious, extravagant objects; they find something shocking in the concept of spending so much money, effort and time – years in the case of some of the Imperial eggs – on creating objects which they regard as mere jewelled baubles.

Those who take such a view will probably never be converted, but it should be remembered that Fabergé reflected the society in which he lived, just as the goldsmiths of 18th-century France reflected their time. The objects made in the France of the 18th century and the

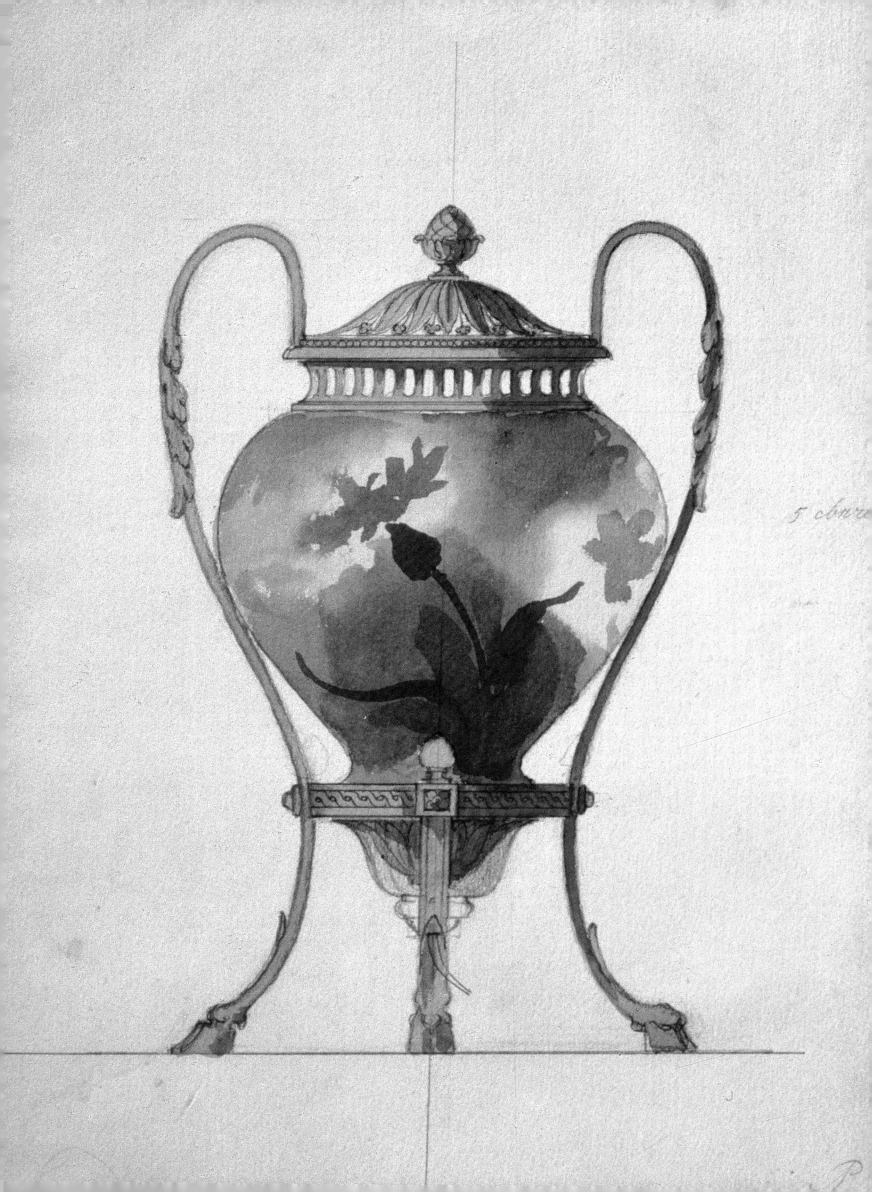

5 店

Russia of the 19th century could have been made only at those times; they speak of the spirit of their age as convincingly as historical documents. Fabergé was also an innovator, particularly in the revolutionary concept of placing emphasis on craftsmanship and quality of design rather than on the intrinsic value of the materials used, and in achieving this with the creations of his *objets de fantasie*, he also succeeded in creating a public demand for his work.

A more serious charge is that Fabergé's work sometimes veers towards kitsch. Critics point to, for example, a matchholder shaped as a pig, mounted on silver, and a silver tablelighter which is shaped like the head of a wolf which protrudes from a shawl, the flame issuing from the mouth. There is something overdone and faintly ridiculous about both pieces which perfectly illustrates pure kitsch. Carrying the same degree of exaggeration is a toadstool naturalistically carved in different colours of agate growing from a mound of unpolished material set with diamonds, the polished head of which can be lifted to reveal a gold-lined inkwell.

Perhaps the objects most likely to make the sensitive observer wince are the Russian national figures, which are made of coloured stones chosen to match the hair or clothes of the subject. The purely naturalistic studies suffer from a lifeless stiffness, while the more animated, almost cartoon, figures are sometimes embarrassingly whimsical. The same generous helping of whimsy can be seen in some of the animal carvings, where animals are caricatured in a style that anticipates Walt Disney.

It may be that examples of this kind were in the mind of Ian Bennett when he was compiling Phaidon's *Encyclopaedia of Decorative Arts, 1890–1940*, in which he takes a highly critical view of Fabergé's work, dismissing it as "the rich man's plaster ducks". He does, however, concede the "unquestionable technical brilliance and perfectly orchestrated use of materials" and the "extraordinary workmanship" of Fabergé's work.

A tribute of the same kind was paid to Fabergé by Henry H. Hawley, curator of the India Early Minshall Collection, Cleveland Museum of Art, when he wrote:

"Even a limited study of the products of Fabergé's workshop indicates that technically they are unsurpassed in the history of European manufacture of objects in precious metals with enamel and jewelled decorations and hardstone carvings. Their only serious rivals are several Parisian and a handful of German workshops of the 18th century, and in at least one respect, the use of transparent enamels, Fabergé clearly exceeded all previous efforts. Thus it can be safely stated that the outstanding products of Carl Fabergé are technically the very best things of their kind ever to have been made in the West."

A more personal accolade came from that ardent devotee Queen Mary, wife of George V, a lady who kept her emotions well in check but was moved to say, while caressing one of Fabergé's cigarette cases, "There is one thing about all Fabergé's pieces, they are so satisfying."

*A*n episcopal panagia *(small pendant icon intended to be worn by a bishop). The painting depicts Christ with the open Gospel and the words: "Peace be upon you". It is decorated with blue enamel and six red gems.*

.

*A*n enchanting design for an art nouveau Brule-parfum *in glass. The circular acanthus leaf cover has an acorn finial, the curling handles are decorated with leaves as is the purple body, and it is mounted on four cloven hooves.*

.

Index

Note: illustrations are shown in italics after the text references. Bold figures denote main references

A

Aarne, Johan Victor 58, 64, 111, 179
 works illustrated *181*
Afanassiev, Fedor 64
Alexander II, Tsar, and Easter eggs 108
Alexander III, Tsar, 12–13
 and Easter eggs 80, 90
 egg commemorating 44 *98*
 monogram *106*
 other items commissioned 49, 178, *179*
Alexandra Feodorovna, Tsarina of Nicholas II 20, 90, 101 *22*
 coronation tiara 30
 Easter eggs 110
 other gifts received 49, 115, 120
 miniatures 28, 128, *36*, *83*, *85*
 monogram *83*, *101*
 provides drawings for pieces 66
 murdered 20
Alexandra, Queen of Edward VII 15, 137, 144, 146, *23*
 Christmas purchases (1912) 146
 given animal collection 156
 monogram *33*
Alexei, Grand Duke (son of Alexander II) 7, 132, 141
Alexis, Tsarevitch 20
 miniatures 102, *61*, *83*, *104*
 photograph *103*
 portrait in Easter eggs 89, 101
Alfred, Duke of Edinburgh 141
Anastasia, Grand Duchess (d. of Nicholas II) 20, *23*
 miniatures *61*, *83*
animals **153–6**, *145*, *154*, *155*, *156*, *157*, *158–9*, *160*, *175*
 forgeries *184*
 lack of marks 154
 prices 173–4, 175, 176
 Sandringham collection 154–6
Armfelt, Karl Gustav Halmar 58–9, 64
Art Nouveau influences 32, 33, 140
Artel, First Silver 77
Astor, Mrs Vincent 168

B

Bainbridge, Henry Charles 26, 144, 178
 and Sandringham animals 154–6
 references from Fabergé biography,
 on F.'s approval of products 51
 on forgeries and marks 180, 183
 on London branch 143, 144, 146
 on secrecy of Imperial eggs 80

on turning away business 60
 other refs. 15, 55, 58, 129, 157
Bakst, Léon 36
Balletta, Elizabeth 15, 131–2
Bennett, Ian: quoted 187
Benois, Alexandre 10, 14, 36, 97
 quoted 36
Birbaum, François 59
Biomerius, Paul 59
Boitzov, Vassili 47
Bolestone, Joan (Alexandra Feodorovna's nanny) 37
Bolin, Carl Edvard 30
Bolsheviks 20
bonbonnières *see* boxes
Boucheron 125
Bowe, Allan 144
Bowe, Arthur 54, 144
boxes 11, 55, **129–34**, *11*, *39*, *130*, *132*, *133*, *184*
 Balletta 131–2, 176, *62*
 Banker's 131
 Freedom 132
 "pound" 157
 prices 176
 see also cigarette cases
Brassow, Mme. 147
Bulgarian Royal Family 126, 141
Butz, Jules 10

C

cane handles *see* handles
Cartier of Paris 125, 183
Chaadayev, Peter 33
Chakrabongse, Prince of Siam 129
Chinese influences 122
Christie, Landsell K 176
Chulalongkorn, King of Siam 15, 129
Churchill, Lady Randolph 144
cigarette cases 39, 41, 129, **134–7**, **140–1**, *30*, *38*, *42–3*, *131*, *134*, *135*, *137*, *140*, *141*, *174*
 hinges and catches 140
 prices 173, 176
 variety of colour and design 137
Clifton, Henry Talbot de Vere 168
clocks *6*, *21*, *28*, *48*, *124*, *166–7*
collections 164–75
 British Royal 123, 124, 154–6, 164
 early American 164
 Forbes 26, 90, 126, 128, 129, 133, 140, 168
 Frick 97
 Green Vaults (Dresden) 31, 90
 Hammer Galleries 25
 Hermitage and Winter Palace 133
 India Early Minshall 168
 King Farouk's 171, 174–5
 Landsell Christie 176
 Lilian Thomas Pratt 89, 168
 Marjorie Merriweather Post 89, 133, 168
 Matilda Geddings Gray 168

Sandoz 171
Thai Royal 129
Walters 164, 168
Wernher 26, 117, 132, 141
colour, Fabergé's use of 39, 41
 in enamelling 47
 samordok technique 41
competitors, Fabergé's 30
Crosby, Mrs Bing 168
Crown Jewels, Imperial 49
Curzon of Kedleston, Lady 146

D

Danish Royal Family 146, 178
 golden wedding gift *179*
Dehn, Lili quoted 114–15
Denmark *see* Danish Royal Family
designers 59, 178, *63*
designs and drawings 176–80
 bowl *183*
 bruleparfum *186*
 drinking vessels *68–9*
 hair ornaments *66*, *74*
 jewellery *33*, *50*, *66*
Devonshire, Duchess of 146
Diaghilev, Sergei 36
 on St Petersburg 10
Dresden 10, 153
 Green Vaults collection 31, 90

E

Easter eggs
 origin of custom and tradition 81–2, 85
 Louis XVI and 'surprise' eggs 82
 miniature 49, 81–2, *47*
 Hammer collection 25
 Imperial **79–111**
 listed **108–10**
 become known through émigrés 24
 first commissioned 13, 80–1
 mechanical surprises 97–8
 Nicholas II doubles number 80
 number produced 85–6
 present whereabouts 86, 89, 90, 108–10
 prices 173, 174, 175, 175–6
 secrecy surrounding 80, 86
 their size 107
 Alexander III Equestrian 44, *98*
 Blue Enamel Ribbed 90
 Catherine the Gt. *see* Grisaille
 Clover 94
 Colonnade Clock 36, 97, 174, *95*
 Coronation 92–4, 107, *93*
 Cuckoo Clock 97–8, 175–6, *78*
 First (Hen) 89–90, 107, 174, *13*
 Gatchina Palace 90
 Grisaille 89, *87*
 Hoof 85
 Lilies of the Valley 90, *90–1*

Mosaic 59, 67, 90, *61*
 Orange Tree 97, 174, *96*
 Pamiat Azova 58, 92, *58*
 Pansy *81*
 Peacock 98–101, 171, *99*
 Red Cross with portraits 101
 Red Cross with Resurrection 101, *100*
 Renaissance 90, *89*
 Resurrection 90, 174, *90*
 Rose Trellis 97
 Rosebud 168–71, *169*
 St George 175, *104*
 Serpent Clock 107
 Spring Flowers 94, *94*
 Steel Military 101
 Swan 98, 171, 175
 Tercentenary 90
 Trans-Siberian Rly. 92, *92*
 Twelve-monogram 58, 90, *106*
 Uspensky Cathedral 107
 Winter 67, *74*
 Kelch 14, 101–3, 111
 Apple Blossom 103
 Chanticleer 101–3, 168, *105*
 Hen 101, 175, *102–3*
 Pine Cone 103, 176, *176–7*
 Twelve-panel *88*
 other 111
 Danish Royal Family's 80, *12*, *13*
 Duchess of Marlborough 107, 168, *84*
 Nobel Ice Egg 103, 107
 Youssoupov 107
 unnamed *164*, *165*, *168*
Edward VII, King 15, 137, 147, 156 *22*
 monogram *33*
Elisabeth Feodorovna, Grand Duchess 49
enamelling 44–7
 champlevé 47
 cloisonné 47, *47*
 guilloche 32, 45
Eugénie, Empress 146
exhibitions
 E. Snowman (1927) 26
 Exp. Internationale Universelle (Paris, 1900) 12
 K. Snowman (1953) 26
 London (1949) 26
 Munich (1986–7) 27
 Northern (Stockholm, 1897) 12
 Nuremberg Fair (1885) 12
 Pan-Russian (Moscow, 1882) 12
 V. & A. Museum (1977) 26
 see also collections

F

Fabergé & Cie (Paris) 21, 125, 183
Fabergé, Agathon (F.'s brother) 11, 31, 54, 59
 mark *184*
Fabergé, Agathon (F.'s son) 10, 49,

59–60
and Crown Jewels 49
mark 184
Fabergé, Alexander (F.'s son) 10,
60, 103
Paris firm 21, 125, 183
Fabergé, Carl (F.'s grandfather) 9
Fabergé, Charlotte (née Jungstedt,
F.'s mother) 9
Fabergé, Eugène (F.'s son) 10, 59,
89, *19*
Paris firm 21, 125, 183
Fabergé, Gustav (F.'s father) 8, 9, 10
Fabergé, House of *8-9, 63, 64, 65*
F. takes over 10
expansion of St Petersburg branch
15, 54
Imperial Cabinet at Winter Palace
144
Kiev Branch 15, 54
London branch 60, 144–7
flowers sales 123
sales ledgers 146–7, 171
Moscow branch 15, 54
numbers employed 15, 54, 55
Odessa branch 15, 54
organization and groups of
employees 55, 57–60
output 54
prices 146–7
stock records 60–2, 66–7, 117
variety of Imperial commissions
14
variety of objects produced 15, 18
other patrons 14–15
working conditions 60
World War 1 and Revolution 20–1
Fabergé, Julia Augusta (née Jacobs,
F.'s wife) 10, 20
Fabergé, Nicholas (F.'s son) 10, 60,
144
photograph by 63
Fabergé, Peter Carl *10, 19*
ancestry 8–9
birth 8
baptism 9
education and training 9, 10
in France and Italy 10
marriage and children 10–11
takes over family business 10
changes its style and materials
11–12
exhibitions and honours 12
Court Jeweller (1885) 12
declines to meet Q. Alexandra
(1908) 146
case against Goldsmith's Co.
(1910) 160
flight after Revolution 20
death and burial 20
character,
attitude to marks 77
collects Japanese netsuke 33
dislike of paper work 60
as employer 60
on himself 30
his role and influence 30, 51,

54–5
sources of inspiration 12, 31–3,
36–7
see also Chinese, French,
Italian, Japanese influences
style 11–12, 15–18, 31
see also Fabergé, House of
Fabergé, Theo (F.'s grandson) 184
Fahy, Dr Everett 97
Farouk, King of Egypt 171, 174
figures **147–153**, 187, *143, 144,
146, 147, 148–9, 150, 151, 152,
153*
John Bull series 150, *146*
materials used 150
prices (modern) 176
Russian tradition 147, 150
sources of inspiration 150, 153
flowers 32–3, **114–25**, *25, 112,
114, 115, 116, 117, 118, 119,
120, 121, 122, 123, 172*
choice of stones 117
containers 120–2
copies and forgeries 183
identifying genuine examples 125
lack of marks 125
London sales 123
not tied to rules of nature 115
prices (original) 173
prices (modern) 175
sources of inspiration 122–3
Forbes, Christopher 168
Ford, Mrs Henry 168
forgeries 180–5
frames 51, 126–9, *127, 128, 129,
170*
prices (original) 173
prices (modern) 176
French influences 12, 32, 41, 44–5
Friedmann (Dresden goldsmith) 10
Froedman-Cluzel, Boris (modeller)
154, 155
functional objects 125–6
barometer *26*
bell-pushes *125, 126, 171, 173*
candlestick *16–17*
desk seals *46, 57*
drinking-vessels *68–9, 86, 179*
Q. Wilhelmina's tray *162*
tableware *34–5, 70–1*
vases and bowls *40, 41, 70–1,
72–3, 161, 170, 181, 182–3*
other items *15, 27, 75, 77, 171,
185, 186*
see also boxes, cigarette cases,
clocks, handles, frames

George V, King, Coronation gift 157
Germinet, Admiral 40
Gibbes, Charles Sidney:
photograph by *23*
Gibson, Allan 54
gold and silver standards 41, 74, 160
Goldsmith's Co., Fabergé's case
against 160

Gooreynd, Mme Koch de 168
Gorianov, Andrei 64
Greece, King of 146
Grey, Lady de 146
Grunberg-Salkaln 154
(modeller) 154

Habsburg, Geza von 27, 97, 103
Hahn, Karl 30
hallmarks *see* gold and silver
standards; marks
Hammer, Dr Armand 25, 168
Hammer, Victor 25
handles, cane and parasol 141,
138–9
Hawley, Henry H. 187
Hollming, August 58, 64
works illustrated *45*
Hollming, Vaino 64
Holmström, Albert 58, 59, 64
designs 176
stock records 60–2, 66–7, 117
works illustrated *32, 76*
Holmström, August (father of Albert)
57–8, 59, 64, 108
flowers 125
Hutton, Barbara 168

Italian influences 153
Ivashov, Alexander 63

Jacobs, Julia Augusta *see* Fabergé,
Julia
Jacobson, Eugène (designer) 178
Japanese influences 33, 122, 154
jewellery
brooches *31, 33, 36, 37, 44, 45*
choice of materials 47–9, 49–51
designs and drawings 179–80, *33,
50, 66, 74*
Imperial commissions 49
materials used 62, 66
pendants, *30, 31, 52, 76*
other items *14, 32, 36, 55*
prices (original) 173
Jungstedt, Charlotte *see* Fabergé,
Charlotte

Karsavina (ballerina) 15
Kchessinskaya (ballerina) 15
Kelch, Alexander 14, 101
Kelch, Barbara 14, 101, 164
Kelch Eggs *see under* Easter Eggs
Kennedy, Una: quoted 117
Keppel, Mrs Alice 137, 146, 154
Kollin, Erik August 12, 55–7, 63
Kritsky, Zosim (designer) 178
Kyrill, Grand Duke 56

Lalique 125
Lauder, Evelyn 168
Le Roy (goldsmith) 90
Lenin, Vladimir Ilyich 20, 24, 25
Lieberg, Ivan *63*
Londonderry, Marchioness of 146
Lundell, Karl Gustav Johansson 64
Lutiger, Frank (modeller) 155
Luton Hoo *see* Wernher *under*
collections

Malycheff, George (modeller) 59,
154
Marchetti, Andrea 183
Marie Feodorovna, Tsarina of
Alexander III 144, 147
and Imperial eggs 13, 14, 80, 86,
108–9
monogram *106*
Marie, Grand Duchess (d. of
Nicholas II) 20, *61, 83*
Marie Pavlovna, Grand Duchess 146
marks **183–5**
Fabergé's 51, 77
flowers 125
state 77
workmasters' 74, 150
Marlborough, Consuelo, Duchess of
84, 107, 144, 168
Marucelli, Silvio 185
Mary, Queen 174
quoted on F. 187
Michael Michaelovitch, Grand Duke
128
Mickelson, Anders 64
miniatures and miniaturists 59, 126
Nicholas II and his wife 28, 128,
36, 83, 85, 91, 104, 130
their children 102, *61, 82, 83, 91,
100, 104*
Mire Iskvussa (World of Art)
movement 10, 36
modellers 59, 154
monograms 131, *33, 55, 83, 101,
106, 135, 137*
Morgan, J.P. Jr 164

Nevalainen, Anders 64, 77
Nicholai Nicholaivitch, Grand Duke
150, *23*
Nicholas II, Tsar 19–20, *22*
doubles Imperial eggs 14
gifts from 120, 132, *135*
see also Easter eggs
miniatures 28, 128, *36, 83, 91,
104, 130*
monogram 131
round-world cruise 58
murdered 20
De Nichols & Plinke (The "English

Shop") 30
Niukkanen, Gabriel Zachariasson 64
Nobel, Dr Emanuel 14, 66, 150, 164
 Ice Egg 103, 107
Norway, King and Queen of 146

O

Olga, Grand Duchess (d. of
 Nicholas II) 20, 101
 miniatures *61, 83, 91, 100*
 monogram *55*
Ovchinnikov, Pavel 30, 47

P

Paget, Lady 146
Panina, Varya 147
 figure 147, 150, 176, *147*
parasol handles *see* handles
Parker, Mr Justice 160
Pauzie, Jérémie (Court Jeweller) 122
Pembroke, Earl of 132
Pendin, Peter Hiskias 97
Perchin, Michael 57, 63, 92
 boxes 130, *133*
 Easter eggs,
 listed 108–11
 illustrated *58, 78, 81, 84, 85,
 88, 89, 90–1, 92, 93, 102,
 105, 106, 169, 176–7*
 frame *170*
Peredvizhnki (Vagrants) 147
Petrov, Alexander (enameller) 47, 65
Petrov, Nicholas (enameller, s. of
 above) 47, *65*
photograph frames *see* framess
picture frames *see* frames
Pihl, Alma 59, 66–7, 107
 works illustrated *61*
Pihl, Knut Oskar 59, 64
Pihl, Oskar Woldemar 59
platinum, use of 41, 62
Poklewski-Koziell, Stanislas 147,
 156–7
Portugal, King of 147

prices **171–6**
 animals 175, 176
 boxes 176
 Christie's Geneva (1989) 176
 cigarette cases 176
 designs and drawings 178, 179
 eggs, 173, 174, 175, 175–6
 figures 176
 flowers 175
 frames 176
Pustinikov (Cossack bodyguard) 147,
 150

R

Rappoport, Julius 64, 77, 178
 works illustrated *28, 179*
Rehren, Dagmar de 180
Reiner, Wilhelm 64
Ringe, Philip Theodor 65
Romanov tercentenary 66, 90
Rothschild, Leopold de 157, 164
Rothschild, Mrs de 146
Ruckert, Fedor 47, 65, 178
 works illustrated *41*
Russia
 industrial expansion 18
 labour reforms 60
 pre-Revolution stirrings 18, 19
 World War I 19
 Revolution 20
 sales of Imperial treasure 24

S

Sackville, Lady 147
Sackville-West, Mrs 146
St Petersburg 9–10
 theatre and ballet stars 14–15
 see also Fabergé, House of
Saltikov, Ivan 47
Sandoz, Maurice Y. 107, 171
Sargent, John Singer 60
Schaffer, Alexander 25
Schramm, Eduard Wilhelm 65
Scythian treasures 12

Seeds, Sir William 150
Semenova, Maria 47
Siam, Royal Family of 15, 129, 150
Sitwell, Sacheverell: on Fabergé 54,
 115
Slavophiles *see* Westerners and
 Slavophiles
Snowman, Emanuel 25, 26, 168
Snowman, Kenneth 25, 26, 117, 179
 acquires stock records 60–2
 quoted 47
Solodkoff, Alexander von 27, 123
 quoted 86
Soloviev, Vladimir 65
Stein, George 94, *56*
Stiquel (Paris craftsman) 185
Stoliza y Usadba: Fabergé interview
 30
Stopford, Bertie 24–5
Stroganov, Count Sergei 12
Strong, Roy: quoted 26–7
Suffolk, Countess of 146

T

Tatiana, Grand Duchess (d. of
 Nicholas II) 20, 101
 miniatures 128, *61, 82, 83, 91,
 100*
Thielemann, Alfred 59, 65
Thielemann, Karl Rudolph 59
Tillander, Alexander 30, 59
Torby, Countess 146, 164
Trotsky, Leon 49

V

Vanderbilt, Mrs W. K. 147
Vartanian, Paul 171
Vassiltchikov, Prince 15
Victoria, Queen 144
 on Alexander III 12
 carved figure of 150
Vieille Russie, La 21, 26, 103
Vladimir Alexandrovich, Grand
 Duke: monogram *137*

W

Wakeva, Stefan 65, 77
Walters, Henry 164
Wartski 25, 168, 174
 1989 prices 176
 purchase of John Bull figures 150
 see also Snowman
Wernher, Lady Zia 26, 141, 164
Westerners and Slavophiles debate
 33, 36
Westminster, Duchess of 146
Wigström, Henrik 57, 63, 94, 125,
 150
 Easter eggs 89, 109, 110, 111
 works illustrated *26, 38, 87, 95,
 99, 100*
Wilhelm II, Kaiser
 monogram *135*
 photograph 129
Wilhelmina, Queen: wedding gift
 162
wood, types used 51, 55
workmasters **55-9, 63-5**
 autonomy 77
 head 63
 individuality 57
 marks 74, 150
 see also under individual names
World of Art movement *see* Mir
 Iskvussa

Y

Youssoupov, Prince Felix 14, 24,
 107

Z

Zehngraf, Johannes 59, 126
Zucchi (ballerina) 14-15
Zuiev, Vassily 59, 89, 101, 126
 works illustrated *83, 87, 127*

Acknowledgements

Key: a=above; b=below; l=left; r=right; c=centre

Abbreviations: C=Christies; FMC=Forbes Magazine Collection, New York; S=Sotheby's; W=Wartski, London

Quarto would like to thank the following for providing photographs, and for permission to reproduce copyright material. While every effort has been made to trace and acknowledge all copyright holders, we would like to apologize should any ommisions have been made.

Page 1 FMC; p.2 FMC; p.6 W; p.8-10 W; p.12 The Royal Danish Collections at Rosenborg Palace, Copenhagen/photo Lennart Larsen: p.13 a FMC b The Royal Danish Collections at the Rosenborg Palace, Copenhagen/photo Lennart Larsen; p.14 FMC/photo Larry Stein; p.15 The Brooklyn Museum, New York, Bequest of Helen B. Saunders; p.16-17 C; p.18-19 W; p.20-21 W; p.22 a A Private Collection courtesy of Sotheby's; b W; p.23 a A Private Collection courtesy of Sotheby's; bl W br A Private Collection courtesy of Sotheby's; p.24-25 W; p.26 C; p.27 S; p.28 Courtesy of Hillwood Museum, Washington D.C.; p.30-31 S; p.32 W; p.33 a FMC/photo Robert Wharton b C; p.34/35 C; p.36 a S b Courtesy of Hillwood Museum, Washington D.C. p.37 Ermitage Ltd, London; p.38-39 C; p.40 The Bridgeman Art Library/Christies London; p.41 C; p.42 al Ermitage Ltd, London ar The Bridgeman Art Library/Christies London bl C; p.43 C; p.44 Ermitage Ltd, London; p.45 l S r FMC/photo Robert Wharton; p.46-47 Ermitage Ltd, London; p.48 The Royal Danish Collections at the Rosenborg Palace, Copenhagen/photo Lennart Larsen; p.50 C; p.52 FMC/photo Larry Stein; p.55 W; p.56 Ermitage Ltd, London; p.57 FMC/photo Larry Stein; p.58 Ermitage Ltd, London/The Armoury Museum, Kremlin; p.60-61 Reproduced by gracious permission of Her Majesty The Queen; p.62 The Bridgeman Art Library; p.63 W; p.64-65 W; p.66-67 C; p.68-69 C; p.70-71 C; p.72-3 C; p.74 C; p.75 W; p.76 FMC/photo Larry Stein; p.77 FMC/photo H Peter Curran; p.78 S; p.81 W; p.82 FMC; p.83 a FMC/photo H Peter Curran b FMC; p.84-85 FMC/photos H Peter Curran; p.86 C; p.87 a Courtesy of Hillwood Museum, Washington D.C. b Ermitage Ltd, London; p.88 Reproduced by gracious permission of Her Majesty The Queen; p.89 FMC; p.90 a FMC/photo H. Peter Curran b FMC/photo Larry Stein; p.91 FMC/photo Larry Stein; p.92 Ermitage Ltd, London/The Armoury Museum, Kremlin; p.93 a FMC/photo Larry Stein b FMC; p.94 FMC/photos Robert Wharton; p.95 Reproduced by gracious permission of Her Majesty The Queen; p.96 FMC/photo Peter Curran; p.98 Ermitage Ltd, London/ The Armoury Museum, Kremlin; p.99 Ermitage Ltd, London; p.100 The Cleveland Museum of Art, The India Early Minshall Collection; p.102 FMC/photo H Peter Curran; p.104-105 FMC/photo H Peter Curran; p.106 Courtesy of Hillwood Museum, Washington D.C.; p.112 Reproduced by gracious permission of Her Majesty The Queen; p.114 Reproduced by gracious permission of Her Majesty The Queen; p.115 l FMC/photo Larry Stein r Reproduced by gracious permission of Her Majesty The Queen; p.116 W; p.117 Ermitage Ltd, London; p.118 Reproduced by gracious permission of Her Majesty The Queen; p.119 W; p.120-121 W; p.122-123 The Cleveland Museum of Art, The India Early Minshall Collection; p.124 Ermitage Ltd, London; p.125 S; p.126-127 S; p.128 S; p.129 W; p.130-131 S; p.132 Courtesy of Hillwood Museum, Washington D.C.; p.133 l Courtesy of Hillwood Museum, Washington D.C. r FMC; p.134 W; p.135 Ermitage Ltd, London; p.136 W; p.137 S; p.138 a S bl C br S; p.139 W; p.140 Reproduced by gracious permission of Her Majesty The Queen; p.141 C; p.142 W; p.144 Reproduced by gracious permission of Her Majesty The Queen; p.145 C; p.146 a Ermitage Ltd, London b W; p.147 a W b FMC; p.148-9 W; p.150-151 W; p.152 W; p.153 l W r Ermitage Ltd, London; p.154 l C r W; p.155 Reproduced by gracious permission of Her Majesty The Queen; p.156 Reproduced by gracious permission of Her Majesty The Queen; p.157 l Reproduced by gracious permission of Her Majesty The Queen r S; p.158 al W ar S bl S br W; p.159 al S ar W bl Ermitage Ltd, London br W; p.160 S; p.161 Reproduced by gracious permission of Her Majesty The Queen; p.162 The Bridgeman Art Library/ Christies London; p.164 S; p.165 a FMC/photo H Peter Curran b FMC/photo Larry Stein; p.166-167 l W c S r W; p.168-169 FMC/photo Larry Stein; p.170 S; p.171 b S r FMC/photo H Peter Curran; p.172 Reproduced by gracious permission of Her Majesty The Queen; p.173 The Royal Danish collections at Rosenborg Palace, Copenhagen/photo Lennart Larsen; p.174 W; p.175 The Bridgeman Art Library/Christies London; p.176-7 S; p.178-9 C; p.180-181 C; p.182-3 C; p.184 Ermitage Ltd, London; p.185 S; p.186 C; p.187 S.

Bibliography

Bainbridge, H.C. *Peter Carl Fabergé*, Batsford, 1949

Benois, A., *Reminiscences of the Russian Ballet*, Putnam, 1947

Buxhoeveden, Baroness Sophie, *The Life and Tragedy of Alexandra Feodorovna, Empress of Russia*, Longmans, Green and Co, 1928

Catalogue of the International Exhibition of Fabergé held at the Victoria and Albert Museum, London, 1977

Dehn, L., *The Real Tsaritsa*, Thornton Butterworth, 1922

Forbes, C., *Fabergé Eggs, Imperial Russian Fantasies*, Harry N. Abrams Inc, 1980

Hawley, H., *Fabergé and his Contemporaries*, Cleveland Museum of Art, 1967

Houart, V., *Easter Eggs, A Collector's Guide*, Souvenir Press, 1978

Menkes, S., *The Royal Jewels*, Grafton Books, 1986

Pares, Sir Bernard, *A History of Russia*, Jonathan Cape, 1947

Priestley, J.B., *The Edwardians*, Heinemann, 1970

Seton-Watson, H., *The Decline of Imperial Russia 1855-1914*, Methuen, 1952

Snowman, A.K., *The Art of Carl Fabergé*, 2nd edition, Faber and Faber, 1962

Snowman, A.K. *Carl Fabergé, Goldsmith to the Imperial Court of Russia*, Debrett's Peerage, 1979

Von Habsburg-Lothringen, G. and Von Solodkoff, A., *Fabergé, Court Jeweller to the Tsars*, Alpine Fine Arts Collection, 1979

Von Solodkoff, A., *Fabergé*, Pyramid, 1988